THE RECKONING
WOMEN ARTISTS OF THE NEW MILLENNIUM

Eleanor Heartney
Helaine Posner
Nancy Princenthal
Sue Scott

PRESTEL
MUNICH · LONDON · NEW YORK

INTRODUCTION

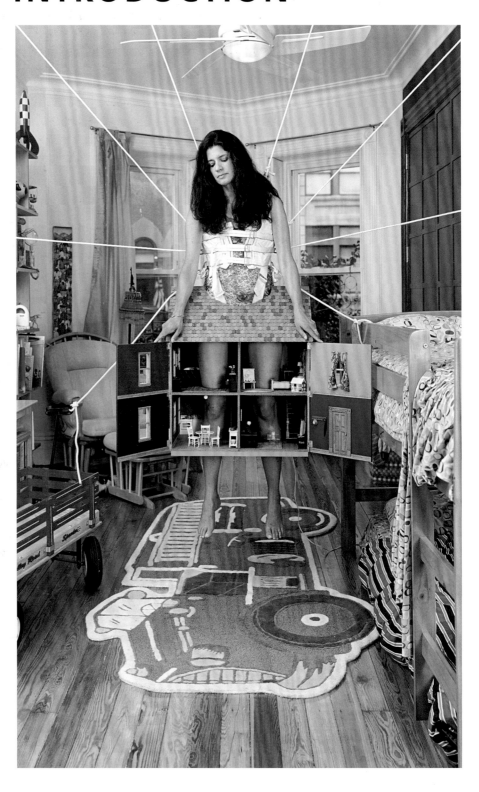

IN THE UNITED STATES, 2007 was hailed as the year of feminism in art. This surprising celebration took place at a time when the women's movement was widely regarded as outmoded, even irrelevant, and feminism was considered a dirty word. The year was marked by a number of significant events designed to applaud and assess women's achievements in the visual arts, including the opening of the Elizabeth A. Sackler Center for Feminist Art at the Brooklyn Museum, featuring an inaugural exhibition on *Global Feminisms*; another large international survey titled *WACK!: Art and the Feminist Revolution*, organized by the Museum of Contemporary Art, Los Angeles, which toured North America; and a two-day symposium called "The Feminist Future" held at New York's Museum of Modern Art, an institution not generally noted for its support of art by women.

In his review of *WACK!*, art critic Holland Cotter offered a bold assessment of the state of art and feminism in the pages of *The New York Times*. He declared, "One thing is certain: Feminist art, which emerged in the 1960s with the women's movement, is the formative art of the last four decades. Scan the most innovative work, by both men and women, done during that time, and you'll find feminism's activist, expansionist, pluralistic trace. Without it identity-based art, crafts-derived art, performance art and much political art would not exist in the form it does, if it existed at all. Much of what we call postmodern art has feminist art at its source." [1] It seems that while the art establishment was attending to business as usual, feminists—male as well as female—had passed them by.

Our contribution to the year of art and feminism was a book titled *After the Revolution: Women Who Transformed Contemporary Art*. Focusing on a dozen exemplary artists, we described the strides they and their colleagues had made since the advent of the feminist movement in the 1960s, and noted the changes that took place in their critical reception, commercial appeal, and level of institutional support. In her foreword to this volume, the distinguished art historian Linda Nochlin observed, "After the revolution comes the reckoning," and asked, "Exactly what has been accomplished, what changed?" *The Reckoning: Women Artists of the New Millennium* is an attempt to address Nochlin's pointed question. We decided to turn our attention to a generation of women artists born post-1960 who have benefited from ground-breaking efforts of their predecessors, and to cast a wider geographical net, reflecting the globalization of the contemporary art world as well as the inroads made by feminism worldwide. The twenty-five women artists selected for

[1] Holland Cotter, "The Art of Feminism as It First Took Shape," *New York Times*, March 9, 2007, http://www.nytimes.com/2007/03/09/arts/design/09wack.html?pagewanted=all.

inclusion in this new survey work in a wide variety of media and across a broad range of subjects. With gradually increasing opportunity and growing popular and critical acclaim, these artists, and their peers, are now positioned to reshape visual culture.

Rather than attempting an encyclopedic survey, we have organized *The Reckoning* around four themes that, we feel, capture significant impulses in artwork by younger women. "Bad Girls" presents artists who exploit "politically incorrect" and sexually explicit material to challenge the patriarchal image regime. "Spellbound" focuses on women's embrace of the irrational, the subjective, and the surreal. "Domestic Disturbances" takes on women's conflicted relationship to home, family, and security. "History Lessons" addresses women artists' engagement with political and social concerns. Each theme is linked to a groundbreaking work by what we came to think of as our artists' foremothers. These landmark works, which demonstrate the continuity between generations, also helped us think through how younger artists differ from their predecessors—how changing circumstances in the world and the role of women within it have subtly inflected longstanding concerns.

We readily acknowledge that many important artists do not fit comfortably within these categories. However, we feel they allowed us to map out a revealing set of relationships among women, culture, and world. The four themes might be thought of as a four-pointed net thrown over our subject. Two of the points involve subjective and individual aspects of women's experience: "Bad Girls" explores the body's role in forging our identity and considers how we are in turn shaped by the other's gaze. "Spellbound" comes at the question of identity from the opposite perspective, examining interior realities shaped by fantasy, subconscious desires, subliminal memories, and dreams. Because both categories deal with the construction of a sense of self, artists in these sections share certain overlapping concerns, among them the uses and abuses of pornography, the role of fantasy in the creation of identity, and the varieties of female pleasure.

The other two points of our net are more social, exploring women's relationship to the larger institutions that make up our world. "Domestic Disturbances" highlights the conflicts that often exist between individuals and family, construed in the widest sense. Dilemmas here include the struggle to balance communal identity and individuality; personal freedom and group responsibility. "History Lessons" pulls back to look at the self in relation to an even larger sphere,

namely the artist's role in the world. Here questions of political power, social responsibility, and national identity come to the fore. Again, there are overlapping concerns between these two more collective categories, among them questions of activism, politics, and communal action.

Together these four points provide a way to make sense of the bewilderingly varied nature of female experience in the contemporary world. They also help explain the increasing diversity in our understanding of the term "feminism." One thing that became apparent to us in considering this generation of women artists is that its notion of identity—sexual, cultural, personal—is strikingly fluid. And while feminism continues to be a drive that transcends individuality (it is meaningless otherwise), it is itself increasingly plural. The ways in which the artists in this book speak about feminism vary enormously (and it should be noted that a few choose not to speak of it at all). For some—Sharon Hayes, for instance—it is a cause their work is organized to promote. Others—among them Tracey Emin and Lisa Yuskavage, two of the artists gathered under the category "Bad Girls"—take feminism as a term of lively contestation. Their work kicks against the traces of earlier activist positions, arguing for a new way of conceiving women's desires and ambitions.

At the same time, the artists considered here generally share the belief that gender identity, on which feminism is after all founded, is itself no longer unitary. *Taking control* (for a long time this was the working title for our book) of the way their sexuality is pictured is a driving force for much of this work, from Catherine Opie's richly formal but highly confrontational portraits of cross-dressing leather dykes, to Kara Walker's blistering depictions of interracial sexual violence. Determined to fashion their own sexual identities, younger women tend to be acutely sensitive to the ways in which commercial visual culture confines their choices. They embrace the realization that it is impossible, and undesirable, to divide gender into a simple binary of straight and gay, or male and female.

Just as the positions sketched out by these women for personal identity are deliberately loose, their modes of work unsettle traditional notions of how art is produced. Many have chosen to work in collaboration; Liza Lou's work with craftswomen in South Africa is one example; Jane and Louise Wilson, and Nathalie Djurberg (who works with musician Hans Berg), are among the many women included in this book who have chosen, often or always, to work in partnerships. One result of this decentered authorship is the possibility of compounded inventiveness.

Crafting new modes of domesticity, of romantic and professional partnership, these artists are creating lives that mirror those pictured in their work, and vice versa. Many live deep in a matrix within which the authentic is nearly impossible to disentangle from the constructed, the individual from the collective. From Cao Fei's online animated world at one extreme, to the quasi-utopian, real-life community of Andrea Zittel's High Desert Test Sites at another, the work these women do aims some heavy blows at already weakened barriers between art and everything else.

The project of assembling a book about women artists inevitably raises questions about whether sexual parity hasn't made arguments on behalf of women artists unnecessary. The statistics we've assembled for both our first book and our second show that while significant progress has been made, there is still work to be done. In *After the Revolution* we looked at the percentage of women artists given solo exhibitions in galleries and museums and featured in monographs to assess progress in achieving professional parity with male artists (see Appendix figures 1 and 2 in this volume). In each case, the numbers have risen from dismally low proportions in the 1970s to between 25% and 30%. While working on *The Reckoning*, we realized these particular statistics were just beginning the conversation. This led us to wonder: how do artists become known and who are the gatekeepers to a successful career?

FIGURE 1
Number of MFA graduates by gender.
— FEMALE
— MALE

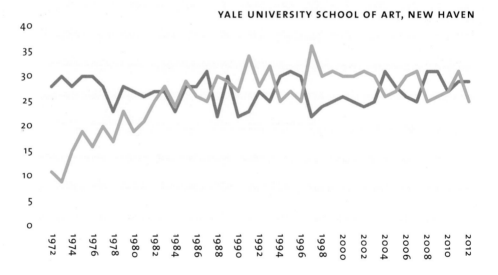

YALE UNIVERSITY SCHOOL OF ART, NEW HAVEN

Looking at leading MFA programs across the United States, we found a consistent upward trajectory of women earning MFAs, equaling or surpassing the number of male graduates over the past forty years. This wasn't always the case. At Yale University, the oldest program surveyed, 11 women and 28 men graduated with MFAs in 1972 (fig. 1). By 1983, more women graduated than men (28:27), and over the last decade, the numbers were almost even year to year. Since the early '80s, both the School of the Art Institute of Chicago and UCLA have typically graduated more women than men (see figs. A3 and A4).

In MFA programs in Sweden, England, and Israel, the ratio of graduates is either equal or favors women. For example, the Royal Institute of Art in Stockholm graduated more women than men in two-thirds of the years surveyed (fig. 2), and we see the same proportion at Goldsmiths, University of London (see fig. A5). The relatively young program at the Bezalel Academy of Arts and Design in Jerusalem, which opened in 2003, typically graduates an equal number of men and women (see fig. A6).

It is striking to move from the academy to the commercial realm, where women remain far behind in terms of gallery representation. In our survey of prominent New York galleries, women artists represented 25%, at the very best, of recent solo shows. Why is this? The answer may be that many younger women—like their feminist progenitors—work in performance and video, which inarguably has

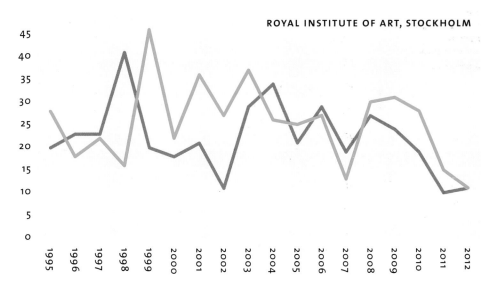

FIGURE 2
Number of MFA graduates by gender.

——— FEMALE

——— MALE

ROYAL INSTITUTE OF ART, STOCKHOLM

INTRODUCTION

less market appeal than the more traditional forms of art making. It is also worth noting that while several of the artists featured in this book lack gallery representation at this time, four have received the prestigious and lucrative MacArthur Award.

On the flip side, contemporary biennials are more supportive of women, perhaps due to their embrace of video and performance work. In the 1973 Whitney Biennial, curated by Marcia Tucker, 27% of participants were women (fig. 3). The infamous boundary-breaking 1993 biennial curated by Elizabeth Sussman (with Thelma Golden, Lisa Phillips, and John Hanhardt) was 40% female. Almost twenty years later, that number is about that same—37% of the 2012 biennial participants were female. The 2010 biennial, curated by two men, should not go unmentioned; it had the same number—27 each—of men and women. The Istanbul Biennial went from 23% participation by women in 1987 to 50% in 2011. The first Documenta, in Kassel, Germany, held in 1955, had 7 women of the 148 participants, or just fewer than 5% (fig. 4). The 1982 Documenta, which showed only one video artist (Dara Birnbaum), saw only 13% participation by women. In 2007, 41% of those chosen were female, dipping slightly to 37% in 2012. (For both these years, at least one of the curators was female.) Manifesta, a relative newcomer which began in 1996, consistently includes upwards of 30% female participants (see fig. A7). These data clearly attest to the progress women have made over time in the international surveys.

Compare all of these statistics to the progress of women in society at

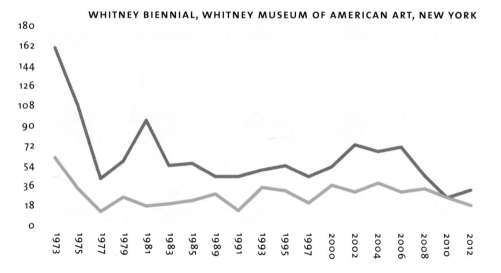

FIGURE 3
Number of featured artists by gender.

 FEMALE

MALE

WHITNEY BIENNIAL, WHITNEY MUSEUM OF AMERICAN ART, NEW YORK

large. The US election of 2012 will be heralded as historic for a number of reasons, not the least of which is the unprecedented election of 20 female senators. Still, that represents only 20% of the senate. A 2012 *New York Times* article entitled "The Myth of Male Decline" discusses and debunks the lingering misconception that women dominate the workplace. [2] Although more women graduate from college than men (60%) and today make up 40% of management, they still earn 73% of what their male colleagues earn. Thus in government and business—as in the art world—women are making impressive strides toward equality but they have not yet reached the goal.

Nonetheless, most of our statistics give a clear basis for optimism. Our reckoning, then, concurs with Cotter's assessment that feminist art is among the most innovative and influential work being made today. Furthermore, women are reaching parity in institutional support. There is, however, still room for improvement, both in representation in galleries and solo shows in museums. There is reason to hope that the market will eventually catch up with the critical and institutional success women artists have enjoyed. In any case, we feel strongly that the rich vitality of work by young women, sampled by the artists in this book, constitutes the best argument for the increased share of attention they deserve.

— ELEANOR HEARTNEY, HELAINE POSNER, NANCY PRINCENTHAL, AND SUE SCOTT

FIGURE 4
Number of featured artists by gender.

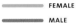 FEMALE

MALE

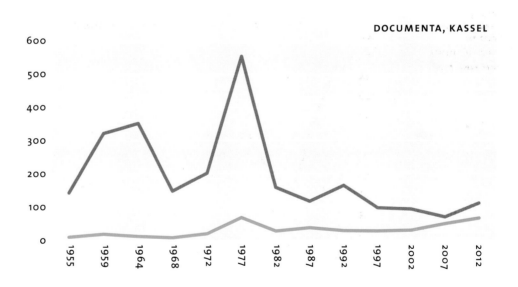

DOCUMENTA, KASSEL

[2] Stephanie Coontz, "The Myth of Male Decline," *New York Times*, September 29, 2012, http://www.nytimes.com/2012/09/30/opinion/sunday/the-myth-of-male-decline.html?pagewanted=all.

BAD GIRLS

by Eleanor Heartney

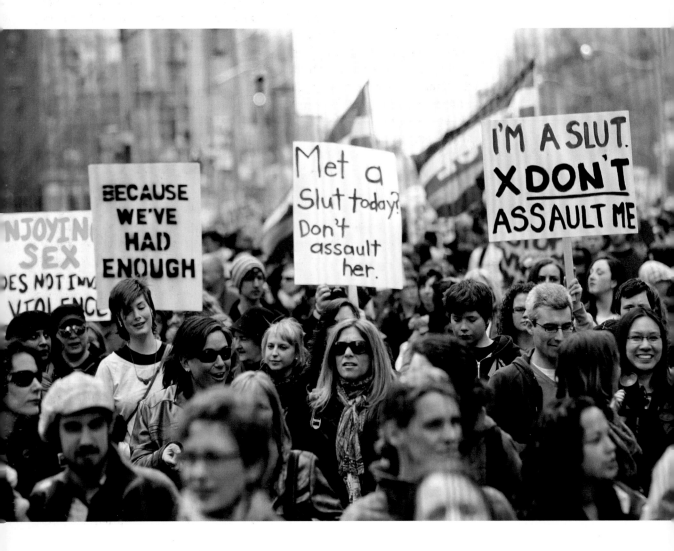

ONE HUNDRED YEARS AFTER Margaret Sanger opened the first birth control clinic in the United States, and fifty years after the onset of the so-called sexual revolution, questions about women's control over their bodies, sexual expression, and complicity with sexual violence remain deeply divisive and controversial. These became a political issue in the 2012 American election campaigns when Republican candidates quibbled about terms like "legitimate rape" versus "forcible rape" (as opposed to what, exactly?) and conservative talk show host Rush Limbaugh dubbed a young law student a "slut" for her advocacy of contraception. This came a year after Canadian feminists, outraged by a Toronto police officer's remark that women could evade rape by not "dressing like sluts," instituted the "SlutWalk," a form of protest in which women dress provocatively while demonstrating against sexual violence (opposite).

So it is clear that, forty years after artist Lynda Benglis was excoriated by other feminists for posing for an ad in *Artforum* magazine wearing nothing but a pair of sporty sunglasses and a giant dildo (below), the debate over Bad Girls goes on. Questions about the power of images, the politics of sexual assertion, and the "proper" expression of female desire refuse to go away. Are women who play with sexually suggestive images liberating themselves or succumbing to patriarchal prejudices? Is pornography, as various feminist writers and artists have argued, a form of male violence against women or is it a potentially subversive tool which may be adapted for women's own purposes? Are phrases like slut, slag, dyke, and cunt to be embraced or rejected? What, exactly is a "Bad Girl" and is it good or bad to be one?

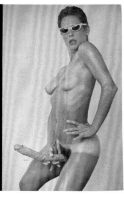

The debate over Bad Girls goes to the heart of competing theories about the male gaze (or, as it is sometimes referred to in more theoretical circles, "the scopic regime of the patriarchal order"). Since the 1970s, feminist art historians have been pointing out that Western art's traditional focus on the female nude underscores the male-dominated culture's assumptions about female passivity, sexual availability, and

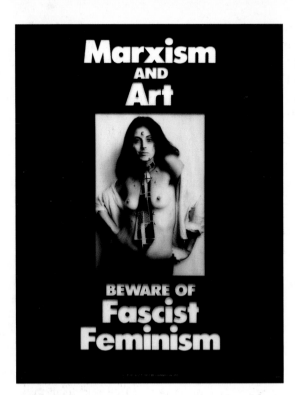

Hannah Wilke, *Marxism and Art: Beware of Fascist Feminism*, 1977. Screenprint on Plexiglas; composition and sheet: 35½ x 27⅜ in. | 90 x 69.5 cm. The Museum of Modern Art, New York; General Print Fund, Riva Castleman Endowment Fund, Harvey S. Shipley Miller Fund, The Contemporary Arts Council of The Museum of Modern Art, and partial gift of Marsie, Emanuelle, Damon, and Andrew Scharlatt, Hannah Wilke Collection and Archive, Los Angeles.

subordination. For feminist artists emerging in the 1970s and '80s, the power of such images posed a challenge: how does one best counter the pervasive presentation in art and popular culture of women as mere objects of male desire?

This led to a standoff in the early days of feminist art. In one camp were those who argued that women's traditional identification with nature, the body, procreation, and ancient goddess cults should be cultivated in opposition to masculine aggression. In the other were those who maintained that gender is a social construction designed to keep women in a subservient position, and that true feminists should avoid any use of female imagery that reinforces pernicious stereotypes. The second camp derided the first as "essentialists" and colluders, while the first camp characterized their critics as puritans, iconoclasts, and even, in the words of Hannah Wilke, one pioneering feminist, "fascist feminists" (left).

It was in this climate that the first feminist Bad Girls appeared, though they did not characterize themselves this way. The notorious Lynda Benglis ad cited above will serve as our introduction to their cheeky assault on propriety and political correctness. Benglis created this image in 1974 as a response to a hyper-masculinist image that had been created a few months earlier in promotion for an exhibition by her friend and fellow provocateur, the artist Robert Morris. For his poster, a half-naked Morris decked himself out with a Nazi-era army helmet, mirrored aviator glasses, steel manacles, and a spiked collar. Slicking down her toned naked body with oil, Benglis and her dildo struck a pose that outdid Morris's super-macho image. The response to Benglis was swift and, in retrospect, surprisingly fierce. Five of *Artforum*'s regular contributors wrote an outraged letter to the editor, and two of them, Rosalind Krauss and Annette Michelson, resigned in order to start their own magazine, the resolutely theoretical and militantly iconoclastic journal *October*. Reaction outside the editorial circle was equally strong, as many readers canceled their subscriptions while others, many of them feminists, announced their support.

BELOW LEFT

VALIE EXPORT, *Action Pants: Genital Panic (Actionshose: Genitalpanik)*, 1969, printed 2001. Black-and-white photograph on aluminum; 65 x 47¼ in. | 165 x 120 cm. Photograph by Peter Hassman.

BELOW RIGHT

Niki de Saint Phalle, *Hon*, 1965–66. Reclining walk-in figure made for the Moderna Museet, Stockholm, and installed from April–July 1966. Fabric on steel scaffolding; approx. 19 ft. 8¼ in. x 105 ft. x 32 ft. 9¾ in. | 6 x 23.5 x 10 m.

Reflecting back on the controversy thirty-five years later, Benglis placed the image in the context of other provocative self-portraits she was doing at the time, including one in which she is photographed from the back, looking over her shoulder, nude with her pants down around her ankles. Explaining her motivations in a 2009 interview, she remarked, "There seemed to be no pinups unless they were essentially the object of the male gaze, so to speak. So after having exhausted different possibilities, I thought to myself, "What if I was my own subject and my own object, looking back at the men and the viewer in general?" [1]

Despite the brouhaha, Benglis was hardly the first feminist artist to explore these kinds of questions; in fact, such sexual provocations already had a long history by the time she entered the fray. By usurping the role of the Bad Boy (a figure of sneaking approbation in the art world), [2] phallus and all, she was simply dramatizing one option available to the Bad Girl. But there were other possibilities, including the flaunting of one's own sex, as undertaken by artists like VALIE EXPORT, who in 1968 exposed her crotch as she entered an art house movie theater brandishing a machine gun, or Niki de Saint Phalle, who even earlier, in 1965, created a huge sculpture of a female body which viewers could enter through the vagina (below). A third approach, undertaken by Carolee Schneemann in her famous 1964 performance

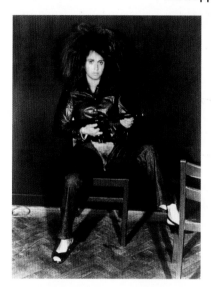

[1] Lynda Benglis, interview by Phong Bui, *Brooklyn Rail*, December 2009/January 2010, http://brooklynrail.org/2009/12/art/lynda-benglis-with-phong-bui.

[2] In fact, it turns out that Krauss had taken the photograph of Morris that ignited the battle of images, suggesting her strong preference for Bad Boys over Bad Girls.

Meat Joy, in which nearly naked men and women rolled about amid plucked chickens, fish, and buckets of paint, was to embrace a polymorphous sexual freedom that blurred the distinctions between male and female.

What all these works had in common was a flirtation with pornographic imagery, which put them in the center of a growing debate over the social, cultural, and political role of pornography. Already in the 1970s, divisions were appearing between "pro-sex" and "anti-porn" feminists. In the early 1980s feminists like Andrea Dworkin and Catharine MacKinnon lobbied for strict anti-porn laws under the claim that pornography was simply the theory of which rape is the practice. [3]

They were joined by theorists like Laura Mulvey, Robin Morgan, and Kate Linker, who insisted that genuine feminism required unequivocal opposition to images whose primary purpose is the titillation of male desire. Such arguments were somewhat muddied by the rise of an equally virulent opposition, especially in the US, to pornography from militant religious and political conservatives. Representatives of this group, which included quasi-religious organizations like American Family Association as well as senators and congressmen like Jesse Helms and Dick Armey, used similar arguments to denounce the social corruption they believed had been unleashed by feminism, the sexual revolution, the gay rights movement, and the permissive culture of contemporary art, which reflected all of these developments. One outcome of this battle was the culture war of the early 1990s, which revolved around efforts to shut down the US National Endowment for the Arts and to defund and even prosecute artists and curators who showed work that was deemed by conservative lawmakers to be sacrilegious, pornographic, or otherwise morally objectionable. Among those caught in this net were curator Dennis Barrie, indicted and eventually acquitted of obscenity charges for mounting a show of the work of Robert Mapplethorpe at the Cincinnati Center for Contemporary Art, and the "NEA Four," consisting of Karen Finley, Tim Miller, John Fleck, and Holly Hughes, four performance artists who fought all the way to the Supreme Court over the instatement of a "decency" requirement for art funded by the NEA.

In the other corner were pro-porn feminists who found themselves in the equally peculiar company of porn industry figures like Larry Flynt, publisher of *Hustler* magazine. Flynt argued that attempts to censor pornography were violations of free speech and civil rights. Taking a somewhat different tack, pro-porn feminist writers like Angela Carter, Joanna Frueh, Camille Paglia, and Paula Webster

[3] See Robin Morgan's 1974 essay "Theory and Practice: Pornography and Rape," in *Going Too Far: The Personal Chronicle of a Feminist* (New York: Random House, 1978).

insisted on the inherently subversive nature of pornography, which after all has historically served to undermine rigid class, social, religious, and political regimes. Arguing that the censure of pornography amounted to a criminalization of the erotic, they suggested that the oppressive potential for sexualized images of women could be countered by images that celebrated female pleasures and desire. As Paula Webster put the case, "If we can switch our focus from men's pleasure to our own, then we have the potential of creating a discourse that will challenge the values of 'good girls' (non-sexual women) and explore the bridge that connects and divides expression and repression." [4]

It was into this quagmire that curators Marcia Tucker and Marcia Tanner waded in 1994 with a pair of exhibitions that introduced the Bad Girl label into contemporary art. The shows, which appeared simultaneously in New York at the New Museum and in Los Angeles at the UCLA Wight Gallery, recognized that a sea change was taking place in the realm of feminist art. After the theoretical stand-off of the 1970s and '80s, a new generation of artists of both sexes was moving past the binary oppositions between masculine and feminine, domination and submission, good sex and bad sex, aggressor and victim, and body versus mind. Instead they turned their attention to multiplicity, the celebration of states of transgender, cross-gender, and sexual anarchy.

Tucker drew on the notion of the carnivalesque promulgated by Russian literary critic Mikhail Bakhtin describing the medieval carnival as "a social space where suppressed appetites could be expressed and sated, where inversions of power and position were temporarily sanctioned, where sexual dimensions could be explored without reprisal. In short, it was an arena where pleasure reigned." [5]

It was in a similar spirit, Tucker argued, that Bad Girl artists turned apparent reality upside down, using the tools of masquerade, humor, and play to undermine official culture. She described various empowering strategies practiced by Bad Girls (who might also, as in the case of Cary Lebowicz or Nayland Blake, be male). These included: "Talking out of both sides of your mouth," "Speak for yourself," and "Bad Girls are hysterical!" She went on to note, "The transgressive body not only mutates from old to young and back, but across genders, redefining itself in multiple ways, rejecting any fixed form." [6]

The new Bad Girls resisted the either/or propositions of previous formulations of feminism. The Bad Girl shows included artists like Rachel Lachowicz,

[4] Paula Webster, "Pornography and Pleasure," in *Caught Looking: Feminism, Pornography and Censorship*, ed. f.a.c.t. book committee (Caught Looking, Inc, 1985), 35.

[5] Marcia Tucker, "The Attack of the Giant Ninja Mutant Babies," in *Bad Girls* (Cambridge, Mass.: MIT Press; New York: New Museum of Contemporary Art, 1994), 23.

[6] Ibid., 34.

who recreated mini-copies of Duchamp's famous urinals out of lipstick and Deborah Kass, who channeled Warhol's portraits of Jackie and Marilyn in her depictions of Barbra Streisand, a personal heroine who mixed genders for her portrayal of a Yentl, a Jewish woman who cross dressed as a man in order to receive a Talmudic education (below). The attitude of Zoe Leonard, who placed close-up photos of female genitalia in Kassel's Neue Galerie in 1992, was typical of the new Bad Girls. She remarked, "I wasn't interested in re-examining the male gaze; I wanted to understand my own gaze." [7]

With the turn of the twenty-first century, the politics of sexuality have shifted again. On one hand, women artists in the United States and Europe are less fearful of creating work that sates the appetites of the straight male viewer. And gender identity itself has become far more fluid with the growing social acceptance of gay, lesbian, bisexual, and transgender rights. Instead of being defined as a state rooted in nature (as per the essentialists) or society (the deconstructionists), gender was now seen as something that might, in the words of curator Johanna Burton, be "exhibited, acquired, acknowledged, and fed back to subjects as they move and interact in the world." [8]

On the other hand, the advances of feminism, both in the West and globally, seem endangered by larger social forces. In the United States, political and religious conservatives appear intent on turning back the clock to the "good old days" of pre-feminist subservience, defining femininity in terms of motherhood and sexual attractiveness (this despite the emergence of female standard bearers like Sarah Palin and Michele Bachmann, who pursue ambitious political careers while espousing conservative positions on social

Deborah Kass, *Double Ultra Blue Yentl*, 1993–2012. Silkscreen and acrylic on canvas; 72 x 72 in. | 182.9 x 182.9 cm.

[7] Quoted in *Secession: Zoe Leonard* (Vienna: Wiener Secession, 1997), 16.

[8] Johanna Burton, "Cindy Sherman: Abstraction and Empathy," in *Cindy Sherman*, ed. Eve Respini (New York: Museum of Modern Art, 2012), 65.

issues). Meanwhile, popular culture promotes a "post feminist" vision of women as either sexually liberated but emotionally dependent sex objects or controlling, sexless harridans (we might see this as the opposition between the paradigms of *Desperate Housewives* versus *The Devil Wears Prada*), sending younger women decidedly mixed messages about sexuality, power, and identity. The return to such reductive stereotypes occurs at a moment when the pornography industry, abetted by the easy access of the Internet, has ballooned, reportedly outstripping the revenues of Microsoft, Google, Amazon, eBay, Yahoo, Apple, and Netflix combined. [9] Internationally, the rise of Islamic fundamentalism, driven by renewed fears of the disruptive nature of sexuality, manifests itself in calls for draconian restrictions of women's freedom. In countries where radical Islamists have gained significant power, this has rendered female challenges to the male gaze literally life threatening.

Even within the feminist community, mixed messages prevail, and there is often a split between older women whose mission has been to undermine degrading stereotypes and younger women who seem to embrace them. The Slut-Walks mentioned above are one example of the latter phenomenon. So is the emergence of Riot Grrrl, an underground feminist punk rock movement that emerged in the US in the 1990s to address the pervasive objectification of women inside and outside the music world through aggressive and highly sexualized performances. (The Russian feminist punk band/performance collective Pussy Riot, three of whose members were convicted in 2012 of blasphemy and sentenced to two years hard labor in a Russian prison camp, cite the movement as an inspiration). [10] In this climate, today's Bad Girl artists become part of a larger debate over the relationship between female power and sexuality.

The so-called Bad Girls featured in these pages adopt and adapt "politically incorrect" images for subversive purposes. Their work makes reference to the tropes of pornography, romance novels and pulp fiction, which undermine rigid social conventions and shed light on social values, sexual mores, and the essential nature of desire and pleasure. For instance, Ghada Amer plays against the Islamic iconoclasm of her native Egypt in canvases embroidered so as to partially conceal pornographic images beneath twisting threads that feminize the ejaculatory drips of Abstract Expressionism. She has remarked, "Pornography is the starting point of the image, then it becomes something else." [11] The British artist Cecily Brown's gestural paintings similarly mix gestural abstraction with transgressive sexual imagery

[9] Internet Pornography Statistics, http://internet-filter-review. toptenreviews.com/internet-pornography-statistics.html.

[10] Sergey Chernov, "Female Fury," *St. Petersburg Times*, February 1, 2012, 1693 (4).

[11] Ghada Amer, interview by Roxana Marcoci, in *Threads of Vision: Toward a New Feminine Poetics*, ed. Larry Gilman (Cleveland Center for Contemporary Art, 2001), 23–24.

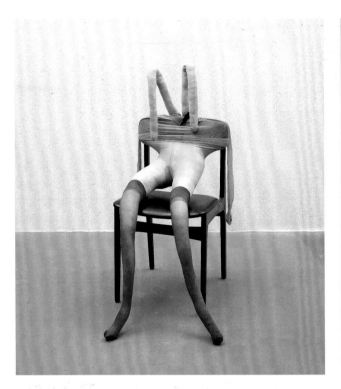

in a manner that subverts the machismo of Abstract Expressionism. Other artists take on sexualized imagery embedded in popular culture. British artist Tracey Emin satirizes the confessional impulse so evident in reality TV and mass media with performances and installations that reveal the most intimate aspects of her sex life and personal history. Polish artist Katarzyna Kozyra works with unconventional actors, among them dwarves, drag queens, and amputees in performances and videos that examine social mores as they apply to gender, aging and illness, religion, and group behavior. Wangechi Mutu addresses the politics of post-colonial fantasy through the language of the grotesque, collaging together clippings from fashion and porn magazines, books about African art, and the pages of *National Geographic*. And, giving the Bad Girl persona an economic spin, Israeli artist Mika Rottenberg creates absurdist video installations that satirize capitalist production systems. She effects this by employing female actors with physical peculiarities who labor to create bi-

Collier Schorr, *Dreamer (130–132)*, 2006. C-print; 11¾ x 15 in. | 29.8 x 38.1 cm; edition of 5.

zarre and often unusable commodities through the manipulation of body processes and fluids.

Though we are highlighting only this group of Bad Girls here, it would be easy to discuss many others in similar terms. For instance, Lisa Yuskavage borrows equally from *Penthouse* and the erotica of Ingres and Titian to create lush paintings of huge-breasted, cartoonish nudes that embrace the guilty pleasure of playing the male fantasy object. Sarah Lucas assembles quotidian objects—among them eggs, pantyhose, cigarettes, and chairs—to create humorous analogues to the human body, with a particular focus on male and female genitalia (opposite). Renee Cox, who is a body builder as well as an artist, poses her buff and often nude body in photographic tableaux that reverse the sexist stereotypes and patriarchal power arrangements more typically found in art history, religious art, comic books, and other sources in popular culture (opposite).

Yet other artists explore the even more complicated relationship between popular imagery and lesbian identity. Among these are Collier Schorr, who uses photographic images of variously feminized, hyper-masculine, and transgendered subjects to suggest the conflation of lesbian and heterosexual desire (above), and Catherine Opie whose photographic subjects encompass S/M-themed self-portraits, drag kings, pregnant and breast-feeding gay women, and any number of other subjects who threaten conventional notions of "normal."

Central to all these artists is an engagement with the body not as a fixed site of meaning but as a fluid component of ever shifting identity. Equally unfixed are the images made from, about, and with the body. Feminist theorists have been insisting since the 1970s that the gaze is an instrument of social, political, and personal power. Bad Girl artists accept this insight and expand on it, exploiting the fluidity of gender and identity to transform images that stem from the impulse to control and dominate into celebrations of female power and consciousness.

GHADA AMER

Ghada Amer, *The Slightly Smaller Colored Square Painting*, 2001. Acrylic, embroidery, and gel medium on canvas; 72 x 60 in. | 182.9 x 152.4 cm.

SPEAKING OF HER BREAKTHROUGH DECISION in 1992 to appropriate pornographic images of women from hardcore magazines as the subject of her signature embroidered canvases, artist Ghada Amer stated, "I wanted these women to be empowered; active, not passive. Pornography was and continues to be my solution. It allows me to represent women using embroidery, a women's tool, but to show Woman, the universal woman, as an activated subject empowered by her own pleasure." [1] By depicting naked women in ecstasy or coupled with other women, Amer took imagery that was long-reviled by feminists and others for its objectification and exploitation of women and slyly subverted its meaning and purpose. In the hands of this "bad girl," pornography becomes a means of both celebrating and asserting female sexual desire, and a way of rebelling against the repression experienced by women within patriarchal society. As an Egyptian brought up in an observant Muslim home, raised and educated in France from the age of eleven, and living and working in the United States since 1995, Amer brings a cross-cultural perspective to the issue of women's subjugation, challenging it with transgressive imagery that destabilizes gender stereotypes and defiantly expresses women's pleasure.

Amer takes a feminist approach to materials and methods as well as to subject matter. As a student in the BFA (1986) and MFA (1989) programs at the École pilote internationale d'art et de recherche, or Villa Arson, in Nice, she was denied entry to painting classes reserved for male students only. Excluded from these classes, and by extension from the male-dominated history of Western painting, she sought a new way to paint, one that would align the subject of women—as domestic, sexual, romantic, and political beings—with crafts typically associated with them. She chose sewing and embroidery, skills learned as a child from her mother and grandmother, as the means of introducing the feminine into a traditionally masculine field. As she observed, "I was speaking about women with a medium for women, and it made the speaking stronger and more present." [2] Amer initially employed a simple stitched line to create works such as *Cinq Femmes au Travail* (1991), a four-part piece depicting women performing basic domestic tasks including cleaning, cooking, and childcare, derived from advertisements in women's magazines. The move to pornographic subject matter in 1992 also prompted a change in her technique. The artist developed a layered, "painterly" method of embroidery that allowed her to partially conceal her erotic silhouettes beneath clusters of colorful, dangling threads. These works also cleverly critiqued Western painting as a male domain by feminizing the aggressive,

[1] Maura Reilly, *Ghada Amer: Color Misbehavior* (New York: Cheim & Read, 2010), unpaginated.

[2] Robert Enright and Meeka Walsh, "The Thread of Painting: An Interview with Ghada Amer," *Border Crossings* 9, no. 111 (August 2009): 25.

Ghada Amer, *Encyclopedia of Pleasure*, 2001. Embroidery on cotton duck mounted on acid-free cardboard structure in 54 parts; dimensions variable.

ejaculatory drips associated with Abstract Expressionism. [3]

Amer's provocative pornographic paintings are objects of great beauty as well as realms of sexual empowerment and liberating potential for women. The artist began by extracting images of women from magazines such as *Hustler* and *Club* and, in works like *Black Series—Coulures Noires* (2000) and *The Slightly Smaller Colored Square Painting* (p. 24), proceeded to trace and stitch her serially masturbating or bound figures into the canvas, obscuring these erotic images behind tangled threads and gel medium. This layering creates an elusive "peek-a-boo" effect in which the viewer is invited to closely examine the work in an effort to decipher its veiled imagery. The experience initially is startling, then intimate, as one enters a world of women in uninhibited states of self- or mutual pleasure. In this extended series, Amer radically reimagines pornography, traditionally created by men for their own pleasure, from a woman's perspective, focusing on the free expression of female erotic fantasies and desires.

[3] See Eleanor Heartney's "Bad Girls" essay, 15.

Although best-known for her embroidered canvases, Amer has created works in other media as well, including drawing, print, performance, sculpture, and installation, and also has engaged in a long-term collaborative project with Iranian artist Reza Farkhondeh, a friend from student days, producing numerous paintings, drawings, and prints. Growing up between Islamic and European cultures, and fluent in Arabic, French, and English, Amer has access to and has drawn on a wide range of sources to create works that comment on and resist the habitual suppression of women across cultures. Texts, as well as images, have served as sources of artistic inspiration. In 2001, the artist created a text-based sculptural installation titled *Encyclopedia of Pleasure* (opposite) based on a twelfth-century Arabic text of the same name written by Ali Ibn Nasr Al Katib. She was intrigued by this literary and medical manual cataloging sexual pleasure for both men and women, which was produced during a progressive period in Islamic culture and forbidden today. To create this work, the artist selected passages of text specifically addressing female beauty and sexuality, which she embroidered in gold thread on fifty-four stacked canvas-covered boxes. For Amer, the discovery of the *Encyclopedia of Pleasure* opened a window onto the subject of Muslim women's sexuality that was both unexpected and affirming.

In 1999 Amer asked herself the question, "What can I do outside?" The answer was gardening, typically a women's pursuit like embroidery, as the garden

Ghada Amer, *Love Park*, 1999. Signs and cut benches; dimensions variable. Installation view, SITE Santa Fe Third International Biennial.

became the site for a feminist critique of such subjects as gender stereotypes, the complexities of love, socioeconomic disparities, and war. Her first public project, titled *Love Park* (1999; left), installed in a park in Santa Fe, New Mexico, consisted of ten park benches split in half and reattached so that seated couples would face in opposite directions. The benches were placed along a path lined with signs quoting various Eastern and Western writers on the meaning of love—from the romantic ("All you need is love") to the contentious ("It is man who rules! Man does not ask if he pleases, if he is lovable. He is only concerned with his own pleasure.... Man exists only for himself and for no one else"). Both the position of the viewers and the contradictory nature of the quotes underscored the gulf that can exist

between couples on this most intimate of topics. Amer addressed gender difference of another kind in a garden work presented in a disadvantaged neighborhood of Barcelona, spelling out the sentence *Today 70% of the Poor in the World Are Women* (2001) in a series of sandboxes along La Rambla del Raval.

Amer's work took a distinctly political turn after the terrible events of September 11, 2001. Prior to that date, she lived quietly as an Egyptian Muslim in New York; life changed soon after as her religion was linked to the perpetrators of the attacks. In response, she decided to confront the charged topic of terrorism in a pair of related installations. Once again she turned to language as a source. The artist looked up the definition of "terrorism" in English, French, and Arabic dictionaries and was surprised to discover that there was no official definition of the word in the Arabic language. For *Reign of Terror* (2005), Amer designed lipstick-pink wallpaper adorned with gold crowns and a lattice pattern onto which she inscribed the numerous English definitions of the word "terrorism." She also made plates, cups, napkins, and tray liners bearing the phrase "Terrorism is not indexed in Arabic dictionaries." The result was both alluring and unsettling.

Amer followed this installation with an even more striking display. *La*

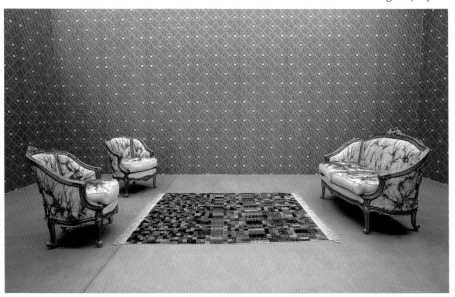

Ghada Amer, *La Salon Courbé*, 2007. Wallpaper, two embroidered chairs, embroidered sofa, silk and wool carpet; dimensions variable.

Ghada Amer, *Diamanda,* **2009.**
Watercolor on paper; 13 x 17 in. |
33 x 43.2 cm.

Salon Courbé (2007; left) resembled the elaborately decorated drawing rooms found in elegant homes across Egypt, complete with a French Baroque-style upholstered sofa and two matching chairs, hand-woven wool and silk carpet, and ornate pink and gold wallpaper, all reminiscent of British colonial décor. However, this inviting domestic setting was not what it seemed, as the richly patterned carpet was inscribed in Arabic with the single Arabic definition of "terrorism" that she was able to find; the furnishings were embroidered with the same definition concealed beneath dense webs of bright pink and red thread; and the wallpaper, originally designed for *Reign of Terror*, retained its message. [4] The dripping threads and rosy-red coloration suggested femininity, as they also brought to mind the flow of blood. In fact, this attractive work packed a powerful punch through the artist's reflection on the insidious way that fear of terrorism has infiltrated our private lives. With their European-inspired furnishings, these installations also served as a commentary on the ongoing legacy of Western colonialism in the Middle East. [5]

Over a career spanning more than twenty years, Amer's most consistent subject has been women and the assertion of female agency through the unorthodox tool of pornography. Recently she produced a series of small embroidered drawings and watercolors, such as *Diamanda* (2009; above), in which for the first time she openly depicts the sexually explicit imagery that has been the partially obscured source of her embroidered paintings. It is a bold move by an artist who has become increasingly sure of her ability to exploit the subversive power of erotic imagery to feminist effect. As always, the beauty of these intimate works is undeniable. As the artist observed, "I always try to connect both ideology and aesthetics in my work as a painter or a sculptor, in one way or another. I am very much interested in this specific relationship. Aesthetics alone are not enough for me and a message alone is just propaganda." [6]

—HELAINE POSNER

[4] Maura Reilly, *Ghada Amer* (New York: Gregory R. Miller & Co., 2010), 41–42. I wish to thank Maura Reilly for her discussion of *Reign of Terror* and *La Salon Courbé* in her excellent monograph on the artist.

[5] Maymanah Farhat, "Creative Rebellion: Ghada Amer," *Canvas,* January/February 2010: 113.

[6] Ghada Amer, "Feminist Artist Statement," Feminist Art Base, Elizabeth A. Sackler Center for Feminist Art, Brooklyn Museum, http://www.brooklynmuseum.org/eascfa/feminist_art_base/gallery/ghada_amer.php.

CECILY BROWN

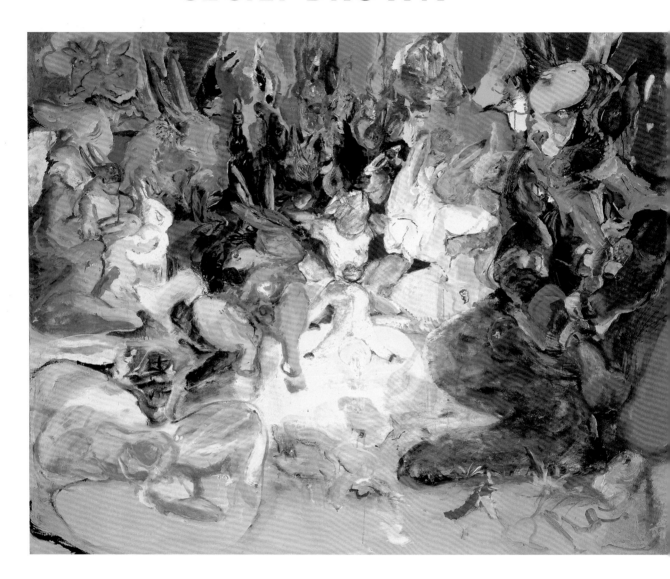

Cecily Brown, *Untitled*, 1996.
Oil on canvas; 48 x 60 in. | 121.9 x
152.4 cm. Private collection.

The death of Bacon has made it easier (for me) to make paintings which use the only subjects worth painting—birth, copulation and death, of course.

— CECILY BROWN [1]

WHEN SHE WAS SIXTEEN YEARS old, Cecily Brown attended the 1985 Francis Bacon retrospective at the Tate Museum in London with esteemed art critic and family friend David Sylvester. Bacon and his work became a major influence on the aspiring artist. Six years later, as a second-year art student, Brown learned that Sylvester was more than merely a family friend and collaborator with her mother, the novelist Shena Mackay; he was Brown's father. The revelation likely helped crystallize Brown's artistic ambition and perhaps also complicated her relationship to Bacon's art.

Sylvester had long been the main critical champion of Bacon, who reigned as Britain's leading figurative painter until his death in 1992. Known for his aggressive, even grotesque, paintings of the figure, Bacon worked in series, painting portraits of friends and obsessively exploring imagery of screams, the crucifixion, and the Pope. One of his best known paintings, *Study after Velázquez's Portrait of Pope Innocent X* (1953), brings together Bacon's variegated interests in existential angst, religion, and art history. Through Sylvester, Brown was introduced directly to Bacon, absorbing both his view of the world and of painting. Bacon often said he wanted to get to the "nerve" of the thing and, perhaps more than imagery or style, this was his legacy to Brown. "Bacon talked about the grin without the cat," she observed; "The sensation without the boredom of its conveyance." [2]

Born in 1969, Brown grew up in a small town outside of London in an idyllic bohemian household, with her mother, Makay, and her mother's husband, Robin Brown. Although she settled on the goal of becoming an artist at a young age and found remarkable success relatively quickly, her early years were not without sacrifice. Brown dropped out of high school and enrolled in the Epsom School of Art, then moved to London, where she studied with the painter Maggi Hambling and cleaned houses to support herself. It was not until she was twenty that she was accepted by the Slade School of Fine Art in London. While at Slade, she earned First Class Honours and was the first-prize recipient of the prestigious National Competition for British Art Students. She graduated in 1993 and the next year moved to New York City, on her way to becoming art world royalty.

[1] Cecily Brown, "Happy Days Are Where, Again?" *Flash Art* 31, no. 200 (May–June 1998); reprinted as "Painting Epiphany" in *Flash Art* 41, no. 261 (July–August 2008): 199.

[2] Cecily Brown, interview by Lari Pittman, *Cecily Brown* (New York: Rizzoli; New York: Gagosian Gallery, 2008), 28.

Cecily Brown, *High Society*, 1998.
Oil on linen; 76 x 98 in. | 193 x
248.9 cm. Private collection.

Cecily Brown, *Performance*,
1999–2000. Oil on linen; 100 x
110 in. (254 x 279.4 cm). Private
collection.

In London, Brown had found herself sandwiched between the tradition of figurative painting, which was then dominated by Bacon, Lucien Freud, and Frank Auerbach, and the celebrity of the Young British Artists, most of whom worked in sculpture, like Damien Hirst and the Chapman Brothers. Her move to New York distanced her from these two worlds while placing her in a community she found to be much more supportive of painters, among them John Currin, Elizabeth Peyton, and Rita Ackermann. As noted, Bacon's death in 1992 was liberating as well. One critic referred to the effect of Bacon's death on Brown as a "reversed Oedipalian counter attack" [3] and Brown herself has said, "As a painterly painter of figures, one does feel

[3] Nichola Trezzi, "The Aura of An Expanded Painter," *Flash Art* 41, no. 263
(November–December 2008): 60.

in the shadow of a recent muddy realism, the worm of Bacon's legacy." [4]

Sexually explicit content defined Brown's work early on, beginning with her hand-painted and animated film *Four Letter Heaven* (1995). In 1997 she was given a show at Deitch Projects—the first painter to be featured in a solo exhibition at the gallery. For *Spectacle*, Brown presented a group of mid-sized paintings that pulled from traditions as disparate as Old Master Painting by artists such as Goya and Poussin, and children's books by authors like Beatrix Potter. In *Untitled* (1996; p. 30), the palette and composition, particularly the golden light in the center of the picture, bring to mind Renaissance paintings of the crucifixion of Christ—no surprise given her connection to Bacon and his reliance on art-historical sources. The canvases teem with bunnies engaged in all manner of sex—orgies, rape, and other salacious activities—seemingly innocuous avatars that allowed Brown to explore taboo themes through an indirect route.

Two years later, for her second show at Deitch Projects, Brown increased the scale of the paintings and, for the most part, jettisoned the bunnies for more direct sexual content. The painting with the same name as the show, *High Society* (1998; pp. 32–33) presents an abstract jumble of body parts, men and women copulating, sprawling women, some men masturbating and others wearing tuxedos painted in the familiar Renaissance palette of blues, pinks, and golden yellow seen in her previous work. Compared to fellow Brit and bad girl Tracey Emin, whose sexual content often originates from a place of personal pain, Brown's exploration seems one of pleasure. Here, the images, of varying scale, collide against one another, creating a collage of abstract patterning. A woman rendered in writhing, lushly painted fleshy tones dominates the left side of the composition, bringing to mind both Bacon and de Kooning, while other, smaller images work their way across the face of the picture. Certainly it seems Brown concurs with de Kooning's famous observation that "flesh is the reason oil paint was invented."

Brown was included in the first incarnation of *Greater New York* at PS1 Contemporary Art Center in 2000, a seminal exhibition that presented young artists working in New York, many of whom, for instance Julie Mehretu and Ghada Amer, went on to achieve major critical and commercial success. One of Brown's featured works, *Performance* (1999–2000; opposite), is a large-scale painting with a limited palette of aqua blue and black. Close up, the marks and gestures are pure de Kooning. Seen from a distance, the marks coalesce into the conjoined image of a

[4] Brown, "Painting: Epiphany," 199.

Cecily Brown, *Black Painting 2*, 2002. Oil on linen; 90 x 78 in. | 228.6 x 198.1 cm. Whitney Museum of American Art, New York; Purchase, with funds from Melva Bucksbaum, Raymond J. Learsy, and the Contemporary Painting and Sculpture Committee.

woman astride a man. This is where Brown took a sharp turn from her predecessors, in combining art history with porn, and high art with low. As Dore Ashton observed, "If [Lucien] Freud and his friends dealt with flesh as it moved through the entire history of art as lodged in museums, Brown and her contemporaries more often had recourse to the risqué illustrations in *Penthouse* and *Hustler*." [5]

As her career was taking off, Brown posed for a number of photographic portraits, mostly for fashion magazines and most of them provocative. Todd Eberle photographed her wearing paint-splattered jeans and a t-shirt, reclining in front of one of her large colorful abstractions for a *Vanity Fair* article. For a David LaChapelle photograph in *Interview*, she donned a bikini top, a short skirt, and a collar with a chain attached. With her left hand she hangs on to the edge of one of her paintings—the explicit image of a man masturbating—and holds a cigarette and drink in her right. For an issue of the *New Yorker* in 1998, [6] Brown was photographed from the back, contemplating one of her paintings. She wears a tight bubblegum-pink skirt and blue t-shirt that matches the palette of the painting.

These self-objectifying photographs along with pictures of Brown published in the society pages, plus her high-profile move to Gagosian Gallery in 1999, contributed to a backlash that continues to dog her career. Reviewers often use sexually-laden language to discuss the work—words like "release" and "flaccid"—which may be clever but lessens the critical gravitas. Roberta Smith makes the connection to Lynda Benglis's notorius 1974 *Artforum* ad (p. 15), taking delight in the way younger women artists, Brown among them, co-opted the ego of male painters. On the other hand, she noted, "The situation is fascinating and dismaying. It's fascinating when these women use the artist's photograph to comment on the history of the genre. The

[5] Dore Ashton, "Cecily Brown En Route," in *Cecily Brown*, 14.

[6] Photograph by Oren Slor, "Gallerygoer," *New Yorker*, June 1, 1998.

[7] Roberta Smith, "Portrait of the Artist as a Young Woman: Glossy Images That Both Mimic and Mock Male Sexuality," *New York Times*, July 5, 2000.

dismay comes from the question of who is using whom." [7] Brown seems to concur with the dichotomy when acknowledging, "I'm playing a risky game by doing things like that photograph. But the thing about the *Interview* photograph is that it's not about the portrait, it's a David LaChapelle, and it's so obviously a parody." [8]

 Black Painting 2 (2002; opposite) was included in the 2004 Whitney Biennial and eventually acquired by the museum. Rather than her customary cacophony of color, here Brown restricted her palette to shades of black and white, highlighted by midnight blue and browns. The single, central figure of a reclining female nude, her hand on her sex, is set in the forefront of the picture plane, the body carved out with blocky gestures and feathery brush strokes. "I've always wanted to convey the figurative imagery in a kind of shorthand, to get it across in as direct a way as possible," she said. "I want there to be a human presence without having to depict it in full." [9]

 With *Black Painting 2*, Brown places herself within the long tradition of painting the reclining nude, from Giorgione's *Sleeping Venus* (1510) and Goya's *Naked Maja* (1800) to Manet's *Olympia* (1863). If with *Olympia* Manet caused a stir by

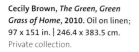

Cecily Brown, *The Green, Green Grass of Home*, 2010. Oil on linen; 97 x 151 in. | 246.4 x 383.5 cm. Private collection.

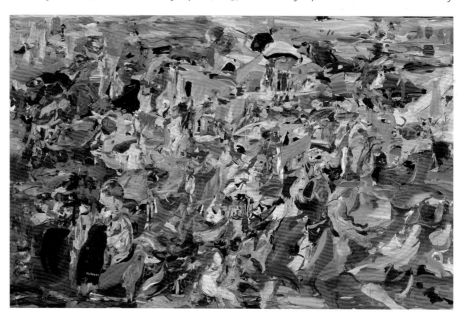

[8] Odili Donald Odita, "Cecily Brown: Goya, Vogue, and the Politics of Abstraction," *Flash Art* 33, no. 215 (November–December 2000): 74.

[9] Brown, interview by Pittman, 28.

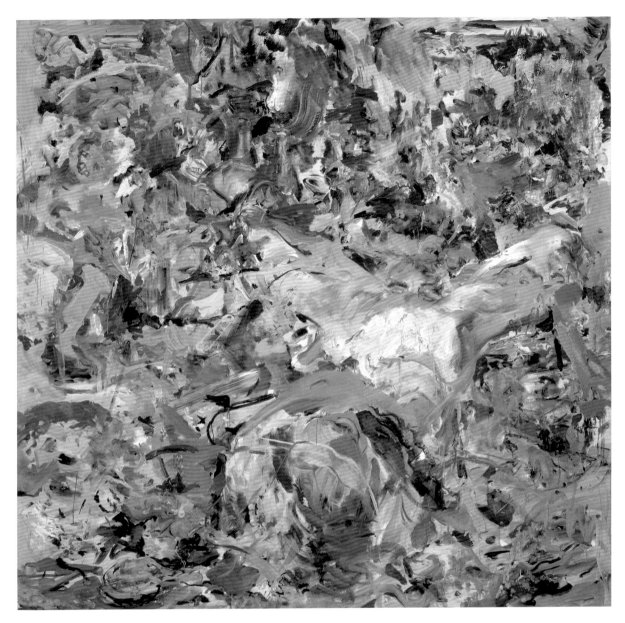

Cecily Brown, *Skulldiver 3*
(Flightmask), **2006.** Oil on linen;
85 x 89 in. | 215.9 x 226.1 cm.
Museum of Fine Arts, Boston;
Museum purchase with funds
donated by Ann and Graham Gund.

painting a prostitute whose glance directly confronts the viewer, Brown further subverts the historical trajectory as a female painter, painting the female nude.

As she matures as a painter, Brown appears to be moving away from the hook of sexuality on which to hang a painting. Though *Skulldiver 3 (Flightmask)* (2006; opposite) still relies on sexual content—the central image is of a woman with her legs spread, a head and face between them—most of the picture is made up of luscious, energetic brush strokes with drips and drags floating in a shallow space that speak more of performance than preconceived notions of content. *The Green, Green Grass of Home* (2010; p. 37), a monumental work measuring twelve-and-a-half feet wide, indicates Brown's continued move towards abstraction. Still, her goal is to make work that presents a conflict between figure and abstraction, with neither the clear winner. "My ideal," she said, "is to have the tension and intensity of an aggressively sexual image without actually having to describe that." [10]

Eleanor Heartney was prescient in reviewing Brown's second exhibition at Deitch in 1998 when she observed, "In the end, one keeps falling back on the virtuosity of the paint handling. Odd as it may seem, Brown's titillating subject matter seems rather secondary to the effect of well-applied paint." [11] The point that Brown's trajectory demonstrates, both as a painter and artist, is that regardless of content or posturing, she succeeds in taking on the machismo of gestural painting on the canvas itself. — SUE SCOTT

[10] Ibid, 26.

[11] Eleanor Heartney, "Cecily Brown at Deitch Projects," *Art in America* 86, no. 6 (October 1998): 131.

TRACEY EMIN

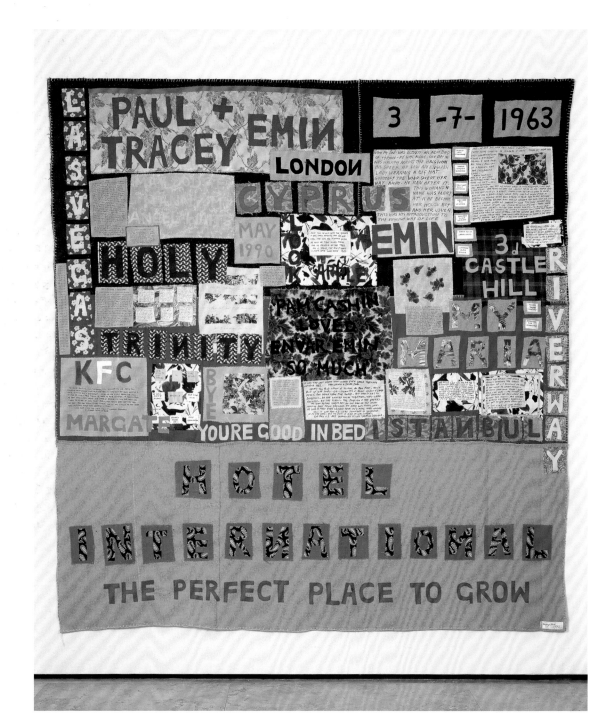

TRACEY EMIN HAS BEEN THE consummate bad girl of the London art scene ever since her audacious debut at White Cube gallery in 1993. Her first, intensely autobiographical exhibition, prematurely (and knowingly) titled *Tracey Emin: My Major Retrospective 1963–1993*, set the terms of a practice in which the artist's life and art are inextricably linked. A skilled storyteller, Emin mines the intimate details of her life experience to create an unabashedly confessional body of work whose major themes include sex, desire, and personal trauma. In the catalogue for her 2011 mid-career survey at London's Hayward Gallery, *Love Is What You Want*, curator Ralph Rugoff described Emin's art as "alternately tough, sentimental, desperate, angry, funny, and full of longing…." [1] Although she presents her tales of sexual promiscuity, rape, and abortion with an in-your-face bravado, it is surprisingly easy to empathize and even identify with Emin's experiences and the emotions they lay bare, especially for women. In fact, her confessional art has been widely embraced in England where she currently enjoys celebrity status as well as the satisfaction of having succeeded on her own highly provocative terms.

The facts of Emin's turbulent life are more frequently the stuff of movies, pulp fiction, and reality television, than of visual art. She was born in London in 1963 and was raised in the British seaside town of Margate by a British mother and a Turkish-Cypriot father. Emin was raped in an alleyway at age thirteen and spent an increasingly impoverished adolescence having sex ("my shagging years"), dancing, drinking, and generally hanging out, often truant from school. Eventually she returned to college, studying at the Maidstone College of Art, Kent, and earning a Master of Fine Art degree from the Royal College of Arts, London, in 1989. In 1990 she had the first of two traumatic abortions and destroyed all the work she made in graduate school. As she recounted, "I gave up painting, I gave up art, I gave up believing, I gave up faith. I had what I called my emotional suicide. I gave up a lot of friendships with people. I just gave up believing in life really…." [2] However, within a few years she found a way to transform her painful experiences into art, creating a range of works that eventually included appliqued blankets, embroidered drawings, monoprints, photographs, videos, neon signs, and sculptural installations that are direct, visceral, and passionate, sometimes angry, and often extremely revealing.

By the time she presented her first solo exhibition at White Cube in 1993 at age thirty, Emin displayed a fully formed artistic sensibility. *My Major Retrospective* included the autobiographical "Wall of Memorabilia," wherein she told

[1] Ralph Rugoff, in *Tracey Emin: Love Is What You Want* (London: Hayward Publishing, 2011), 6.

[2] Carl Freedman, "How It Feels," in *Tracey Emin: Works 1963–2006* (New York: Rizzoli, 2006), 67.

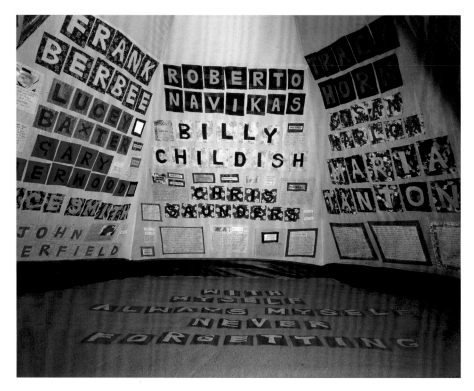

Tracey Emin, *Everyone I Have Ever Slept With, 1963–1995*, 1995 (interior view). Appliquéd tent, mattress, and light; 48 x 96½ x 84½ in. | 121.9 x 245.1 x 214.6 cm. No longer extant.

tales of her "nan," her dead uncle, and her abortion through the use of highly personal objects, diaries, letters, and photographs. She also exhibited her first text-based appliquéd blanket, *Hotel International* (1993; p. 40), introducing audiences to the handcrafted, faux-naïve aesthetic that became a mainstay of her art. To create this work Emin sewed bold capital letters cut from her own clothing, along with bits of fabric covered in tiny handwritten text, onto her pink childhood bedcover. The title of her self-styled "CV-on-a-blanket" refers to the Margate hotel run by her mother where she grew up, and includes text documenting important moments from her childhood and teenage years. Now numbering over forty in all, these colorful, handmade, traditionally feminine works first attract, then repel, as the viewer is confronted with obscene language, "you don't fuck me over," and name calling, "psycho slut," courtesy of *Mad Tracey from Margate*. . . . Though steeped in personal

history, Emin's persona also is the creation of a great storyteller, part truth and part performance of self. [3]

During the latter half of the 1990s, Emin sealed her fame with two installation works that were at once shocking and intimate. On the interior of an igloo-shaped tent, the artist appliquéd and embroidered the names of *Everyone I Have Ever Slept With, 1963–1995* (1995; opposite) since the year of her birth. Though intentionally provocative, the hundred names stitched into this cozy, enterable space included not only sexual partners but friends and family, including her grandmother and two aborted fetuses, with whom she had only slept. As Emin noted, "To some people this list of names seemed to be very important. What was important about it to me was that when I wrote out the names and sewed them it was like carving out tombstones, having to deal with my past. That was pretty cathartic actually." [4] Initially compelling in a voyeuristic tell-all way, the tent also prompted deeper feelings of nostalgia as the names seemed to be a gauge of life taken by its most intimate measure. (The work was destroyed in a warehouse fire in 2004.) In an even bolder act, Emin displayed her (actual) soiled and unmade bed surrounded by empty liquor bottles, used condoms, dirty underwear, cigarettes, and other remains of a tumultuous life. The initial shock of seeing the artist's private life on public view quickly faded as feelings of empathy were evoked by this poignant scene.

In 1999 Emin was nominated for the Turner Prize, a prestigious contemporary art award given annually to a British artist under the age of fifty. Works by the shortlisted artists were shown at London's Tate Britain prior to the final selection and Emin's *My Bed* (1998; left) was a standout. Her star had been rising as a member of the YBAs, or Young British Artists, who dominated the English art scene of the 1990s. Known for making work that explores sexually charged, morbid, and violent subjects, as well as for their hard-partying ways, the YBAs, including Sarah Lucas, Damien Hirst, and the Chapman Brothers, along with Emin, became critical and media sensations. Their controversial work was featured in such landmark exhibitions as *Brilliant!: New Art from London* presented at Minneapolis's Walker Art Center in 1995, and *Sensation*,

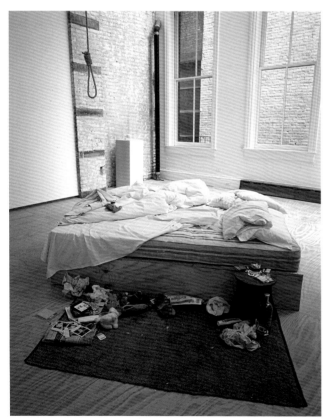

Tracey Emin, *My Bed*, 1998. Mixed media; dimensions variable. The Saatchi Gallery, London.

[3] My thanks to Cliff Lauson for this insight in his illuminating essay " Love Is What You Want," in *Love Is What You Want*.

[4] Tracey Emin, interview by Julian Schnabel, *Interview*, June 2006: 107.

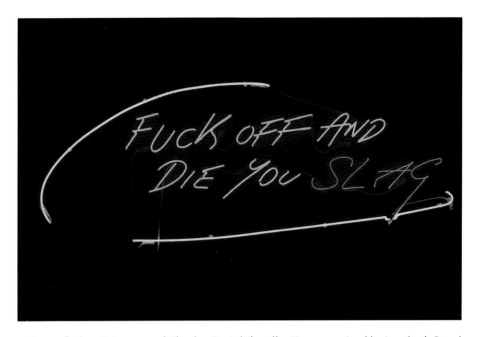

Tracey Emin, *FUCK OFF AND DIE YOU SLAG*, 2002. Neon; 29 x 78¾ in. | 73.7 x 200 cm. Courtesy of the artist.

a show of advertising mogul Charles Saatchi's collection organized by London's Royal Academy of Arts in 1997, followed by an international tour. As Emin has acknowledged, her timing could scarcely have been better.

Along with her appliqued blankets, Emin is best known for the neon works she has created since 1995. Adopting a medium most often associated with the cool language of minimal and conceptual art, the artist's neons, based on her handwritten scrawl, are among her most raw and aggressive works. These tawdry signs, illuminated in bright blues, pinks, reds, and whites, make outrageous declarations such as *PEOPLE LIKE YOU NEED TO FUCK PEOPLE LIKE ME* and *FUCK OFF AND DIE YOU SLAG* (above; both 2002) in a form recalling sex shop displays. Once again Emin turns the taunts on herself with a familiar blend of humor, brutal honesty, and self-loathing.

The tone of Emin's work started to shift around 2000 as she moved past the wild days of her youth. A sense of melancholy took root as she began to contemplate notions of love, loss, and her own mortality. She continued to make colorful, visually complex appliqued blankets but they now contained revelatory messages like "I do not expect to be a mother but I do expect to die alone" (left). Her

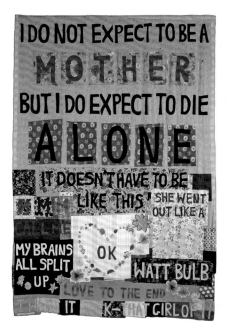

Tracey Emin, *I Do Not Expect*, 2002.
Appliqued blanket; 104 x 72¾ in. |
264.2 x 184.8 cm. Art Gallery
of New South Wales—Private
Collection, Sydney.

Tracey Emin, *I've Got It All*, 2000.
Inkjet print; 41 x 47 in. | 104.1 x
119.4 cm. The Saatchi Gallery,
London.

neon signs seemed to whisper rather than shout in sentences like *I Can Feel Your Soul* (2005), as her passionate desire for sex became a wistful quest for love. The artist continued to work inventively in a broad range of media including photography, video, and sculptural installations constructed of found objects. Emin also created a series of sixteen drawings in collaboration with Louise Bourgeois, adding tiny figures and moving handwritten texts to the senior artist's gouaches of male and female torsos. In these intimate works, titled *Do Not Abandon Me*, the artists examined shared and persistent themes of female sexuality, emotional dependency, fear, and loss, across generations.

For all her acclaim Emin has not lost the ability to cast a critical eye on herself and the systems that reward her. She represented her country at the 2007 Venice Biennale, the most prestigious international exhibition of contemporary art, and one of her neon works, *More Passion* (2010), was displayed at 10 Downing Street by invitation of the Prime Minister. Amid some controversy, Emin was elected a Royal Academician by London's Royal Academy of Arts (also 2007) and received an honorary doctorate from the University of Kent the same year. In 2011, she was appointed Professor of Drawing by the Royal Academy, adding institutional credentials to her growing fame and fortune. In a witty send-up of her success, Emin featured herself in a large photograph ironically titled *I've*

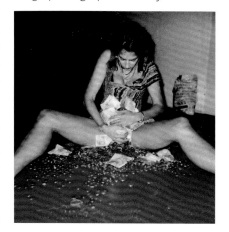

Got It All (2000; right) wearing a fashionable Vivienne Westwood dress and sitting on the floor with her legs splayed while shoving foreign currency into her crotch. According to Emin, the work is "about fecundity and saying that even if I seemed to have it all, I didn't actually have anything." [5] It seems a pornographic mix of sex and money is not the key to happiness. For Emin, it lies in the things she lacks, like children and love, which she continues to explore in her art and life.

— HELAINE POSNER

[5] Tracey Emin, interview by Ralph Rugoff, in *Love Is What You Want*, 167.

KATARZYNA KOZYRA

Marching naked in formation with a group of naked women was for Tereza the quintessential image of horror. When she lived at home, her mother forbade her to lock the bathroom door. What she meant by her injunction was: Your body is just like all other bodies; you have no right to shame; you have no reason to hide something that exists in millions of identical copies. . . . Since childhood, Tereza had seen nudity as a sign of concentration camp uniformity, a sign of humiliation.

— MILAN KUNDERA, *THE UNBEARABLE LIGHTNESS OF BEING* [1]

IN HIS 1984 NOVEL *The Unbearable Lightness of Being*, Czech writer Milan Kundera draws the reader into the contradictions inherent in Soviet life. Not least of these were the contradictions posed by femininity and the female body. Soviet ideology posited the total equality of men and women (a principle frequently contradicted in practice), while all but criminalizing private realms of experience like domesticity and sexual expression that had traditionally been linked to women. The result, in Cold War terms, was a false gender equivalence supported by the political opposition between a de-sexed communism and a hyper-sexed West.

When the Soviet Empire crumbled, many of the societies freed from its iron sway found themselves buffeted between the new ideal of an open society and the older reality of political, social, and religious repression. In Poland, one manifestation of this tension was the emergence of what became known as Polish Critical Art. Associated with artists like Paweł Althamer, Zbigniew Libera, and Artur Żmijewski, this approach pushed the limits of acceptability in matters of both politics and sexual expression, leading to frequent clashes with political and religious authorities.

One of the leading representatives of Polish Critical Art is Katarzyna Kozyra. Born in 1963, she emerged as an artist-provocateur with her 1993 thesis show at Warsaw Academy of Fine Arts. Titled *Pyramid of Animals*, it consisted of a stack of taxidermied animals accompanied by a video of the slaughter of the horse at the base of the work (opposite). (This work preceded Maurizio Cattelan's very similar *Love Saves Life* by two years.) Audiences responded with outrage despite Kozyra's protestations that the animals were already slated for extermination. The controversy underscored the hypocrisy of a society that condemns the display of slaughtered animals while continuing to consume them in great quantities. Kozyra's subsequent installations, performances, and videos have similarly rattled chains over social attitudes toward religion, illness, death, and commerce.

[1] Milan Kundera, *The Unbearable Lightness of Being*, Modern Classics ed. (1984; New York: Harper Perennial, 2009), 57.

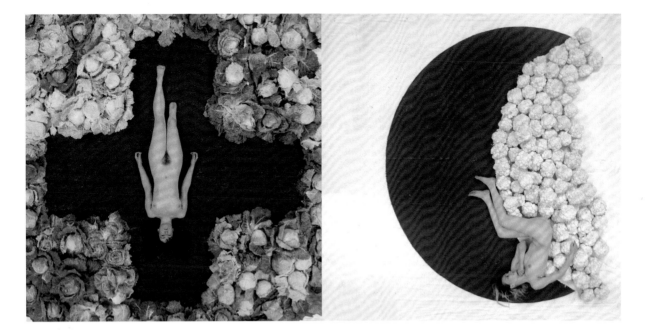

Katarzyna Kozyra, *Blood Ties*, 1995/1999 (detail). Four color photographs; 78¾ x 78¾ in. | 200 x 200 cm.

Almost without exception, these works use human bodies as primary ingredients. In particular, Kozyra is interested in gender—how it is constructed, how it is perceived, and how it constantly shifts, melds, and is subject to reinvention. While these concerns echo investigations of gender by Western feminists during the 1970s and '80s, they come out of a society where the social construction of masculinity and femininity served the interests of the Communist state. It is tempting to read Kozyra's polymorphic approach to gender as a rejection of the Soviet regimentation of gender roles and its condemnation of "abnormal" sexual expressions, nonproductive activities, and gender-based play.

Throughout her work, Kozyra undermines the binary opposition between traditional conceptions of masculinity and femininity. In her world, gender is completely malleable, identity is fluid, and selfhood is a matter of negotiation and performance. Actors in her works include drag queens, midgets (she prefers the politically incorrect term), naked men and women of all ages, amputees, and body builders. She is frequently an actor in her videos, playing roles that range from

cheerleader and prima donna to dominatrix, transsexual, and castrato. Because she has a very slight boyish build, it is easy for her to present the markers of masculinity and femininity simultaneously. One could not be further from the Soviet leveling of individuality and sexual difference.

These works have a more personal source as well. While still a student, Kozyra was diagnosed with Hodgkin's disease, a cancer of the lymph node. She spent three years in and out of hospitals as she was treated with radiation. She most directly references this condition in a photo and video work titled *Olympia* (1996), for which she assumed the pose of Manet's *Olympia* while a real nurse administered an intravenous drip. She has pointed out the irony of this work—here the medical procedure promised life, while in *Pyramid of Animals* it was the agent of the horse's death.

Kozyra's focus on the body takes many forms. Many of her works celebrate less than perfect bodies. In 1999 she recreated Stravinsky's ballet *The Rite of Spring* using naked old people. They lay on a sheet on the ground so that their movements, when photographed from above, could be assembled to approximate the choreography of the original ballet. To further distance her work from the original, she outfitted the men with artificial vaginas and the women with penises.

Kozyra sometimes uses bodies for political purposes. One particularly controversial work was *Blood Ties* (1995/1999; opposite), a photo-based work created for display on billboards throughout Poland. The original design presented images of naked women (one was Kozyra herself and the other her sister who has an amputated leg) lying on a red cross and a red crescent. By referencing Christian and Islamic symbols, the work was intended as a statement about the suffering of women incurred by the religious nationalisms at the heart of the Kosovo War. Following a clergy instigated campaign against the billboards, they were ultimately displayed with genitals covered and religious symbols effaced.

Her 2002 video *Punishment and Crime* dealt with gender and violence. Here she filmed male paramilitary enthusiasts shooting and exploding various targets in the Polish woods while wearing cheap plastic masks of women's faces. The masks provided a disguise while transforming this exercise in faux warfare by an all-male enclave into a weirdly stylized performance by impassively cheerful female warriors.

Two works, one from 1997 and the other from 1999, take on the trope of the gaze. The first, titled *Women's Bathhouse*, took Kozyra inside a Budapest bathhouse with a hidden video camera. The second, filmed two years later, took her into

Katarzyna Kozyra, *Men's Bathhouse*, 1999. Multi-channel video installation with sound.

a men's bathhouse (left). Here, the infiltration was obviously more difficult; Kozyra disguised herself as a young man by applying facial hair, covering her small breasts with a towel, and attaching prosthetic genitals. Two collaborators, both men, surreptitiously filmed Kozyra as she walked around the bathhouse (she was afraid to go into the shower or sauna lest her faux member fall off). Together, the two works suggest a marked difference in the behavior of men and women in the absence of the other sex. While the women barely noticed her and instead seemed more preoccupied in private grooming activities, the men were constantly eyeing each other.

Since 2003 Kozyra has been preoccupied with a multipart, multidisciplinary project with the umbrella title *In Art Dreams Come True*, which incorporates many elements from her earlier works. Loosely organized and presented on various stages, theaters, and as part of other art events, *Dreams* is Kozyra's most complete exploration to date of the ambiguities of gender. Many of the discrete parts revolve around Kozyra's training in the arts of femininity by two "experts"—one is the "Maestro" (opera coach Grzegorz Pitulej), who trains her to be a prima donna. The other is the "Drag Queen" (noted Berlin drag performer Gloria Viagra), who teaches her how to be "female." Videos show Viagra taking her shopping and to nightclubs and teaching her about makeup and fashion. We also see Pitulej acting as a vocal coach and leading her in breathing exercises.

Kozyra put this training to use in several performances where she sings operatic arias. These include *Madonna from Pelago*, in which a procession of a statue of the Virgin culminated in Kozyra's appearance in full costume singing Mozart's Queen of the Night aria, assisted by the Maestro in a rat mask.

Il Castrato (2006; opposite) turns the process of becoming an opera singer into a spectacle. This video, which was produced for the Gender Bender Festival in Bologna, presents an elaborate opera performance enacted by drag queens

before a rapt audience of towel-clad young men. It climaxes with the appearance of Kozyra dressed in an exaggeratedly baroque gown and flanked by her mentors, the Maestro and Gloria Viagra. They disrobe her to reveal a young boy's body, complete with rubber prosthetic genitals, which they snip off and place in a bowl. In homage to the tradition of the eighteenth-century castratos, who sacrificed their genitals to achieve purity of voice, Kozyra then performs a rendition of Schubert's Ave Maria before riding off on a white horse.

Kozyra repeats this transsexual turn in her 2006 *Cheerleader* in which she plays a female cheerleader cavorting in a men's locker room (overleaf). The performance ends when she pulls off her wig and outfit to appear, again with the help

Katarzyna Kozyra, *Il Castrato*, 2006. From the series *In Art Dreams Come True*; single-channel video with sound. Production photograph by Marcin Oliva Soto.

of prosthetics, as a naked boy. Other semi-independent segments of *Dreams* include *The Midget Gallery*, in which Kozyra unleashes a troupe of male dwarves in Bavarian costumes on various international art gatherings, and a performance as Lou Salomé, a psychoanalyst and consort of Rilke and Neitzsche, both of whom, in this video, become dogs disciplined by Kozyra/Salomé.

The final installment of *Dreams* is *Summertale* (2008; opposite), a convoluted video narrative with echoes of Snow White, Alice in Wonderland, Cinderella, and Dracula. It involves female dwarves in folk costumes, giant mushrooms that split open to reveal Kozyra, the Maestro, and Gloria Viagra and, after various plot twists and turns, presents the murder of Kozyra's two mentors by the dwarves.

With the close of *Dreams*, Kozyra has moved on to *Casting Call*, in which she auditions volunteers for the lead role in her autobiography. In keeping with her approach to gender, the role is open to all—male or female, old or young, beautiful or not. As of this writing, the role remains open.

Drawing on a wide array of literary, musical, theatrical, and pop-culture references, Kozyra pulls viewers into her constructed reality. It is a place where gender is literally a costume, where male mentors teach women how to be female, and where, as one critic puts it, Kozyra "performs as a female impersonator of female roles." [2] By turns playful, shocking, seductive, and subversive, Kozyra's post-gender world suggests that identity is something we perform, not something we are.

— ELEANOR HEARTNEY

[2] Harald Ficke et al., *Katarzyna Kozyra: In Art Dreams Come True*, bilingual ed. (Ostfildern, Germany: Hatje Cantz, 2007), 41.

WANGECHI MUTU

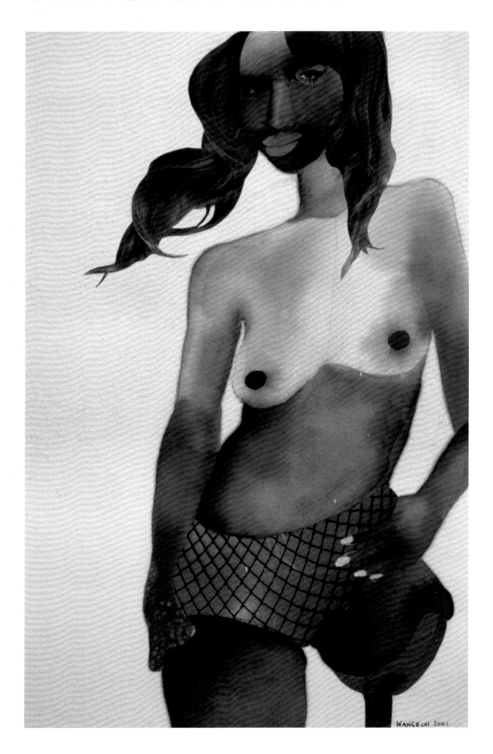

ACCORDING TO KENYAN-BORN, NEW YORK-BASED artist Wangechi Mutu, "Females carry the marks, languages and nuances of their culture more than the male. . . . Anything that is desired or despised is always placed on the female body." [1] In her dazzling figurative collages, Mutu takes a cross-cultural look at the exoticized, eroticized, and demonized female body, particularly the black female body, as the repository of society's fascination and fears. Appropriating images from such disparate sources as pornographic and biker magazines, along with *National Geographic* and *Vogue*, her intricate assemblages offer a potent critique of the sexual and racial stereotypes that pervade patriarchal culture as seen in publications that court or cater to the male gaze. Mutu's aesthetic is as alluring as it is bizarre. Her fantastic hybrid creatures, crafted of fragmented human, animal, and machine parts, range from primal warrior-goddess to futuristic cyborg. At once strangely seductive and disturbingly grotesque, Mutu's abject bodies wittily subvert the patriarchal image order while shrewdly exploring issues of gender, race, violence, and colonialism in imagery both freakish and sublime.

After completing her studies in art and anthropology at The Cooper Union for the Advancement of Science and Art, in New York (1996), and earning a master's degree in sculpture at Yale University (2000), Mutu began a series of ink, watercolor, and collage works, which she cheekily titled the *Pin-ups* (opposite). In these works semi-nude black women, provocatively posed in leopard-skin boots, fish-net bikinis, and other fetishized items, sport incongruous blond wigs and thick-lipped grins. These simultaneously attractive and repulsive figures further undercut their charms by openly displaying such deformities as arms and legs reduced to bloody stumps supported by wooden crutches and peg-legs. Writing in the catalogue for the exhibition *The Visible Vagina*, art historian Anna C. Chave described the work of a younger generation of global women artists, including Mutu, who unabashedly appropriate pornographic imagery made by and for men, thereby "claiming the unauthorized pleasures available to them there, or a right to disrupt the pleasures on offer, or both." [2] She goes on to say, "It was increasingly accepted that everyone looks at everyone else and may take some degree of pleasure—not only from looking but also from being looked at. . . ." Mutu's *Pin-ups* seem to revel in their ability to at once court and resist the male gaze, functioning as ambivalent objects of desire while alluding to the devastation wrought by land mines in the Sierra Leone Civil War of the 1990s.

[1] Merrily Kerr, "Wangechi Mutu's Extreme Makeovers," *Art on Paper* 8, no. 6. (July/August 2004): n.p.

[2] Anna C. Chave, "Is This Good for the Vulva?: Female Genitalia in Contemporary Art," in *The Visible Vagina* (New York: Francis M. Naumann Fine Art, LLC; New York: David Nolan Gallery, Inc., 2010), 23.

Mutu's critique of the stereotypes that oppress black women takes most overt form in *The Ark Collection* (2006; left), a series of thirty-two postcard-sized collages in which pornography meets ethnography. Elegantly displayed in four glass vitrines in a black-painted room, these works skillfully combine hyper-sexualized images of women cut from black porn magazines with postcard reproductions of photographs documenting Masai tribal ceremonies in Kenya and

Wangechi Mutu, *The Ark Collection*, 2006 (detail). Collage on 32 postcards displayed in vitrines; each postcard: 6½ x 4¼ in. | 16.5 x 10.8 cm.

Tanzania taken by the American photojournalist Carol Beckwith. (Beckwith's photographs have been widely distributed as postcards, calendars, and, most notably, in the illustrated book *Women of the African Ark*.) In an essay titled "*The Ark Collection*: Disjunctive Continuity," curator David Moos observes, "To Mutu, a Kenyan native, the quasi-scientific and stock ethnographic style of Beckwith's imagery—similar to the glossy romanticism of *National Geographic*—offers a template against which to launch a critique of this highly constructed and fallacious stereotype of the African female." [3] In juxtaposing clichéd images of the idealized African woman with the bare breasts and spread legs of her African-American counterpart, Mutu highlights the cultural biases operating against each—one the object of Western post-colonial fantasy and the other the target of commercial pornographic exploitation. By splicing the two into one body, the artist creates a single disjointed being who encapsulates the tyrannical dualism that categorizes women as either Madonna or whore.

Mutu's expressive use of collage technique reached new heights in a number of elaborate, large-scale figurative works incorporating such diverse materi-

[3] David Moos, "*The Ark Collection*: Disjunctive Continuity," in *Wangechi Mutu: This You Call Civilization?* (Toronto: Art Gallery of Ontario, 2010), 11.

als as ink, acrylic, collage and contact paper, glitter, beads, and fur on Mylar surfaces. Her work in this medium takes precedent in the politically-charged, formally-innovative collages of the German artist Hannah Hoch (1889–1978) and African-American Romare Bearden (1911–1988), as well as in the venerable history of Cubist, Dadaist, and Surrealist collage. [4] While her overall body of work includes drawing, video, performance, sculpture, and installation, collage remains her signature medium—one she has made distinctly her own.

In the dazzling *Le Noble Savage* (2006; below), Mutu critiques the Western notion of the "exotic" African woman as both a personification of Mother Nature and as the ultimate signifier of difference. Dancing with abandon, this female fertility figure appears to spring from a field of tall grass, while a palm tree, encircled by hummingbirds and parrots, shoots from her upraised arm. Her body is strong and brilliantly adorned in a triangular pattern of African design, a grass skirt, tropical flowers, and "wild" animals including leopards, lions, and silvery snakes. She seems to literally erupt with life. At the same time, *Le Noble Savage* embodies a highly reductive or essentialized concept of Africa in general and the African female body in particular. She represents nature to our culture—a symbol of beauty, wonder, and power that the patriarchy both desires and fears.

All Mutu's bodies tell a story, filled with abundant detail. In the complex and disturbing collaged drawing titled *This you call civilization?* (2008; overleaf), the artist questions the supposed cultural and moral superiority of the dominant Western powers and their so-called civilizing missions. Except for a pair of strong supporting legs, the viewer can barely distinguish among the four intertwined female figures that seem to mutate, dissolve, and decompose before our eyes. As in the work of the Surrealists, Mutu's uncanny, grotesque, and unbounded bodies undermine the traditional binaries of human and animal, rational and irrational, dream and waking,

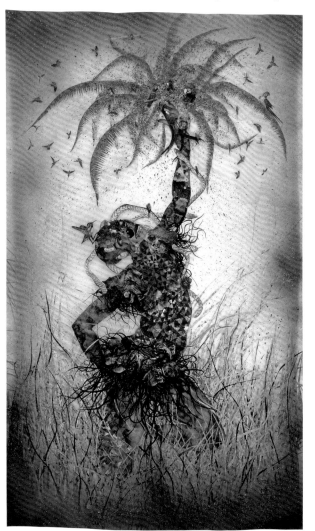

Wangechi Mutu, *Le Noble Savage*, 2006. Mixed media on Mylar; 91¾ x 54 in. | 233 x 137.2 cm.

[4] Josée Bélisle, "The Anatomy of an Exquisite Horror: An Introduction to the Complex, Dazzling, Monstrous—and Moving—Art of Wangechi Mutu," in *Wangechi Mutu* (Montreal: Musée d'art contemporain de Montréal, 2012), 59.

Wangechi Mutu, *Cutting*, 2004.
Single-channel video with sound;
5:45 min.

as they express personal and cultural fears and anxieties. As noted by art critic Stephanie Cash, "The metaphor of a civilization in crisis is clear." [5] For Mutu, the very notion of civilization is up for grabs. In describing this work, and her exhibition of the same name at the Art Gallery of Ontario, the artist declared, "Since the West has called its habit of dominating and destroying 'civilization,' I am also alluding to the hypocrisy and contradiction in that term. When asked, 'What do you think of Western civilization?' Gandhi responded, 'I think it would be a very good idea.' I cannot say it as brilliantly as he did." [6]

The female body also is the primary focus of Mutu's videos. While the body featured in her collage work is deliberately artificial and excessive, the woman appearing in her videos is natural, restrained, and reflective. It is the artist herself as the quintessential African woman, dressed in modest attire, performing the mundane, repetitive chores of domestic life. In *Cleaning Earth* (2006), she undertakes the futile task of diligently scrubbing a dirt floor in a gesture that assumes a ritualistic, otherworldly aura. She is everywoman, quietly laboring to clean her home while symbolically cleansing a land that has been stained with the blood of countless conflicts. Mutu appears once again as a solitary figure on the horizon of a desolate rural landscape in *Cutting* (2004; above), methodically hacking away at a pile of large branches. The suggestion of violence is more overt in this video as the machete, designed as an agricultural tool, has more recently become a weapon of war in the massacres, genocides, civil wars, and other armed conflicts that continually plague the African continent.

In Mutu's work the representation of the black female body runs the gamut from the horrific to the sublime. As a feminist artist, and as an African living in the West, she brings a multifaceted, global perspective to her work. Mutu looks at the distortions and violence visited on women across patriarchal cultures from the viewpoint of a self-described "post-colonial individual," confronting the damage done to one's psyche and sense of self while facing the challenges of making a new life in exile. The artist explores the body as the site of conflicting cultural projections regarding race, gender, and colonialism with extraordinary flair, offering the viewer ample visual pleasure along with a powerful social and political critique. — HELAINE POSNER

[5] Stephanie Cash, "Terrible Beauty: Wangechi Mutu," *Art in America* 98, no. 5 (May 2010): 124.

[6] Wangechi Mutu, interview by Rich Blint, *Wangechi Mutu: This You Call Civilization?*, 98.

MIKA ROTTENBERG

OPPOSITE
Mika Rottenberg, *Barbara from Mary's Cherries*, 2004. C-print.

BELOW
Mika Rottenberg, *Mary's Cherries*, 2004. Single-channel video installation with sound; 5:50 min.; edition of 5.

A VIDEO PRODUCED BY MIKA Rottenberg while she was in graduate school opens with a woman jogging barefoot. Soon the subject is running, still shoeless, through snow, and then, abruptly, she is fast-walking on her hands, backwards. The camera shifts to take her perspective, turning the world upside down, and for a few dazzling moments we watch a young woman clinging to the snowy, tree-fringed planet as it hangs above her, a clear blue sky beneath her feet.

Rottenberg, who was born in Argentina in 1976, raised in Tel Aviv, and now lives in New York (she is a graduate of NYU and Columbia), is best known for video installations that feature physically exceptional women employed in activities that are both logical and deeply absurd. In discussing her concern with the art market's uneasy relationship to labor, and to women's labor in particular, she cites Marx and notes that her parents grew up on kibbutzim. Her work explicitly concerns interactions between bodies and machines, and "the idea of value and ownership generally." She notes, firmly, that she is a feminist and is concerned with "the way women's labor has been marginalized and almost invisible throughout history." [1] But she also draws attention to the formal, and intuitive, aspects of her videos and installations, which tend to demonstrate, in myriad ways, the importance of a simple twist of space.

To date, she has done so with videos, installations, and performances featuring makeshift mechanisms that produce useless consumer products from various bodily exertions and byproducts. Among the earliest is *Mary's Cherries* (2004; opposite and below), which involves the transmutation, apparently through vigorous pounding, of fingernail clippings into Maraschino cherries. It introduces a number of motifs

that have recurred in subsequent videos: very big women; generic uniforms (here in pastel shades); a contraption with a pedal-operated conveyor belt reminiscent of Rube Goldberg (or Buster Keaton, or Charlie Chaplin, to name connections often cited); and the progress of a negligible product along a confoundingly complicated series of passageways.

[1] Eleanor Heartney, interview with Mika Rottenberg, published in French as "Mika Rottenberg: Corps Fragmentés," *Art Press*, no. 377 (March 2011): 46.

Mika Rottenberg, *Felicia from Tropical Breeze*, 2004. C-print; 20 x 24 in. | 50.8 x 61 cm; edition of 7.

Tropical Breeze (2004; opposite) again features a woman at a pedal-driven machine, this one driving a conveyance that carries Kleenex forward from the back of a truck—the video is shot within the moving vehicle—to the African-American female driver, who in real life is a champion bodybuilder named Heather Foster. Sweating profusely, Foster wipes her face with the Kleenexes as they reach her, then sends them back along the moving line to the woman at the back of the truck, who presses and packages them. It is this video's punchline that by drinking a lemon flavored thirst quencher, Foster lends the tissues—sold under the work's name—a pleasing citrus scent.

For *Dough* (2005–6), Rottenberg created an installation which, paralleling the structure of the video, places viewers on a rudimentary bench in a cramped and roughly carpentered screening station. Similarly wedged into confining spaces, the video's protagonists are the six-hundred-pound model Raqui, a "size-acceptance activist," and Tall Kat, a model who is 6'9." They are responsible for the unlikely progress of a lump of dough as it is kneaded, stretched, and urged through various openings between adjoining chambers. Sniffing bright-colored flowers causes Raqui to weep so profusely (due to an allergy, the alternating use of an inhaler suggests) that tears run down her body, drip off her foot, drop onto a sizzling hotplate below, and produce steam that hastens the expansion of the dough. Each risen lump is vacuum-packed in plastic and deposited on a growing pile. As in others of Rottenberg's works, the pull of physical comedy in *Dough* is strong. (It seems to explicitly recall, sexual innuendo and all, a famous *I Love Lucy* episode in which Lucy overestimates how much yeast she needs for homemade bread; the loaf she puts in the oven forces open its door and overtakes the kitchen.) But the slapstick in Rottenberg's work is significantly mitigated by the eccentricities of the bodies involved, and the dignity the actors command. Speaking of the power dynamics typified in *Dough*, Rottenberg has explained, "Many of my 'talents' admit to being exhibitionists—and I know I'm a voyeur—so we all end up satisfied." [2] But she also points to more metaphysical concerns, saying, "I was inspired by the unit of the calorie." [3] That is, *Dough* documents the transmutation of matter to energy (flour, yeast, and water to nutrition), of dross to gold (the titular pun), and, most broadly, of negligible materials to art.

Cheese (2008; overleaf), which establishes a more linear narrative, stars members of an Internet club called "Floor-Length Hair"; those featured have hair between six and thirteen feet long. A multichannel work screened within a se-

[2] Ibid.

[3] Judith Hudson, "Mika Rottenberg," *Bomb*, no. 113 (Autumn 2010): 27.

ries of ramshackle, farm-like enclosures resembling those shown onscreen, *Cheese* begins at daybreak, as the sun strikes a rustic manger in which the six women are asleep on various wooden pallets. As the day progresses, the women busily tend to nearly two dozen barnyard animals; all the while, they comb, stroke, twirl, shake, and fan their hair, which is made to resemble animals' manes or tails, or waterfalls. Near the video's conclusion, before the sun sets and the women return to sleep, a funnel is held up to a roaring cascade of water. The reference is to Niagara Falls, whose waters were said to have been collected for the tonic sold as "Hair Fertilizer" by the seven Sutherland Sisters, late-nineteenth-century siblings whose career peddling a (bogus) cure for baldness inspired Rottenberg's video. Again, however, she also points to the ahistorical appeal of her subject, in this case hair so long it is as much inanimate commodity as human form: "I like the idea of the body expanding and becoming an object," she has said about *Cheese*. "I like this duality, this connector between interior and exterior space." [4]

 Squeeze (2010; pp. 66, 67), more ambitious still, includes settings not constructed by Rottenberg: it was partly shot on a lettuce farm in Arizona worked by

[4] Robert Enright, interview with Mika Rottenberg, *Border Crossings*, no. 117 (March 2011): 45.

OPPOSITE
Mika Rottenberg, *Cheese*, 2008.
Installation view, Whitney
Biennial, Whitney Museum of
American Art, 2008. Collection
Melva Bucksbaum and Raymond
Learsy.

BELOW
**Mika Rottenberg, *Still from Cheese*,
2007.** C-print; 16 x 24 in. | 40.6 x
61 cm; edition of 7.

Mexican laborers, and at a rubber plant in Kerala, India. We see rubber trees being tapped, heads of lettuce being harvested and sorted. Knives flash, conveyor belts run, and the work looks hazardous and backbreaking. There are also characteristically provocative scenes played by actors in fabricated sets. A tongue is thrust through a stuccoed wall, its tip turning suggestively from side to side; a row of Asian women massage a line of hands that extend from sleeves issuing from another wall; behind the women is a row of naked human buttocks, each framed by a custom-shaped hole in yet another partition. Bunny Glamazon, a "fetish worker" who performs (in her day job) wrestling and role-playing, is shown being compressed by two mattresses. As her face is slowly squashed, she brushes sparkly pink flecks off her cheeks.

While again concerned with the production of a useless commodity—in this case, a cube of matter composed of squashed lettuce, latex, and cosmetic blush—*Squeeze* takes Rottenberg's challenge to the art market further. The cube is illustrated in a photograph, where it sits in the hand of the art dealer Mary Boone, but the object itself is sequestered on an offshore tax haven; investors may purchase shares, but Rottenberg retains controlling interest. Clearly, this work reflects her sustained interest in economic and political questions: the alienation of labor, a Marxist term for what happens under capitalism, is mirrored in the representation of alienation in its psychological form, as the experience of isolation. Rottenberg ties both to the conditions of immigrant aliens, a huge portion of the global labor force. Dis-

cussing *Squeeze*, she notes her interest in "one of Marx's main points, that capitalism basically gives shape to and creates units out of shapeless substances." [5]

But when asked if she considers her work political, she responds, "No, for me that would mean you have a goal that you want your work to achieve. My work doesn't have a goal; it's an experiment." [6] Other influences on this work's visual repertory include a squeeze mechanism developed by Temple Grandin to help relieve panic in individuals with autism (it is based on chutes used to calm animals before slaughter). Comparisons have been made to the

[5] Heartney.

[6] Ibid.

RIGHT
Mika Rottenberg, *Squeeze*, 2010.
Digital c-print related to the single-channel video installation with sound; 20 min.; video edition of 6.

OPPOSITE
Preparatory drawing for *Squeeze*, 2010.

work of Ann Hamilton (her weeping wall in particular) and to Janine Antoni (Rottenberg cites Antoni's photograph of an eyeball being licked [7]). Another inescapable comparison is to Marcel Duchamp, in particular the erotic machines that appear throughout his work, from the pulsing abstractions of the "Rotoreliefs" to the mechanical bachelors and chocolate grinders of the *Large Glass*.

Some of Rottenberg's formal choices are based in old-fashioned filmic devices, as when circular apertures open out to admit a full screen or close like an iris in the sun. Rottenberg has herself emphasized the formalism that shapes her videos, explaining that *Mary's Cherries* was conceived, in the most abstract terms, as a vertical line, *Dough* as a plus sign, and *Cheese* as a circle. [8] Her most recent work, *Seven* (2011), featured live performers as well as a multichannel installation and sculptural components by Jon Kessler, and its narrative spans the globe from New York City to rural Botswana; its geometry is complex indeed. But Rottenberg's concern with interplays among spatial disorientation, economic marginalization, and personal displacement remains constant, yielding work that is richly complicated, often very funny, and always deeply humane.

— NANCY PRINCENTHAL

[7] Enright, 42.

[8] "I started with a vision of a three-dimensional shape, like a kid's game. It has one shape, you twist it and it has another shape; you turn it in half, another shape. Each of the five pieces from the last five years had its own basic shape.... *Tropical Breeze* is a horizontal line, *Mary's Cherries* is a vertical line, *Dough* is a plus sign, *Cheese* is a circle. I feel *Squeeze* completes this body of work by combining all these shapes in a single kinetic sculpture." Hudson, 31.

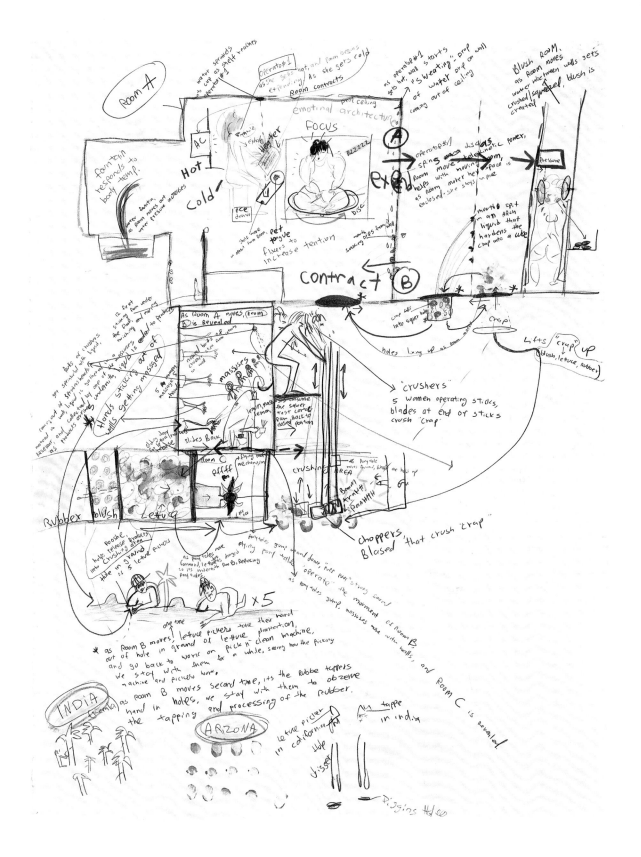

SPELLBOUND

by Nancy Princenthal

THE RECKONING

Louise Bourgeois, *The Destruction
of the Father*, 1974. Latex, plaster,
wood, fabric, and red light;
93⅝ x 142⅝ x 97⅞ in. | 237.8 x
362.3 x 248.6 cm. Collection of
The Easton Foundation.

DREAMINESS, OR TRANCE, OR SPELL-BOUNDEDNESS—an inclination to wander off topic and away from material reality—has often been considered a feminine trait, sometimes dismissively. Using a trusty tactic of subversion, many young women artists have turned the characterization upside down, finding in this inclination a source of expressive strength. A lineage can be traced from their work back to the Surrealists who, in the 1920s, began to transpose the language of dreams—and its newly formulated vocabulary of displacement, condensation, and seemingly irrational "screen" content—into poetry and art. But young artists are also turning to radical transgressions against logic undertaken by women who stood to the side of those investigations, among them Louise Bourgeois, whose *The Destruction of the Father* (1974; opposite) can serve as a paradigmatic antecedent. With its rage against patriarchs both particular and general, its grisly humor, and its huge ambition, this womblike installation has helped gestate all manner of visual and narrative provocation, including much of the work to be discussed under the heading "Spellbound."

Highly educated and culturally sophisticated—that is, nothing like the inarticulate fonts of intuition that Surrealism's founding fathers, among others, notoriously claimed women to be—the French-born Bourgeois created *Destruction of the Father* when she was in her early 60s. It is not her most ingratiating work by a long shot. A dark and claustrophobic diorama-like room, it features bloated latex lumps hanging from the ceiling and heavy drapery on walls and floor. At its center is a surface strewn with obscurely nasty objects. In the artist's description, "There is a dinner table and you can see all kinds of things are happening. The father is sounding off, telling the captive audience how great he is, all the wonderful things he did, all the bad people he put down today. But . . . a kind of resentment grows in the children. There comes a day when they get angry. Tragedy is in the air." [1] As Bourgeois imagines it, the children put the father on the table, dismember and then eat him. In reality, what one sees are latex casts of animal limbs that she bought at a local market—lamb shoulders, chicken legs. But, Bourgeois continues, the table is also a bed, since "those [are] two things that count in one's erotic life: dinner table and bed." [2] Mary Ann Caws suggested this installation's symbolic range (although she was not speaking of Bourgeois's work in particular) when she wrote, "The dislocated and separated body parts that appear frequently in surrealist imagery can . . . be interpreted negatively as a trace of trauma and psychological disturbance . . . but they can also be a positive manifestation of desire." [3]

[1] *Louise Bourgeois: Destruction of the Father, Reconstruction of the Father;
Writings and Interviews 1923–1997,* ed. Hans Ulrich Obrist and Marie-Laure
Bernadac (Cambridge, Mass.: MIT Press; London: Violette Editions, 1998), 115.

[2] Ibid.

[3] Mary Ann Caws, *Surrealism* (London: Phaidon, 2004), 30.

Sheila Pepe, *Gowanus*, 2004.
Nautical towline, shoelaces, and
shopping cart; approx. 30 x 80 x
20 ft. | 9.14 x 24.38 x 6.1 m.

While the desire
at play in *Destruction of the Fa-
ther* is decidedly oblique, the an-
ger is unmistakable, [4] expressed
with a bloody-mindedness that
Robert Storr has connected to
the sanguinary, dead-animal-
laden performances of the Vien-
nese Actionists in the 1960s and
early 1970s. [5] But the installa-
tion's fury has a counterpoint, as
Storr also observed, in its black
comedy. By expressing the pos-
sibility that rage could lead not
only to hysteria (long considered
the special province of disturbed
women) but also to the brink of
hilarity, Bourgeois spoke for a
connection between productive
mayhem and women's laughter
that was just at the time being
framed in critical terms. In fact,
the connection had a long his-
tory, going back to the world of
Rabelais and the carnivalesque; Mikhail Bakhtin's *Rabelais and His World*, first pub-
lished in the mid-1960s, [6] describes a culture in which laughter, not paralyzing mel-
ancholy, is the distinctive domain of women. In this respect, Bourgeois can be tied
to the "Bad Girls" discussed in this book's first chapter by Eleanor Heartney, from
Carolee Schneemann and Niki de Saint Phalle to Deborah Kass and Mika Rottenberg;
the carnivalesque is a link as well to Nathalie Djurberg, Pipilotti Rist, and others
considered below.

Approaching the questions raised by Bourgeois's work from a for-
mal perspective, Rosalind Krauss points to its impulse "to short-circuit the logic of
forms and to produce an unthinkable mutation within form in which oppositions

[4] This installation is often described as a response to infidelities
committed by Bourgeois's father, although she didn't start to talk about
his betrayals until a decade after *Destruction of the Father* was completed.
And their importance may have been overblown. When Jerry Gorovoy, her
long-time assistant, said in a late interview, "I can tell you the six key events
in Louise's early life: the first is the introduction of Sadie, the children's
governess, into the family and Sadie's ten-year relationship with Louise's
father....," Bourgeois interrupted him to say, "The most important event
in my life was the birth of Jean-Louis," her first biological son. Louise
Bourgeois, interview by Paulo Herkenhoff, transcribed and edited by Thyrza
Nichols Goodeve, in Robert Storr and Paulo Herkenhoff, *Louise Bourgeois*,
(London: Phaidon, 2003), 9.

[5] Storr noted that an Actionist poster long hung in Bourgeois's living
room. Robert Storr, "A Sketch for a Portrait: Louise Bourgeois," in Storr and
Herkenhoff, *Louise Bourgeois*, 66.

[6] This is the subject of Jo Anna Isaak's *Feminism and Contemporary Art:
The Revolutionary Power of Women's Laughter* (London: Routledge, 1996),
see esp. 11–26.

are collapsed to produce what Georges Bataille has termed the *informe*." [7] Bataille's "definition" of *informe*—formlessness—is itself notoriously ambiguous. In *Formless: A User's Guide*, a catalogue co-authored by Krauss and Yve-Alain Bois, Bois quotes Bataille: "To say that the universe resembles nothing and is only *informe* amounts to saying that the universe is something like a spider or spit." Bois goes on to say, "Nothing in and of itself, the formless has only an operational existence: it is a performative, like obscene words, the violence of which derives less from semantics than from the very *act* of their delivery." [8] That the spider is a key figure in Bourgeois's later work is a coincidental connection, but the performative impulse, and the formless as Bataille conceived it, are surely central to her sculpture and the long trail of its influence. Latter-day manifestations of the *informe* range from Kiki Smith's sculptures of women and men trailing feces, blood, milk, and semen to the web-like nets and scatterings of domestic detritus in installations by Judy Pfaff, Tracey Emin, Sarah Sze, and Sheila Pepe (opposite).

More dubiously, Krauss also claimed, "The famous passivity with which the surrealists practiced"—that is, produced their mediumistic writing, automatic poetry and drawing, and dream-derived imagery—"is a kind of feminization of art making." [9] Of course femininity and passivity are hardly synonymous, but, in any case, Bourgeois—far from passive (and, as it happened, a lifelong insomniac)—insisted that she was not a dreamer. "Everything pays dividends except dreaming—dreaming softens you and makes you unfit for daily work," she wrote in a 1950 diary entry. [10] It was on this point especially that she opposed herself to the Surrealists, who "talked about the dream all the time. I don't dream. You might say I work under a spell. . . . It's not a passive state, like a dream. The dream blinds you, the spell does not." [11] Keeping her eyes wide open to the full range of her experiences, Bourgeois focused hard on those pertaining to motherhood and the trappings (pun intended) of home—emphases she shared with other artists of her generation, from Meret Oppenheim to Dorothea Tanning (overleaf). Above all, she was insistent on representing female embodiment in ways that didn't cater to, or even presume, male desire. It was among her most fruitful bequests to succeeding generations of women artists.

There is, however, one thing that sharply distinguishes Bourgeois from the many artists working in her descent: in the more recent work, rage against fathers has been largely laid to rest. Criticism of the founding Surrealists' patent condescension toward women has given way to consideration of the female artists who

[7] Rosalind Krauss, *Bachelors* (Cambridge, Mass.: October/MIT Press, 1999), 71.

[8] Yve-Alain Bois and Rosalind Krauss, *Formless: A User's Guide* (New York: Zone Books, 1997), 18.

[9] Krauss, *Bachelors*, 13.

[10] *Louise Bourgeois: Destruction of the Father*, 57.

[11] Ibid., 160.

Dorothea Tanning, *Rainy Day Canapé*, **1970.** Upholstered wood sofa with wool, polyester, and rayon plan weave cover, wool batting, cardboard, and Ping-Pong balls; 31½ x 57 x 33 in. | 80 x 144.8 x 83.8 cm. Philadelphia Museum of Art; Gift of an anonymous donor, 2002.

were excluded from the movement's ranks, [12] and acknowledgment of the resources it offered even to those who were sidelined. In the catalogue for a 2012 exhibition of female Surrealists, many of them historically neglected, Maria Elena Buszek cites recent scholarship suggesting that "if Surrealism was not good *with* women, . . . we might say that Surrealism was in many ways good *for* women." [13] That is, it offered a real-life alternative to submission and silence. Says art historian Whitney Chadwick, "The young women who joined the Surrealists in Paris in the 1930s—or, . . . declared themselves *not* Surrealists . . . —saw Surrealism, rather than direct political action, as their best chance for social liberation" from middle-class marriage, motherhood, and its traditional constraints. [14]

In other words, from the start there were plenty of women who found the language of dreams, daydreams, and spells as having a liberatory and even activist potential, and many younger women have expanded on that possibility. But a striking shift has occurred in the understanding of where introspection leads. Over the past several decades, individual identity has come to be viewed, increasingly,

[12] See Krauss, *Bachelors*; Whitney Chadwick, ed., *Mirror Images: Women, Surrealism and Self-Representation* (Cambridge, Mass.: MIT Press, 1998); Natalya Lusty, *Surrealism, Feminism, Psychoanalysis* (Hampshire, U.K.: Ashgate, 2007); Patricia Allmer, *Angels of Anarchy: Women Artists and Surrealism* (Munich: Prestel; Manchester Art Gallery, 2009); and Ilene Susan Fort et al., eds., *In Wonderland: The Surrealist Adventures of Women Artists in Mexico and the United States* (Munich: Prestel; Los Angeles County Museum of Art, 2012).

[13] Angela Carter, quoted in Elena Buszek, "Eros and Thanatos: Surrealism's Legacy in Contemporary Feminist Art," in *In Wonderland*, ed. Fort et al., 209–10.

[14] Whitney Chadwick, "An Infinite Play of Empty Mirrors: Women, Surrealism and Self-Representation," in *Mirror Images*, ed. Chadwick, 5.

as fluid, while the unconscious has moved decisively out into the world. Younger artists do not generally see quotidian life as a fixed, generic backdrop for a quarantined field of internal experience; instead, they are concerned with how psyche, body, and culture shape each other—and, particularly, with how that interaction affects gender roles. Some of the women belatedly added to the Surrealist roster, including Claude Cahun (above) from the early years, and in the next generation Cindy Sherman and Francesca Woodman, turned photographic self-portraiture toward the exploration of these questions, in work associated with what psychology has termed *masquerade*. Kiki Smith's meditations on the ways that myth have shaped femininity are a part of this lineage, too, as are Lesley Dill's incarnations of ecstatic language, borrowed from secular poetry and also spiritual texts (above).

This is all another way of saying that the remarkably durable reign of orthodox psychoanalysis over the understanding of imagery associated with subconscious states may finally be ending. Many female theorists have been at pains to point out the patriarchal biases in Freud's writing. Nonetheless, critical discussion

of artwork associated with Surrealism long continued to contend with his theories (and those of his most culturally influential heir, Jacques Lacan)—especially, ironically, discussion of artwork by women addressed to questions of physical and emotional identity. But younger theorists—and artists—have many other models to turn to. Arguably the most important are grounded in an acceptance that psychological experience has a biological basis (an acceptance expressed, in society at large, by the skyrocketing prescription rates for psychotropic drugs). This realignment has complicated the picture of dreams as revelatory of suppressed psychological truths. Neuroscientist J. Allan Hobson writes, "Freud, like his followers, religiously believed that dream bizarreness was a psychological defense against an unacceptable unconscious wish." [15] But in fact, he continues, "we do not dream because our unconscious wishes or drives would, if undisguised, wake us up. We dream because our brains are activated during sleep." [16] Dreaming, in this view, is a state that produces "as much cognitive trash as treasure." [17] In exchange for relinquishing the exalted status Freud granted dreams (and their interpreters), artists have at their disposal an increasingly rich and complex picture of how the brain produces mental events, from the literal snapshots produced by Functional Magnetic Resonance Imaging machines to new studies showing how imagination and perception are cross-wired.

Rona Pondick, *Cat*, 2002–5. Stainless steel; 4½ x 33 x 14⅛ in. | 11.4 x 83.8 x 35.9 cm; edition of 3.

If looking inward yields a view of synapses firing rather than a steamy drama of sex and violence, that image is mirrored with striking precision in the networked system of electrical impulses that is the Internet—our historical moment's collective unconscious. A public space as inchoate and ungoverned as the wildest dreamscape, and justly praised for its democracy, it is also notoriously open to all kinds of nastiness, with women and girls particular targets. "Sexism, racism, homophobia and general name-calling are longstanding facts of life in certain corners of online video

[15] J. Allan Hobson, *Dreaming: An Introduction to the Science of Sleep* (Oxford: Oxford University Press, 2002), 6.

[16] Ibid., 156.

[17] Ibid., 100.

games," according to a front-page *New York Times* article of summer 2012 about sexual harassment in the world of Internet gaming, [18] a world where—like many other neighborhoods of the Internet—emotional and even physical integrity are poorly secured against malicious dishonesty, predatory commerce, and anonymous aggression. The growing body of artwork produced on and/or for the Internet must contend with these challenges—for some, the challenges are part of the appeal.

This is not to suggest that brain science and online gaming have caused younger artists engaged with emotional experience to forsake the ineffable or the corporeal—or to turn their backs on dreams. But increasingly, distinctions are seen to blur between material reality and interiority, as with lines, challenged decades ago, dividing male and female, and even human and animal (the last a border Bourgeois often trespassed). Janine Antoni, for instance, has produced some especially vigorous gender bending with a pair of photographs showing her parents switching roles by cross-dressing; in a photograph of herself apparently suckling a cow, Antoni crosses a boundary between species as well. While both projects are rife with psychoanalytic implications, in *Slumber* (1993) Antoni has charted her dreams from a decidedly neuroscientific perspective, recording her brainwaves during REM stages of sleep and weaving their patterns into a blanket by day.

Of course, the fact that people share much with other animals, and that imaginary interspecies hybrids are a rich source of metaphor, has impelled artwork long before Surrealism, from Neolithic carvings to ancient Greek statuary; Rona Pondick is notable among current artists exploring chimerical conjunctions of humans (herself, in particular) and other mammals (opposite). This is part of the lineage of Nathalie Djurberg's clay-animation videos, which feature cartoonish human characters and various animals engaging in all manner of social and sexual intercourse, much of it as grisly as the Actionists linked to Bourgeois—and as richly Rabelaisian. Victims in Djurberg's videos are barely distinguishable from perpetrators, who are as likely to be women as men; their brutalities, often disturbingly funny, are subject to neither judgment nor consequence, which contributes to their confoundingly childlike innocence.

A number of video artists have similarly combined guileless reverie with intimations of violence, among them the Finnish Eija-Liisa Ahtila, who has sharply probed the experience of emotional instability and its intersection with spiritual transport—an examination that veers away sharply from the coordinates

[18] Amy O'Leary, "In Virtual Play, Sex Harassment Is All Too Real," *New York Times*, August 1, 2012, http://www.nytimes.com/2012/08/02/us/sexual-harassment-in-online-gaming-stirs-anger.html?hp.

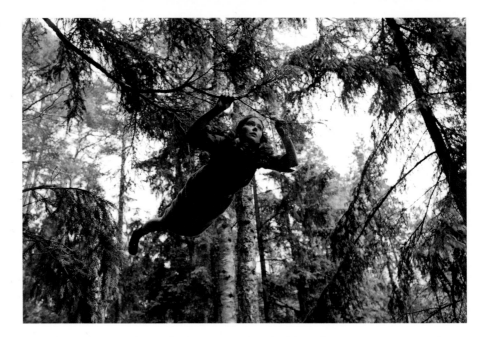

of Freudian analysis (above). Pipilotti Rist's video installations sometimes achieve monumental proportions, and generally combine overwhelming sensuality with elements of menace. Immersive and sensual, *Pour Your Body Out* (2008), a seven-channel work, brings viewers literally to their knees, encouraging visitors to lounge on soft furniture and abandon themselves to its saturated colors and sensual floral and bodily imagery: an example of the *informe* in motion. On the other hand, an earlier work by Rist featured an ingenuous young woman cheerfully smashing car windows with what looks like a flower, an act of serial vandalism witnessed benignly by a policewoman—another expression of rage without remorse, as funny as it is cathartic.

The alternate realities envisioned by the British sisters Jane and Louise Wilson are based at least in part on historical institutions, and weave subjective states with social realities in subtler, more allusive alternatives to the epic mock-histories of artists like Pierre Huyghe or Matthew Barney. The visionary social programs once served by the abandoned Soviet-era buildings that provide settings for the Wilsons are made to seem as unlikely as the beliefs held by the itinerant Renais-

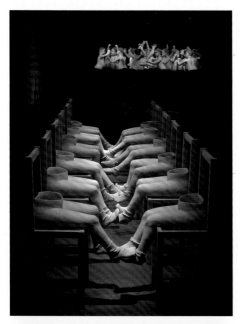

sance festival workers, or nudist colonists, or survivalists, that are the subjects of Justine Kurland's photographs. The retro-futurism in the Wilsons' videos—and in the madcap global-manufacturing scenarios of Mika Rottenberg's video installations—finds a counterpart in Cao Fei's work, which has taken the form of (among other things) a Second Life internet role-playing game, in which her avatar is decidedly unfazed by the (predominant) male players.

Just as Surrealism favored new techniques in photography, younger artists working in its wake have clearly been drawn to video imagery and other digital media. But there is also an extensive body of painting and sculpture that has explored the borderlands between youthful fantasy and darker adult imaginings, from Balthus's moody, sexualized images of prepubescent girls to Hans Bellmer's violently ruptured and recombined *poupées,* and from Francesco Clemente's sloe-eyed beauties to John Currin's hyper-curvaceous babes. Sculptors working in this tradition include—in addition to Bourgeois, Smith, and Pondick—Elise Siegel, who has made psychologically complex tableaux of children of curiously ambiguous sexuality, and Judy Fox, whose disturbingly believable mythical figures lurk between innocence and hypersexuality (left). Lisa Yuskavage's luscious, candy-colored paintings of impossibly big-breasted women give spectacular expression to the kinds of sexual fantasies internalized early on by girls. Few men enter these dewy, pastel toylands, and again, as with Bourgeois, male desire does not seem to be the force that shapes the imagery.

As provocatively as anyone, Yuskavage raises the question of whether women have a particular stake in artwork that plumbs the subconscious. But she is not alone in asking, is there a gender politics of surreal imagery? It is hardly a mode of working from which men are barred. But the evidence strongly suggests that venerable, culturally imposed associations between femininity and introspection, as between femininity and departures from rationality, have been long since taken over by women artists themselves and fashioned into sources of active, affirmative inquiry.

JANINE ANTONI

IN A 2009 INTERVIEW JANINE Antoni acknowledged the strong influence of ninety-eight-year-old artist Louise Bourgeois on her body of work, citing Bourgeois as "my art mother." [1] For Antoni as well as a number of artists who came of age in the 1980s and early '90s, such as Robert Gober, Annette Messager, Cindy Sherman, and Kiki Smith, Bourgeois's examination of autobiography and identity, sexuality and gender, and intense psychological states, coupled with her visceral approach to art-making, laid fertile ground for their own artistic explorations. Bourgeois's feminist reclamation of such enduring subjects as the body, the family, and the home also influenced the work of these younger artists. The senior artist imbued these subjects with the pain, fear, and anger that originated in her early experience and remained embedded in her psyche stating, "I identify myself with extreme emotions." [2]

Like Bourgeois, Antoni explores issues surrounding the body, identity, and the psychology of domestic life, though she does so with a lighter touch and an undercurrent of dark humor. The younger artist employs an unusual range of methods and materials, transforming everyday rituals such as eating, sleeping, and washing, into sculptural processes, often using her body as an artistic tool. She has sculpted with her teeth, painted with her hair, and modeled with her body, performing intense and intimate acts that encourage the viewer (especially the female viewer) to relate to her objects through their own bodies. As the artist once observed, "I am interested in extreme acts that pull you in. . . . I choose seduction over hostility." [3] More recently, Antoni has created contemplative photographs that reflect on the nature, complexity, and ambiguity of family relations, particularly motherhood, exploring the ways that myth and fantasy may pervade daily life.

Antoni also acknowledges a debt to the some of the pioneering feminist artists of the 1960s and '70s who focused on female experience expressed through visceral, body-based, performance work. Her sources of inspiration include Carolee Schneemann's *Meat Joy* (1964), a Dionysian performance using humans and animal flesh as material; Ana Mendieta's *Silueta Series* (1973–80), in which the artist ritualistically merges her naked body, or its trace, with the earth in a return to the maternal source; and Hannah Wilke's *Venus Pareve* (1982–84) and *S.O.S. Starification Object Series* (1974–75), for which the artist cast herself in chocolate in the former, and photographed her nude body adorned with vagina-shaped bits of chewing gum in the latter, to critique cultural myths of beauty and desire. Antoni also acknowledges the influence of artists of the 1980s, including Sherman, Barbara Kruger, and

[1] Janine Antoni, "Escape Hatch: Janine Antoni in Conversation with Douglas Dreishpoon," *Art in America* 97, no. 10 (October 2009): 128.

[2] Louise Bourgeois, "Paulo Herkenhoff in Conversation with Louise Bourgeois," in *Louise Bourgeois*, by Robert Storr and Herkenhoff (London: Phaidon, 2003), 20.

[3] Janine Antoni, interview by Stuart Horodner, *Bomb*, no. 66 (Winter 1999).

Jenny Holzer, who explored issues of gender identity and its representation through media-based conceptual work, but feels a closer kinship with the more subversive feminist performance strategies of the 1970s.

Antoni made an impressive art world debut in the early 1990s with works such as *Gnaw*, *Lick and Lather*, and *Slumber*, where she turned physically and emotionally demanding performances and processes into compelling sculptural objects and installations. *Gnaw* (1992; below) consists of two 600-pound cubes, one made of chocolate and the other of lard, on which the artist gnawed to the point of exhaustion. She went on to convert the chewed-off, spit-out lumps of chocolate into heart-shaped candy box trays, and to combine the discarded animal fat with pigment and beeswax to make bright red lipsticks. Taken together the chocolate/candy box trays and lard/lipsticks refer to women's competing appetites for romance and

Janine Antoni, *Gnaw*, 1992. 600 lbs. of chocolate gnawed by the artist (24 x 24 x 24 in. | 61 x 61 x 61 cm); 600 lbs. of lard, gnawed by the artist (24 x 24 x 24 in. | 61 x 61 x 61 cm); 45 heart-shaped packages for chocolate made from chewed chocolate removed from the chocolate cube and 150 lipsticks made with pigment, beeswax, and chewed lard removed from the lard cube.

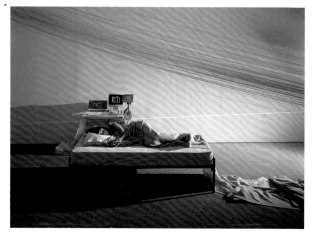

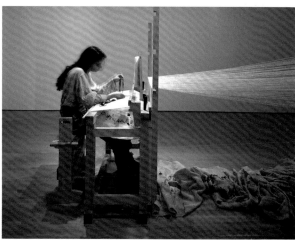

Janine Antoni, *Slumber*, 1993.
Performance with loom, yarn, bed,
nightgown, PSG machine, and the
artist's REM reading; dimensions
variable.

tempting sweets, desires that are deemed incompatible in our image-conscious consumer culture. For *Lick and Lather* (1993; p. 78), the artist molded fourteen classical self-portrait busts, seven in chocolate and seven in soap; then gently yet persistently licked off the chocolate and washed away the soap, gradually distorting and effacing her own image. With these acts, Antoni suggested the mutability of female identity and the illusion of fixed notions of the self.

Dreams become the material of art in *Slumber* (1993; left), a performance work comprised of a bed, a large maple loom, and an electroencephalograph that recorded the artist's brainwaves as she dreamed in the gallery. The EEG machine produced a graph of the artist's rapid eye movements (REM) during dream activity from the artist's first overnight in the gallery, providing a physical link to her unconscious mind. During the day, Antoni wove the EEG's zig-zagging patterns into a voluminous blanket using strips of fabric torn from her nightgown until it was consumed, in effect drawing her dreams. In this way, she paired the traditional craft of weaving with the advances of modern technology. In a twist on the Surrealists' use of dream content as a source of psychic subject matter, and in a departure from the nightmarish Freudian revenge scenario that animates Bourgeois's *The Destruction of the Father* (1974; p. 68), Antoni chose to explore the science of dreams over their unconscious meaning, opening up new avenues for the investigation of our inner selves.

In 1994 Antoni created *Mom and Dad* (overleaf), a photographic triptych depicting the artist's mother and father elegantly dressed and smiling for the camera. In this work, Antoni reversed her parents' roles, switching their appearance through the use of prosthetics, wigs, and clothing, as her mother (figuratively) became her father and vice versa. With this uncanny exchange—posing her mother

and father as each other, and presenting her father with her "father," and her "mother" with her mother—the artist created a set of portraits that "skew stable ideas of gender and upset the foundations of family." [4] The resulting photo work, an unsettling reversal of established gender identities and family relationships, oscillates between biological fact and social construction in a strange and witty form of domestic disturbance.

Antoni continued to take an imaginative look at family relations, particularly her connection with her mother, and later her daughter, in staged photographs exploring issues of motherhood and nurturing. In *Momme* (1995; opposite), we see the artist's mother, seated on a sofa and dressed in a simple white gown, serenely gazing into the distance. Slowly, we notice a third bare foot at the hem of her dress and a swelling at her stomach suggesting pregnancy. The bulge and foot, naturally, belong to the adult artist, who, hidden beneath her mother's gown, has discovered a unique way of easing the psychological strain of separation anxiety as she enacts a darkly funny and entirely fantastic return to the womb. Antoni takes over the role of a serene and nurturing mother of sorts in *2038* (2000), in which the artist, bathing nude in a large tub set up in a dairy barn, appears to nurse a cow poised at her breast. (A tag in the animal's ear identifies her as number 2038.) In this oddly tender scene of interspecies role reversal, the artist evokes the Madonna and Child of her Catholic upbringing and conjures a fairy tale waiting to be told.

Inhabit (2009; see p. 6) is a large and striking photographic self-portrait in which the artist further reflects on the complexity of the maternal role, once

[4] Marina Warner, "Child's Play," in *Janine Antoni* (Kusnacht, Switzerland: Ink Tree, 2000), 83.

again touched by a sense of wonder. In this work, Antoni appears to float midair in her daughter's colorfully adorned bedroom, suspended by an elaborate harness attached to ropes that fan out from her body like a spider's web. A furnished dollhouse takes the place of a skirt as the artist wears it on her body like a child's version of the home. Her expression and open gesture are sublime, yet the image remains ambiguous given that the artist is intentionally "unclear about whether my body is suspended or ascending, entrapped or the structure of support." [5] Antoni is simultaneously a transcendent figure, reminiscent of the Virgin Mary or Jesus Christ, and the embodiment of everywoman trapped by her maternal responsibilities.

Again, the influence of Louise Bourgeois is inescapable. Antoni's identification of the woman/mother with the home readily recalls Bourgeois's iconic *Femme Maison* paintings and drawings of the late 1940s in which a woman's head and upper body is engulfed or entrapped by her home, rendering her vulnerable and isolated from the outside world. In *Inhabit*, Antoni takes the architectural reference a step further in suggesting the womb as humanity's original dwelling place. The spider web, and on closer inspection the spider inhabiting the dollhouse, surely refer

Janine Antoni, *Momme*, 1995.
C-print; 36 x 29 in. | 88.9 x 73.7 cm; edition of 6.

to Bourgeois's magnificent, monumental, and often threatening spiders, cast in bronze in her later years. (It is interesting to note that Bourgeois associated her own mother, a weaver by profession, with the potent image of the spider.) However, the younger artist's work differs from her mentor's in a fundamental way; while Bourgeois's work consistently gave form to the deep inner workings of an individual psyche, Antoni regards herself as a "conduit," and her body, the basis of so much of her work, as a "funnel through which the world has been poured," as she explores women's experience and its resonance in the collective psyche. [6] —HELAINE POSNER

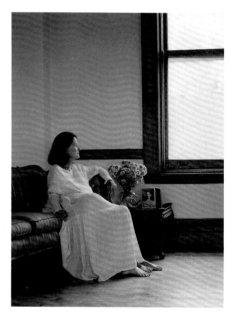

[5] Dreishpoon, 128.

[6] Janine Antoni, press release for the exhibition *Janine Antoni: Up Against* at Luhring Augustine, New York, September 12th–October 24th, 2009.

CAO FEI

We are what we pretend to be, so we must be careful about what we pretend to be.

— KURT VONNEGUT [1]

THROUGHOUT HISTORY, FANTASY HAS PROVIDED channels of escape from an everyday existence that seems too mundane, too tiring, too boring, or too painful. Literature, theater, art, music and, some would argue, religion allow participants to explore other worlds, inhabit different times, and live other lives. Today advances in technology have intensified both the experience and the reach of fantasy. 3-D films give viewers the illusion of careening through space, interactive online games enable the continual reconstruction and reinvention of self and world, and virtual reality makes it possible for our invented selves to create and inhabit parallel universes.

But what does it mean to be able to disappear into a self-constructed role and inhabit a wholly elective community? Are social bonds strengthened or loosened by our ability to dispense with age-old boundaries of time and space? What happens to "real life" when the world of the imagination is so much more intense and satisfying? Do we, as Kurt Vonnegut maintained, become what we pretend to be?

Such questions are at the heart of Cao Fei's complex, seductive, multidisciplinary works. Born in 1978 in Guangzhou, China, Cao Fei is a child of MTV, the worldwide web, the miracles of digital wizardry, and other manifestations of the brave new world of the late twentieth century. She has noted that her work exists in the nebulous region between reality and dream. [2] It reflects a youth culture that connects across national and ethnic boundaries and that reflects young people's sense of frustration toward the apparently ever-diminishing possibilities available to them in the global marketplace. But while Cao's work speaks the language of international pop culture, it does so with a distinctively Chinese accent.

Cao Fei's father was an official artist in China, and in fact in 2005 she created a film documenting his creation of a bronze memorial to Mao's successor Deng Xiaoping. She herself received a conventional Chinese art education at the Guangzhou Academy of Fine Arts in the late '90s. However, the real foundation for her work was laid by influences outside school. One of the most important of these was MTV, which, she notes, began importing foreign pop influences into China in the late 1980s. [3] Another was her exposure to the hybrid culture being created in China's Pearl River Delta where she grew up. During the 1980s and '90s this was

[1] Kurt Vonnegut, introduction to *Mother Night* (New York: Dell, 1966), v.

[2] "Fantasy" episode, *Art in the Twenty-First Century (Art21)*, season 5 (New York: PBS, 2009), http://www.pbs.org/art21/watch-now/segment-cao-fei-in-fantasy.

[3] Ibid.

Cao Fei, *Deep Breathing* **from** *COSPlayers Series***, 2004.** Digital c-print; 29¼ x 39¼ in. | 74.3 x 99.7 cm.

Cao Fei, *My Future Is Not a Dream 02* **from** *Whose Utopia?***, 2006.** Digital c-print; 47¼ x 59 in. | 120 x 150 cm.

ground zero for China's experiments in capitalism, as the region became a showcase economic zone serving as manufacturing hub to the world. Workers drawn to the region's burgeoning factories created one of the most densely populated urban centers in the world, creating inevitable clashes between urban and rural lifestyles, traditional and modern values, and Asian and Western ways of doing business.

Both experiences remain important touchstones for her work. MTV's blend of montage, music, and image underlie Cao's promiscuous mixing of genres, styles, and modes of presentation. And the contradictions of the Pearl River Delta have provided rich fodder for her works. This is particularly evident in works that use PRD as their setting. In Cao's 2002 video *Rabid Dogs*, office workers roam through their workplace in humorously homemade canine outfits (p. 84). *COSPlayers* (2004; opposite) features teenagers from the PRD who engage in role-playing games inspired by comic books, manga, and anime. She depicts them posing in their own superhero costumes as they sit disconsolately in their distinctly unheroic homes or roam about in the weirdly dystopian landscapes springing up on the fringes of Guangzhou. *Whose Utopia* (2007; opposite) is set in a lightbulb factory in the Delta and focuses on the fantasies of an older group of PRD residents. The video stars actual factory workers, following them first through their daily routines and then as they act out their secret workplace daydreams by singing, performing ballet pirouettes, or jamming with an electric guitar in the corridors of the plant.

Cao's most ambitious take on the Pearl River Delta took the form of a full-scale opera titled *PRD Anti-heroes* (2005; below), which was presented for the Guangzhou Triennial in 2006. It comprised a cast of thirty non-professional actors

who played characters representing the human flotsam and jetsam tossed about the Pearl River Delta in the wake of globalization. Coolies, beggars, gamblers, mistresses, fortune-tellers, trash-collectors, and sellers of pirated DVDs took the stage, acting out scenes that were part Chinese soap opera and part hip-hop dance performance.

Cao Fei, *PRD Anti-heroes*, 2005. Multi-media opera, performed at the Guangzhou Triennial.

More recent works have taken Cao Fei out of the Pearl River Delta and into virtual reality, providing her fascination with fantasy and role-playing greater scope. *i.Mirror* (2007; left), is a three-part video which the artist describes as a virtual documentary of her life in the online role-playing game called Second Life. In Second Life players construct avatars or identities through which they can roam about an elaborate virtual universe with its own currency, social networks, and transactions for virtual real estate, sex, and art.

To explore Second Life, Cao created an avatar named China Tracy. As she was drawn more deeply into this alternative reality, China Tracy morphed from a representation of an "every woman" passively observing the rituals of Second Life to a customized, proactive character who fell into an intense relationship with another avatar named Hug Yue. In his Second Life personal, Hug Yue appeared as a Chinese youth with long blond hair and the world-weary air of a Romantic era poet. In the video *i.Mirror* we see China Tracy and Hug Yue in various realistic and fantastic locations as snippets of their conversations about life, philosophy, and love scroll across the bottom of the screen. Eventually China Tracy and Hug Yue revealed their "First Life" identities to each other and it turned out that her paramour was a 65-year-old American communist activist.

TOP
Cao Fei, *i.Mirror by China Tracy (AKA Cao Fei), A Second Life Documentary Film*, 2007. Single-channel video with sound.

BOTTOM
Cao Fei, *RMB City 4*, 2007. Digital c-print; 47¼ x 63 in. | 120 x 160 cm.

i.Mirror took Cao Fei's longtime interest in role-playing to a new level. Instead of observing and documenting other people's fantasies and transformations, she here underwent her own. In an interview with curator Hans Ulrich Obrist, Cao described the complexity of this experience: "What's fascinating is that while the protagonist is me, it's not me at the same time, since I'm on the outside and the person in control. When I looked at 'China Tracy'

and 'hugyue' together, I felt like I was watching a movie. Yet the person engaging in dialogues is me." [4]

Many of the settings in *i.Mirror*'s virtual landscape have a dystopic air and echo the scenes of urban dislocation and anomie seen in *COSPlayers*. This led to Cao's next work, a new Asian island city the artist erected in Second Life. Named *RMB City* (a play on "renminbi," the official Chinese currency), it is composed of a collage of elements from contemporary China ranging from familiar stereotypes like a flying panda and a gesticulating Mao, half-sunk in the harbor, to landmarks referencing Chinese history and the country's current state of frantic development (opposite). Though the city exists wholly in Second Life, it is funded with real-life money by collectors who can lease various buildings and customize them as they like. Hence, in *RMB City* the contradictions Cao first sensed in the Pearl River Delta become the basis for a deliriously heterogeneous amalgam of socialism, communism, and capitalism.

Fantasy and role-playing are the subtext of nearly all Cao's works. She shares this interest with artists like Cindy Sherman and Yasumasa Morimura, but it is instructive to examine how greatly their approaches differ. In the older artists' "self portraits" they become chameleons, reinventing themselves in response to images from movies, pop culture, mass media, and high culture. In Cao's work, by contrast, role-playing becomes a social activity. She documents and then joins virtual communities bound by fluid and ever-changing social relationships.

Cao makes a distinction between the older notion of parallel universes that exist in alternate realities and the new possibility, fostered by the Internet, of parallel universes that inhabit the same reality. She both is and is not China Tracy. *RMB City* exists simultaneously in the virtual and in the "real" world where it is financed and supported by collectors.

There is another parallelism that runs through her work. As a contemporary Chinese artist, Cao is in an ideal position to survey the double-think that underlies the faux utopias of communism and capitalism. The failure of the promises of both ideologies drives the disaffection of global youth who trade public heroes for private ones and flock to the Internet for communities that offer a sense of belonging and purpose they find lacking in the non-virtual world.

Cao Fei presents a brave new world where dreams are no longer private affairs. There is both hope and caution in that fact.　　—ELEANOR HEARTNEY

[4] Cao Fei, "What's Next? Hans Ulrich Obrist Interviews Cao Fei," in *Cao Fei: Journey* (2007), 68, http://www.caofei.com/texts.aspx?id=42&year=2007&aitid=2.

NATHALIE DJURBERG

In Nathalie Djurberg's clay-animation videos, brusquely modeled Plasticine figures engage in all manner of physical congress, much of it violent and some of it very funny. Born in Lysekil, Sweden, in 1978 and now resident in Berlin, Djurberg focused during her schooling (at Hovedskous, in Gothenburg) on painting. That training is visible in her figures' clearly hand-modeled facture, which can be equated with a gestural expressionism—a kind of three-dimensional, live-action finger painting. But if her technique was, especially at first, deliberately childlike, it has grown increasingly sophisticated, as have the narratives it serves.

A brief, untitled video made when she was a student shows a limber, slender, scantily clad dancer stretching and exercising on the floor. "I do love you" appears written in crude letters on the wall behind her, as a monstrous figure enters and begins whipping her zestily. "Man, I killed him!" reads the next handwritten statement, though the victim is clearly female; this exclamation is followed by the remark, "It's ok, he's only clay." Despite its sketchiness, this video introduces characteristics that have been sustained throughout Djurberg's work to date: sordid and irresistibly charming, it invites us to laugh at an incident of frank brutality. It has the logic of a dream, insistent and inescapable, and—this feature especially has become more developed in recent work—implicitly political; if Gumby is one precedent, William Kentridge's loosely political animations are another. As in all of Djurberg's subsequent films, the characters are mute, but they are spoken for in occasional title frames and writings-on-the-wall which only magnify their powerlessness in the face of volcanic urges and dire predicaments. Not least, this early video introduces a concern with the question of what seriousness means in art—of what counts as a subject.

One way Djurberg has addressed this question is by having humans and other animals share the stage; she examines their relationships both from the point of view of humanity's inherent bestiality—understood, conventionally, to mean our lust, hunger, viciousness—and from the perspective of our physical domination. The ambiguity about whether the center of emotional gravity is in people or animals parallels a deliberate confusion between perpetrators and victims, for whom, she says, she has developed equal empathy. [1] Noteworthy, in this respect, is that aggression takes place in Djurberg's work among women as well as between sexes and species. And affection can break out at any time. The cheerily vulgar *Tiger Licking Girl's Butt* (2004; an instant YouTube classic, it follows an earlier, shorter video on the same theme) features a big, lithe feline that paces a pretty girl's bedroom,

[1] Talk at the New Museum, New York, May 3, 2012.

Why do I have this urge to do these things over and over again?

Nathalie Djurberg and Hans Berg,
Tiger Licking Girl's Butt, **2004.**
Clay animation, video with sound;
2:15 min.; edition of 6.

eying her as she towels off and then greedily licking her naked behind. Between every lick—the only sounds we hear are the cat's soft slurps and the girl's quiet "ahs"— a title frame appears, each time reading, "Why do I have this urge to do these things over and over again?" Ultimately, the cat leaps into her bed, where she joins him in happy resignation. The compulsive repetition to which the written phrase alludes is not just a psychological symptom played for laughs, it is also fundamental to the clay animation process, with its enormous demands on time and focus. But the repetition in this kind of animation is, of course, only approximate; in each new frame something changes, and the profound instability of the characters' identities and circumstances is more striking than the compulsive actions they can be said to result from, and sometimes represent.

If some of Djurberg's early videos are broadly comic, things take a decidedly darker turn with such works as *The Necessity of Loss* (2006; opposite), which involves a young girl and a figure resembling a Spanish conquistador. (Like most of Djurberg's videos since 2004, it features music by her partner, Hans Berg.) When the girl curls up in the man's lap, he thrusts her out, but that doesn't solve the problem of his arousal— nor does any amount of self-mutilation. Although he cuts off first his penis, then an arm, both legs, and finally his own head, the girl—victim? vixen? witch?—winds up, in a sexual frenzy, sitting on his face. The even more lurid *The Experiment (Greed)* (2009), begins with three richly clothed priests and a naked woman who crawls, increasingly exhausted, beneath first one cleric's robes and then another's; she takes brief comfort at last in the arms of a woman who shortly strips her of her flesh. In this longer work (it is roughly ten minutes long, to the earlier videos' five), the drama's developments include the unearthing of a lavishly proportioned woman who winds up suckling two tonsured

monks; spilling milk forms a pool in front of them that attracts a Bambi-like fawn, which laps it up. Djurberg works without storyboards, preferring to allow the narratives to take their own shapes, which contributes to the dreaminess (or nightmarishness) of the results.

As she has done several times before, including in *The Experiment* at the 2009 Venice Biennale where she presented a dense garden of sinister plants, Djurberg included sculpted figures in *The Parade*, first shown at the Walker Art Center in 2011 and then in 2012 at the New Museum in New York (p. 90). With this installation, the sculptures—over eighty life-size birds, including pelicans, flamingos, turkeys, eagles, a dodo, and a snowy owl—take center stage. Made of wire, foam, silicone, painted fabric, and clay, and sporting glorious plumage, curving beaks, glittering eyes, and sharp claws, they raise their wings, twist their necks, groom and alight on each other. Often their mouths are open, voraciously.

In a talk at the New Museum, Hans Berg noted that viewers of the installation, looking around inquisitively, resemble the birds that look back at them. For her part, Djurberg said these birds are the shell of experience, the surface content of the five videos (all 2011) that serve as *The Parade*'s subconscious. One features a wide-eyed black woman on a sunbaked desert, beset by snakes and a handsome devil. In another, a Dracula-like figure swaps identities with a crocodile; together they excavate a giant egg from the multicolored depths of an unpromising hill. In

Nathalie Djurberg and Hans Berg, *The Necessity of Loss*, 2006. Clay animation, video with sound; 4:12 min.; edition of 4.

the third, a thumb-sucking, skeletal baby is comforted by a big, gorgeous pelican, which chases a window, drawn in chalk, that flits around the room in which they're confined; ultimately, the bird carries the baby off through the illusory aperture. The fourth video features a trio of kerchief-capped peasant women who, like the witches in *Macbeth*, stir a cauldron of venomous-looking brew; soon, they are drawn into a grotesque ecstasy of consumption. Most complex is *I Wasn't Born to Play the Son*, in which men dressed in waistcoats, breeches, and bird masks walk around and over a prostrate woman's body. Advising her to close her eyes and relax, and promising it won't hurt, they slowly dismember her, as blood spurts in riots of color from every joint. Like Serge Diaghilev's landmark 1917 bal-

BELOW TOP & BOTTOM
**Nathalie Djurberg and Hans Berg,
Parade of Rituals and Stereotypes,
2012.** Clay animation, video with
sound; 10:56 min.; edition of 4.

let *Parade* (which featured music by Erik Satie, costumes by Picasso, and a scenario by Jean Cocteau), Djurberg's multi-dimensional project evokes the barely controlled advance team of a traveling circus, in a spectacle both clamorously compelling and deeply disturbing.

A video made for the New Museum exhibition, *The Parade of Rituals and Stereotypes* (2012; below), begins with a white-robed princess crowned with a

ring of candles. Three wigged judges appear, and then a red-skinned devil, who snips the white gown to expose the princess's breasts and then gouges out her eyes. A trio of bishops carries away the corpse, their expressions varying from remorse to sparkly-eyed greed. What follows is indeed a parade of rituals and stereotypes: priests and whores, marching-band drummers, and judges both robed and naked are among those who strut through the shallow stage. An anorexic showgirl staggers by and is sodomized by one of the judges; top-hatted black men in fancy dress are clubbed by white-draped Klansmen; emaciated figures grub for root vegetables in tarry dirt; an obese woman with grotesquely big breasts nurses the famished showgirl. Intermittently, the judges repair to their bench, and hold up scorecards rating the characters that pass before them. It is a morality play as told by a court jester, cheerfully vicious and as sly as it is crude.

Because of its use of torn-apart and reassembled figures that resemble dolls, Djurberg's work has been compared with Hans Bellmer's *poupées* of the 1930s. But there's little of the German artist's airless brooding in her work, which favors the ravenous, remorseless appetites characteristic of children over

the more rarefied tastes of adults and strikes an impossible balance between juve-
nilia and eroticism, gimlet-eyed innocence and utter cynicism. One thinks of the rib-
ald and often deceptively comic-bookish paintings of Peter Saul, John Wesley, Carroll
Dunham, and Steve Gianakos; the sculptural animal-human hybrids variously fash-
ioned by Kiki Smith, Rona Pondick, Stephan Balkenhol, and Anne Chu may also come
to mind. Djurberg's own references include Chris Burden's unrelievedly grim early
work, as when he had himself shot, or crawled across glass. She has also noted, as a
formative experience, that when she was twelve years old a girl brought a hardcore
porn film to a biology class, which was screened with the teacher's permission. Early
exposure to just about everything is surely a hallmark of Djurberg's generation, and
she captures with precision the complicated appeal of watching dangerous-looking
behaviors that don't yet quite make sense. In fact, her Grand Guignol comedies leave
us in just that position, queasily engrossed by a sweetly nonsensical maelstrom of
mostly female figures variously penetrated, flayed, eaten, and torn limb from limb.

— NANCY PRINCENTHAL

PIPILOTTI RIST

Pipilotti Rist, *Pour Your Body Out
(7354 Cubic Meters),* **2008.
Multi-channel video installation
with sound, projector enclosures,
circular seating element, and
carpet.** The Museum of Modern
Art, New York; Commissioned
through the generosity of UBS, the
Wallis Annenberg Fund for
Innovation in Contemporary Art,
Marie-Josee and Henry Kravis,
Maja Oeri and Hans Bodenmann,
Jerry I. Speyer and Katherine G.
Farley, Franz Wassmer, Monique
Barbier-Mueller and by Pro
Helvetia, Arts Council of
Switzerland.

WHEN NEW YORK'S MUSEUM OF Modern Art opened its new building in 2008, topping the list to inaugurate the grand atrium was Swiss artist Pipilotti Rist. Rist was a brilliant selection for an institution not lauded for its support of women artists; her subsequent multi-projection commission, *Pour Your Body Out (7354 Cubic Meters)* (opposite), bathed the atrium in a soft pink glow, like a womb at the center of massive masculine structure. Measuring twenty feet high and comprised of seven projectors, the video surround offered a seamless and elliptical narrative that encircled the viewer in a hallucinatory wash of light, color, and images.

The projected images were gigantic. A naked woman crawls through the grass; in extreme close-up shots, her painted fingernails look like moving eyeballs. A black-spotted pig careens across the countryside, roots around, and edges his snout towards the camera, sniffing, slobbering, and engulfing the lens. The woman and pig gorge on apples, perhaps partaking of the apple of knowledge. Colors billow up and gently fall back down, flower petals drift against a bright blue sky, the woman floats in a pond. A giant hand, dirtied by soil, picks up a worm. The viewer is the worm, seeing the world from a worm's-eye view. This might be the dark side of Eden.

Rist rarely presents her videos in the traditional format (i.e., viewer watching moving images in a box), and *Pour Your Body Out* is no exception. Not surprisingly, a primary influence on Rist was Nam June Paik, one of the earliest practitioners to explore the sculptural possibilities of video art. "We both try to draw the viewer inside it," Rist has said. "At first you look at the box, behind the glass, within the wall. Reconquering the space inside the TV set: that's one of my aims as well." [1]

Rist encouraged non-traditional museum behavior in her installation design for *Pour Your Body Out.* The floor was covered in a plush carpet; in the middle sat an outsized round sofa, which, black in the center and circled with white, resembled an unblinking eye staring up at the ceiling. Viewers lounged on the sofa, rolled around on the carpet, did yoga, or napped. Contrary to the casual appearance, Rist was in control of the viewers' experience, transforming them from observer to participant through deep immersion, drawing them inside her head, inside her dream. This fusion of the projected image within an environment, the manner in which she intertwines external and internal experience, and the physical insertion of the viewer within the work is a leitmotif for Rist.

Born in 1962 in Grabs, Switzerland, Rist was christened Elizabeth Charlotte. In 1982, she changed her name to Pipilotti, combining her childhood nick-

[1] Pipilotti Rist, interview by Hans Ulrich Obrist, in *Pipilotti Rist* (London: Phaidon, 2001), 15.

Pipilotti Rist, *I'm Not the Girl Who Misses Much*, **1986.** Single-channel video with sound.

name Lotti with the Swedish storybook heroine Pippi Long-stocking, a precocious character with superhuman strength and a Peter Pan complex. Like Longstocking, Rist is not bound by convention. She once told an interviewer who was questioning her about unrealized projects that she wanted "to live in your nose." [2] The worlds she envisions are fantastical and dreamlike, effortlessly shifting in scale, focus, and tempo.

Rist attended the University of Applied Arts in Vienna (1982–86) and studied video at the School of Design in Basel, Switzerland (1986–88). Part of the rock band Les Reines Prochaines from the late 1980s to the mid-'90s, Rist was immersed in a culture of experimental music and the recent phenomenon of music videos (MTV was first broadcast in 1981), all of which informed her early work. The music of John Lennon led to her important discovery of the performances, films, and music of Yoko Ono. "In my village in Switzerland I had a small window on the art world through the mass media; through John Lennon/Yoko Ono I moved from pop music to contemporary art," she said. "It was through my interest in mass media that I became involved in art." [3]

The student work *I'm Not the Girl Who Misses Much* (1987; above) depicts Rist wildly dancing, in a state of dishabille, naked breasts hanging out of her short dress. As she spasmodically jerks to a distorted rendering of the Beatles' "Happiness Is a Warm Gun," Rist co-opts Lennon's line, "She's not a girl who misses much" as her own, claiming, "*I'm* not the girl who misses much." She sings the line repeatedly with the track at warp speed, making her voice squeaky and cartoonish. The imagery and soundtrack are also distressed and distorted, going in and out of focus, as the video morphs from black and white to red, with lines periodically disrupting the image. The imagery matches the method; both border on hysteria. There is a brief respite in which Lennon's voice, in contrast, gently sings the original tune, Rist's wink to the viewer of her source. Pitched somewhere between comedy and nightmare, Rist's video challenges clichéd representations of women often found in music videos, then and now. Her character, though she appears out of control, actually dominates the situation.

Another early video, *(Absolutions) Pipilotti's Mistakes* (1988; opposite), which has not been shown publically, reveals the seeds of her mature work, particu-

[2] Ibid.

[3] Ibid., 16.

larly the way Rist taps into psychological elements of personal insecurity and nightmares, like finding oneself naked on a bus, or back in school squeezed into a desk that is too small. In a twelve-minute sequence, set to a soundtrack of drum beats and occasional staccato music, Rist is shown falling in a field, a lawn, a parking lot. She is also seen swimming in a pool where a disembodied hand continually pushes her underwater, or offers her help out of the water only to release her back into the pool. The video is interspersed with abstract rolling bands of color and pulsating squares of color.

Rist first won worldwide acclaim, and the Premio 2000 Award, at the Venice Biennale for her overlapping dual-video projection *Ever Is Over All* (1997; overleaf), for which Rist co-wrote the music with her collaborator Anders Guggisberg. On one side of the projection, a young woman dressed in a blue tea dress and red shoes skips down the street, joyfully smashing car windows with a metal rod in the shape of a long-stemmed flower. A second, overlapping projection offers a close-up of Rist's "weapon," a flame-red flower atop a pale green stalk—a flower known as a redhot poker. The redhot poker, filmed in close-up, rotates in surreal slow motion, floating against a bucolic green field. As the young woman dances down the street, pausing

Pipilotti Rist, *(Absolutions) Pipilotti's Mistakes ([Entlastugen] Pipilottis Fehler)*, **1988.** Single-channel video with sound.

**Pipilotti Rist, *Ever Is Over All*, 1997.
Video installation with two
overlapping projections; sound
with Anders Guggisberg.**
Installation view, Kunsthalle Zurich.

only to smash another window, a policeman slowly approaches from behind. The
viewers steel themselves for the confrontation, but as the uniform closes in, one
realizes it is a policewoman, who salutes as if condoning and even encouraging the
transgression. The reading is straightforward and humorous. The benign flower has
magically been imbued with a strength which the heroine uses to destroy the ma-
chine, here not only a symbol of capitalism but of masculine power. In Rist's world,
the uniformed symbol of authority is female. The viewer completes the triangle, a
complicit voyeur.

Pipilotti Rist, *Selfless in the Bath of Lava (Selbstlos im Lavabad)*, 1994. Single-channel video with sound.

In another early work, *Selfless in the Bath of Lava* (1994; left), Rist shifts scale as a way to further explore modes of perception while expressing her own sense of humor and bizarre take on the world. A tiny video screen inserted in the floorboards is a permanent installation at MoMA PS1 in New York. In this miniscule presentation, which could easily be missed by the museum visitor, a naked Rist, like a tiny figure from a Bosch painting, reaches up to the viewer out of a flowing pool of burnt orange molten rock. She first exclaims, "I am a worm and you are a flower," and later repeats the words, "excusez-moi," either an attempt to get the attention of the viewer or apologizing for her presence, or both. Almost fifteen years later, Rist reverses the dynamic, shrinking the viewer and radically expanding the image in *Pour Your Body Out*.

Rist's venture into commercial film work, *Pepperminta* (2009), a feature about the transformative possibilities of color, was disappointing. *New Yorker* critic Peter Schjeldahl noted, "*Pepperminta* presents a squirmy spectacle of actors who are visibly baffled, though game, by what is expected of them." [4] Perhaps the constraints of narrative inherent in feature-length films limited Rist's normally fluid approach. Her 2010 installation *Heroes of Birth* at Luhring Augustine Gallery, New York, a year later, showed her back in form. It featured projections of green mountains and grazing sheep interjected with computer animations projected on scrims hanging throughout the gallery through which viewers walked, experiencing the hallucinatory yet personal spaces she created.

Rist's place in the evolution of video art, particularly as it relates to women, their bodies and their psyches, cannot be underestimated. "Emerging out of a complex narrative moment in video art at the end of the 1980s," Chrissie Isles observed, "her installations internalized both an engagement with the politics of the female body, landscape, fairy-tales and myths, and the use of tableaux that combined projections and video monitors with objects such as domestic furniture, tree branches, clothing and books." [5] By turning video inside out, Rist projects her particular quirky view of the world, a view which remains open-ended and expansive. As she famously observed in comparing the medium to a woman's handbag: "Inside there is room for everything, painting, technology, language, movement, lousiness, poetry, commotion, premonition, sex and friendliness." [6] —SUE SCOTT

[4] Peter Schjeldahl, "Feeling Good, The Art of Pipilotti Rist," *New Yorker*, September 27, 2010, 88.

[5] Chrissie Isles, "You Are a Queen: The Selfless Spaces of Pipilotti Rist" in *Pipilotti Rist: Eyeball Massage*, ed. Stephanie Rosenthal (London: Hayward Publishing, 2011), 106.

[6] Obrist, 19.

JANE & LOUISE WILSON

Jane and Louise Wilson, *Stasi City
(Operating Room)*, 1997. C-print on
aluminum; 108 x 108 in. | 274.3 x
274.3 cm.

IN THE FINAL SCENES OF the gripping film *The Lives of Others* (2006), [1] Georg Drey-man, a successful playwright and dedicated communist living in recently-liberated East Berlin, discovers that he was the victim of intense surveillance by Stasi intel-ligence during the Cold War. Eager to learn the extent of the surveillance, he visits the building containing the Stasi's archive, which was made public after the fall of the Berlin Wall, and is staggered when a clerk wheels out his personal files stacked high and deep on a cart. As Dreyman reads the incredibly intimate account of his life detailed over several years, the camera lingers on his face. The audience shares in the moment of his shock as he discovers just how invasive the Stasi were.

This devastating moment of realization, condensed into a single emo-tionally-charged image in which the past is brought into focus, is at the heart of Jane and Louise Wilson's art. Because they work primarily in video, documenting set-tings that have a dark and often mysterious history, the Wilsons' work is sometimes discussed in terms of popular film; they have been compared to filmmakers ranging from Alfred Hitchcock and Roman Polanski to David Cronenberg and Chantal Aker-man. However, their style is really an amalgamation of Hollywood, horror, documen-tary exposé, and surveillance. Louise Wilson once compared the impact of their video installations with the experience of leaving a movie theater on a cold winter day: "You emerge into darkness afterwards with all these images in your head," she said, "and it is as if time and space has shifted slightly." [2]

In his essay "V.I.: Jane and Louise Wilson," art critic Peter Schjeldahl argues that the Wilsons are not filmmakers as much as they are pioneers of video installation, two of the most vital contributors to the medium since Bruce Nauman began making video installations in the 1960s. [3] And, indeed, their work pushes the boundaries of video with their combination of multi-screen projections, sculptural objects, and related photographic works, creating an environment that emotionally if not physically replicates the experience of a place haunted by its history.

The Wilsons, who are twins, grew up in Newcastle-upon-Tyne, Eng-land. Their father was a naval architect who often took them to the boatyard to see the results of his designs. They attended different colleges, Louise graduating in 1989 with a BA from Duncan of Jordanstone College of Art and Design, Dundee, and Jane that same year with a BA from Newcastle Polytechnic. They collaborated on their thesis shows, both exhibiting a series of identical black-and-white photographs that capture the sisters in charged scenes of attempted homicide: in one image, one of

[1] Directed by Florian Henckel von Donnersmarck, and set in 1980s Berlin.

[2] Tim Adams, "Jane and Louise Wilson," *Guardian*, October 10, 1999.

[3] Peter Schjeldahl, "V.I.: Jane and Louise Wilson," in *Jane and Louise Wilson: Stasi City, Gamma, Parliament, Las Vegas, Graveyard Time* (London: Serpentine Gallery, 1999), 3.

Jane and Louise Wilson, *Gamma: Operations Room*, 1999. C-print on aluminum; 71 x 71 in. | 180.3 x 180.3 cm.

the twins attempts to drown the other—in another, one tightens a noose around the other's neck. The sisters went on to attend Goldsmiths College together, where they graduated with MFAs in 1992, and have since lived and worked together in London.

From the first, the pair was drawn to interiors as subject, perhaps a result of their lifelong exposure to their father's architectural drawings. Among their initial projects together were large-scale photographs of the inside of their flat, and later the interior of a dilapidated bed-and-breakfast in their neighborhood. *Hypnotic*

Suggestion 505 (1993), which was included in the group show *Beyond Belief* at Lisson Gallery in 1994, marked their debut into the London art world. The video shows the sisters in an actual session of hypnosis and reveals their uncanny psychic connection; when the hypnotist instructs each woman to touch her own face, they simultaneously reach out and touch the face of the other. The piece "started with a quote from Cocteau," Louise notes, "about all cinema being a form of mass hypnosis." [4]

Like Michel Foucault, whose name is often invoked in critical assessments of the pair, the Wilsons are interested in architecture—specifically, buildings that house modern institutions—as an instrument of power. As their work has evolved, they've come to focus on historical sites or events symbolic of particular ideologies or abuses of this power. With the video installation *Stasi City* (1997), the Wilsons garnered international attention. Their first challenge in making the work was to gain access to the former Stasi headquarters in East Berlin, which was rendered powerless with the fall of the Berlin Wall. The title of the piece was inspired by a West German journalist who, upon visiting the site, was amazed by the extent of the sprawling complex, which was tucked into a suburban neighborhood whose inhabitants had no idea of what went on behind the gates. With their interest in the history of place, the Wilsons hit a bonanza with the Stasi headquarters and its layered and nefarious background. Prior to its role as Stasi headquarters, it had been a Nazi catering depot and then a Russian internment camp under Stalin.

Like archaeologists walking into an untouched tomb, the pair found "rooms full of files that existed in limbo; doors that had not been opened since the Wall came down" [5] and used their camera to document and detail their findings. The resulting video and series of photographs may at first appear benign but the implications of their quiet details are terrifying—the monitor room with banks of old fashioned televisions, interior corridors with rows upon rows of double doors, the interview room with a single tan chair flanked by two chairs with magenta upholstery, positioned as if an invisible interrogation were taking place. For the installation, the Wilsons included a sculpture of the padded doors; curiously, the interrogation rooms were not soundproofed and the pads were more about intimidation than function, "like bureaucratic theatre," Louise concludes. [6]

The photograph *Operating Room* from *Stasi City* (1997; p. 102) is as chilling as the pale blue tiles that line the walls of the room. Large chunks of paint have peeled off the ceiling and crumbled to the floor. A giant reflective light, like

[4] Jane and Louise Wilson, "We Are a Camera," interview by William Leith, *Independent*, August 29, 1999.

[5] Adams.

[6] Leith.

those used during medical operations, glares at the viewer as it once illuminated the procedures one can imagine having taken place there. Although the Wilsons have been accused of filming sets that appear staged, it is crucial to their concept that they document what they have found as they have found it. There is, however, an unmistakable sense of drama to their installations, which has much to do with a careful attention to scaling and a use of perspective that positions the viewer in the center of the spaces depicted.

For their next major work, *Gamma* (1999; p. 104), first shown at Lisson Gallery, the Wilsons looked for another location whose original purpose, once mysterious and powerful, had become outmoded and forgotten. They found it close to home in Greenham Common, a former Royal Air Force station in Berkshire, England, co-operated by the US Air Force, that housed nuclear missiles during the Cold War. The site was decommissioned in 1992, long after a Soviet nuclear threat had passed, and had since sat empty.

Gamma has the same ominous sensibility as *Stasi City*, with its images of control panels, decontamination chambers, and empty silos. Whereas the imagery in *Stasi City* was mostly focused on the empty building, a human presence activates the spaces in *Gamma* by dramatizing the site's daily activities in scenes that are at once mundane and highly charged. Characters in authentic uniforms fill in giant secret logs in the command center or stand at attention in mirrored repetition. One photograph from the series features a close-up of a hand, its fingers poised at the ready above a row of lighted buttons.

In 1999, the Wilsons were shortlisted for the Turner Prize and given a solo exhibition at London's Serpentine Gallery, which included *Stasi City*, *Gamma*, and a new commissioned work, *Parliament (A Third House)* (1999). For *Parliament*, they filmed the corridors and basements of the House of Commons and the House of Lords during recess. While this august institution may be more benign than a nuclear silo or East German prison, its details—the ornate woodwork, privately designated phone booths, and symbolic colors—nevertheless speak of history, ritual, and secrecy. "Although they weren't originally planned as such, *Stasi City*, *Gamma* and *Parliament* form a kind of trilogy of related works," observed Lisa Corrin, the curator of the Serpentine's exhibition. "Power is revealed and concealed within architectural details and in the codes that regulate the external, public workings we see, as well as those that only insiders can manipulate." [7]

[7] Lisa Corrin, "In Stereoscopic Vision: A Dialogue between Jane & Louise Wilson and Lisa Corrin," in *Jane and Louise Wilson* (1999), 10.

Jane and Louise Wilson, *Platform II, Gorilla VI—A Free and Anonymous Monument*, 2003. C-print on aluminum; 71 x 71 in. | 180.3 x 180.3 cm.

For *A Free and Anonymous Monument* (2003; left), they turned their attention away from institutional expressions of power to consider the legacy of modernist architecture and its failed utopian ideals. The installation was centered on the Apollo Pavilion, which was designed by Victor Pasmore and built in 1958 in North East England, not far from where the Wilsons grew up. Pasmore, an artist and architect known for his murals of architectural scale, designed the concrete and steel structure for the town of Peterlee, which was built as part of a British post-war planning initiative intended to encourage manufacturing in struggling areas. The bridge-like structure of the pavilion was designed as a central gathering place for the community, meant to embody and promote a utopian ideal of multi-use public space. But the structure received a cool reception and sat neglected and covered in graffiti, a modern day folly of public art and planning, until in recent years when it was restored through public funding.

The installation for *A Free and Anonymous Monument* was a complex environment comprised of thirteen large-scale projections shown on architectural components that echoed the pavilion. The effect was one of impressive immersion, with the video projections ingeniously extending the pavilion's architectural surfaces to help recreate the experience of walking through Pasmore's structure. Scenes of the pavilion were juxtaposed with images of other run-down modernist and post-industrial sites— an engine factory, a vacant parking lot in nearby Gateshead, and an oil rig—that together evoked both the original optimism with which they were built and the creeping failure of their subsequent decline.

The Wilsons cite Stanley Kubrick as an important influence on their cinematic sensibility ("He's somebody for whom every other frame is a still."). [8]

[8] Jane Wilson, quoted in Louisa Buck, "Stanley Kubrick's Photographs Brought to Life by Jane and Louise Wilson," *Art Newspaper*, February 11, 2009, http://www.theartnewspaper.com/articles/Stanley%20Kubrick's%20photographs%20brought%20to%20life%20by%20Jane%20and%20Louise%20Wilson/16943.

Jane and Louise Wilson, *Unfolding the Aryan Papers*, 2008. Single-channel video installation with sound and three walls of mirrors; 17:48 min.

Like the sisters, he also embarked on extensive preliminary research for each of his film projects. In 2008 the Wilsons were given ten days of access to Kubrick's archives, which are housed at the London College of Communication. Given their limited time, they focused on one of Kubrick's unrealized project, *Aryan Papers*, which tells the story of a young Jewish boy who was hidden by his aunt during the Holocaust. Though Kubrick worked on the film for close to twenty years off and on, he abandoned it in 1993. No one knows exactly why Kubrick stopped work on *Aryan Papers*, although it has been speculated that the release of *Schindler's List* that same year had something to do with it. Moreover, the research was highly personal and emotional for Kubrick, whose own family was victimized during the Holocaust.

Rather than restage the narrative of Kubrick's film in *Unfolding the Aryan Papers* (2008; left), the Wilsons focus on the experience of Johanna Ter Steege, the actress originally cast as the lead in Kubrick's film, who collaborated with the Wilsons on their project. In the single-channel video, which is made more complex in installation by three walls of mirrors that repeat the video infinitely, a prism of memory is evoked through new photographs of Steege in wardrobe that are based on original production photographs, as well as shots of Steege reading from the original script and speaking about her work with Kubrick. The work becomes a kind of performative excavation and reinterpretation of Kubrick's archive, which to begin with entailed a complicated and extremely personal mediation of his original historical sources.

Face Scripting, What Did the Building See? (2011; opposite), was made in collaboration with the architectural theorist Shumon Basar and facial recognition specialist Eyal Weizmanset, and revolved around the 2010 murder of Mahmoud Al-Mabhouh, a high-level Hamas operative. Filmed in the Dubai hotel where Al-Mabhouh was killed, the work is primarily an investigation of the hyper-surveillance surrounding the event, specifically the use of "face scripting" technology, which identifies people by charting the distance between a person's eyes, nose, and mouth.

As the camera flickers and then slowly pans the interior and exterior of the hotel—the revolving doors, hallways, tennis courts, and private rooms—the

Jane and Louise Wilson, *Face Scripting, What Did the Building See?*, 2011. Video projection, gauze box, screen, and mirros; 11:39 min.

scenes are juxtaposed with images of the two Wilsons with white tape on crucial parts of their faces—a camouflage which can confound the face scripters. A voiceover narrated by actor Nadim Sawalha ricochets between descriptions of the murder and mysterious statements about the "architecture of the face," as he compares eyes to windows and the nose to a bridge and talks of ways of disguising the face.

The Wilsons use the camera to scrutinize what buildings and structures tell of a culture—an investigation that keeps their work open-ended. Think of the plight of the character Georg Dreyman, a committed communist living in East Berlin, who is nevertheless a victim of the state. Is this something that happens only in the past? Through the Wilsons' lens, in the modern day world of constant but unseen surveillance, paranoia may be justified and everyone is a potential victim. In focusing on sites of institutional control from the recent past, their work suggests something ominous about similar, as yet unknown abuses of power happening today.

When asked by an interviewer why they are drawn to the "darker side of human experience," the artists invoked Cindy Sherman, who said, "In horror stories or in fairytales, the fascination with the morbid is a way to prepare for the unthinkable." [9] It may be unthinkable, but as the Wilsons show, the unthinkable can happen.

—SUE SCOTT

[9] Stephanie Cotela Tanner, "Artists Jane and Louise Wilson Investigate Kubrick," *Dazed Digital*, May, 2010, http://www.dazeddigital.com/artsandculture/article/1942/1/artists-jane-and-louise-wilson-investigate-kubrick.

LISA YUSKAVAGE

Lisa Yuskavage, *The Gifts*, 1991. Oil on linen; 30 x 26 in. | 76.2 x 66 cm.

I want to expose a specific frame of mind that I have experienced as female: the flight from reality through wallowing in one's fantasies and suffocating in the sticky, candy flavored sentiment that springs up around this state of mind. It's an extreme case of vertigo—the fear, not of falling but of the knowledge that you want to fall.

—LISA YUSKAVAGE [1]

FOLLOWING A SOLO SHOW IN Los Angeles in 1994, Lisa Yuskavage got the kind of review that would cause many young artists to curl up in a fetal position and eat a quart of ice cream. *Artforum* critic Lane Relyea castigated her for "mak[ing] a travesty of the medium" of painting, for her work's "icky pandering" and its "hamfisted treatment." He also took aim at any viewers foolish enough to defend her work, noting that the paintings are "scandals, visual stink bombs launched for the sole purpose of watching the rationalizations fly by." Worse, he described their appeal to "a power hungry gaze, one that demonstrates its might in a single violent gesture, at once caricaturing women in ideological shorthand and raping them." [2]

From the perspective of Yuskavage's now well-established career, which includes solo shows at numerous prominent institutions worldwide and a devoted critical following, this review appears a bit overheated. But it also puts its finger on some of the most important issues surrounding her work. Yuskavage is celebrated and vilified for figural paintings that are at once part softcore porn, part Maxfield Parrish kitsch, and part medley of art-historical references. She has been praised for the almost ethereal luminosity of her paint and the seductiveness of her candy-like colors. She has been condemned for the politically incorrect nature of her representations of the female nude. Yuskavage herself takes a sanguine approach to the controversy her work engenders, remarking that "I've always known you don't change the world through painting. I think that's part of the reason why I allow myself to take such liberties." [3]

These liberties take the form of a cartoonishly exaggerated presentation of the blossoming bodies of adolescent and pre-pubescent girls. For Relyea, such representations are grotesque capitulations to the male tendency to objectify women, made more reprehensible by the fact that their creator is female. But for others, the case is not so simple. Critic Peter Schjeldahl, who has been a proponent since early in her career, notes of Yuskavage's subjects, "They seem nice sorts who

[1] Lisa Yuskavage, "The Question of Gender in Art," *Tema Celeste*, no. 37 (Autumn 1992): 70–71.

[2] Lane Relyea, "Lisa Yuskavage," *Artforum* 33, no 4 (November 1994): 92.

[3] Lisa Yuskavage, "What Kind of Thing Am I Looking At?" interview by Jayson Whitehead, Gadfly Online, April 1998, http://www.gadflyonline.com/archive/April98/archive-yuskavage.html.

have sexuality like others have Ebola virus." [4] Or, to paraphrase the curvaceous cartoon character Jessica Rabbit: They're not bad. They're just drawn that way.

As Yuskavage's career has progressed, it has become clear that her work is less another iteration of the rebellion against political correctness than an exploration of a uniquely female psychological territory. From early works that tended to feature lone nudes in ill-defined and abstracted settings, she moved on to tableaux that combined (mostly female) subjects, and placed her Lolitas alongside still lifes in domestic interiors or within fully-realized landscapes whose every detail seem a projection of their interior emotions and states of mind. She has even, in one monumental triptych from 2011, created a scenario that she describes as an homage to Freud's tri-part model of human psychology.

Yuskavage's self-described embrace of "bad taste" has its roots in biography. Born in 1962, she grew up in a Catholic working-class neighborhood in Philadelphia. Among her early influences she cites both Catholic holy cards and devotional art, whose depictions of Christ with radiant curls and a bleeding heart struck a deep chord, and a copy of *Penthouse* she found and treasured. She also was affected by a junior year abroad in Rome in which she haunted museums and churches in her private version of the Grand Tour. This mingling of sacred and profane laid the groundwork for an imagination that effortlessly fuses kitsch and sublimity, creating an artistic persona she sums up as "poor white trash girl loves Italian Renaissance." [5]

In 1986, after receiving her undergraduate degree in art from Tyler School of Art in Philadelphia, Yuskavage arrived, improbably, at Yale. This graduate department was and arguably still is the pinnacle of American art schools, and Yuskavage found herself suitably intimidated. She was consumed by a desire to fit in that dogged her through graduation and into her first solo show in New York two years later in 1990. Walking into the show, a series of paintings of women's backs, she realized how much she hated her work's reticence and decorum. Her husband suggested that she exchange her mild art with her more abrasive personality, and the result was her first mature work, a painting titled *The Gifts* (1991; p. 108). It presents a frontal-view female nude with huge breasts, bound arms, and a corsage stuffed into her mouth. Yuskavage has confessed that her aim here was to approach painting through the eyes of the Dennis Hopper character in *Blue Velvet*. [6]

This work freed Yuskavage to pursue the mix of provocative subject matter and ever-more masterly painting that have become her trademark. At first

[4] Peter Schjeldahl, "Purple Nipple," *Village Voice*, September 29, 1998: 138.

[5] Yuskavage with Whitehead.

[6] Lisa Yuskavage, interview by Mónica de la Torre, *Bomb*, no. 117 (Fall 2011): 117.

she worked purely from the imagination, and then, feeling the need for more struc-
ture, from sculpted maquettes, life models, and photographs. She also began to ex-
plore the psychological dimensions of light. A pair of paintings from 1999 reveal her
development. The poses and exaggerated breasts and buttocks of the scantily clad
women in *Day* and *Night* (above) are drawn from *Penthouse* magazine; however, the
theatrical light and the figures' air of unselfconscious reverie set them apart from
the clinical exhibitionism of their sources.

Works like these did little to resolve the critical debate surrounding
Yuskavage, which continued to be dominated by either-or questions such as: Are
these young girls mere fodder for the male gaze or do they represent an effort to
reach inside the female psyche and explore young women's often contradictory at-

titudes toward their own bodies? Is Yuskavage exploiting or upending the venerable tradition of the female nude? Is she challenging or complicit with the dominant patriarchal order? Yuskavage herself avoids talking about her work in these terms. Instead she has argued that she draws from her own inner conflicts, noting to one interviewer, "I don't work from an elevated place looking down; if they are low, then I am in the ditch with them and by painting them I am trying to dig us out together." [7]

As time went on her scope of references began to widen. Works like *Brood* (2005–6; opposite) pay homage to the still-life tradition—again veering disconcertingly between the grand allegorical tradition of the Dutch still life, with its coded symbols of death, decay, and fecundity, and the pretty banality of calendar art. In this work, as in several closely related paintings, the swollen breasts and belly of a young woman in the background visually and thematically rhyme with the rounded offerings of the fruit platter in the foreground, turning both into a meditation on the melding of fertility and eroticism.

Other works from the mid-2000s introduce multiple figures. Here again they are open to multiple interpretations. Pairs of women of varied ages cling to each other in poses that are both protective and potentially sexual. In *Imprint* (2006; left), for instance, a young woman sits on an older woman's lap. The two clutch each other with a ferocious intimacy and the pressure of their figures on each other's flesh bears out the implications of the work's title. As in other works from this period, there are subtle classical allusions to artists like Bernini whose sculptures present similarly twisting figures caught between eroticism and vulnerability.

In 2012 Yuskavage presented her most ambitious works to

[7] Lisa Yuskavage, interview by Claudia Gould in *Lisa Yuskavage*, ed. Marcia B. Hall and Katy Siegel (Philadelphia: Institute of Contemporary Art, 2000), 10.

Lisa Yuskavage, *Afternoon Feeding*, 2011. Oil on linen; 86 x 71 in. | 218.4 x 180.3 cm.

date. These place her nubile young women within expansive landscapes haunted by ghostly background figures reminiscent of the sturdy Russian peasant women more commonly found in Soviet Socialist Realist paintings. In the context of these works, the older women suggest intrusions from history into an otherwise time-less landscape of sensual pleasure. Yuskavage has reported that one monumental three-panel work, titled *Triptych* (2011) became, as she worked on it, an allegory of the Freudian partition of the psyche. Set in a great plain against distant mountains and saturated in lime green light, the first panel of the painting presents a young girl lying on the ground sucking a lollypop in the middle distance—a representation, according to Yuskavage, of the ego. In the center panel, close to the viewer, is a view into the crotch of another girl splayed on a table above a pile of tools representing the unused tools of reason. She is the unconscious id. And in the last panel we see a forbidding row of dour peasant women in the distance, Yuskavage's representation of the inhibitory super ego. Together they create a striking visualization of the con-flicting forces that shape the human personality.

The overt symbolism in *Triptych* is unusual in Yuskavage's work; how-ever some of its elements appear in other contemporaneous paintings. In *Afternoon Feeding* (2011; opposite), for instance, one naked young girl offers another a cluster of grapes while spectral peasant women stand like sentinels in the background. Here the playful sensuality returns as the girls' voracious appetites all but blot out the stern moralists behind.

And this seems the ultimate message of Yuskavage's work. She has remarked that the ability to be an adult and to still be able to play is her idea of heaven, noting, "We have so much order, whether it's Santa Claus, the Pope, God or whoever—all these long beards—saying 'No.' No to being a woman, no to having sex, no to being juicy." [8]

Instead, Yuskavage offers a resounding yes.　　　—ELEANOR HEARTNEY

[8] Lisa Yuskavage, interview by Sabine Heller, *Purple Fashion Magazine*, no. 18 (March 2012): 208–15.

DOMESTIC DISTURBANCES

by Sue Scott

OPPOSITE
Susan Frazier, Robin Weltsch, and Vickie Hodgett, *Nurturant Kitchen* from *Womanhouse*, 1972.

BELOW
Sandra Orgel, *Linen Closet* from *Womanhouse*, 1972.

THE MEANING AND RESPONSIBILITIES of home and family are issues that women artists have probed for years with varying degrees of acceptance and resistance. In literature the domestic sphere has often been portrayed as either a prison or a sanctuary. On one side there is Ibsen's Nora, who could find herself only by leaving home. On the other is Emily Dickinson, who discovered creative freedom by removing herself from the world. The feminist cry of the 1970s, "The personal is political," was an effort to resolve these contradictions.

One of the most ambitious responses to the dilemma was *Womanhouse*, a project initiated in 1971 by Judy Chicago and Miriam Schapiro as part of the Feminist Art Program they founded at the California Institute of the Arts (CalArts) (opposite and below). *Womanhouse* gave twenty-one female students space in a seventeen-room dilapidated mansion in Hollywood. The women learned carpentry, plumbing, and electrical work while fixing up the mansion and creating their own installations, which were presented to the public for a month in early 1972. Participants staged performances and consciousness-raising sessions that addressed difficulties ranging from the boredom of housekeeping to the horrors of domestic abuse. Installations titled *Menstruation Bathroom*, *Bridal Staircase*, and *Nurturant Kitchen* made use of previously taboo materials including underwear, sanitary napkins, children's toys and clothes, makeup, and kitchen utensils. While drawing attention to domesticity's challenges for women, *Womanhouse* also remade the idea of home as a utopian place where women could carve out their own space.

Equally germane to this discussion is Martha Rosler, a pioneer in performance, video, and agitprop art, whose series of photomontages (ca. 1967–72) and iconic video *Semiotics of the Kitchen* (1975; overleaf) left their imprint on artists who followed. For *House Beautiful: Bringing the War Home*, she cut and collaged images of the Vietnam War from *Life Magazine* and juxtaposed them with images of idealized domestic interiors from *House Beautiful* and similar magazines. At the time there was no commercial outlet for the work, and Rosler rejected art-world exhibition; rather, she circulated the collages on flyers and in underground newspapers. It wasn't until twenty years later that the works were produced as limited editions and presented to the art world.

In *Semiotics of the Kitchen*, Rosler, wearing an apron over a turtleneck, addresses the camera in a send up of cooking shows, demonstrating for her viewers with the utmost care various kitchen tools and gadgets in an A-to-Z primer, as if

their operation was akin to launching a nuclear missile. For each letter, she displays the object—apron, bowl, chopper, dish, etc.—and then shows how it is used. Rosler spells out the last three letters of the alphabet like a cheerleader, gesturing with her arms and body to shape the letters. For Z, she whips a knife through the air like Zorro leaving his signature mark on an unseen victim. The scenario makes a mockery of domesticity in a spare and ironic manner, bringing humor into the equation in a way *Womanhouse* lacked.

Forty years have passed since *Womanhouse* was completed and close to that since *Semiotics of the Kitchen* was performed. Yet their legacy can be seen in much of the feminist work being made today by younger artists, both in terms of wide-ranging materials and the overwhelming embrace of performance and video as the most effective vehicles for reexamining social boundaries and the notion of the personal as political. These women blow open the conversation with art that asks: What is the value of women's work? What is the function of private space?

Is domesticity to be shunned or embraced? And what about the changing role of domesticity, particularly as it relates to the redefinition of family and community? And, finally, what if the concept of domesticity were expanded to include steward-ship of the earth?

Rosler and her colleagues initially had to justify performance and video as viable mediums. As Rosler noted in a 2005 interview, "Ironically, feminism is responsible for the reinvigoration of performance. We do have to go back to Al-lan Kaprow's Happenings, alongside other New York performers in the 1960s like Carolee Schneemann and Yvonne Rainer, since Kaprow was the teacher of a number of young feminists at CalArts in Los Angeles. . . .The women were largely ignored outside the feminist and artist community, but then Paul McCarthy and Chris Bur-den, and a few other guys from the same LA milieu, also started doing these 'women things,'—that is, performance—and then performance received validation. Video was excluded from Documenta VII in 1982 because the director, Rudi Fuchs, had sup-posedly ruled that video was a women's form, and therefore not really art." [1]

Janine Antoni is one of the preeminent performance artists who came of age in the early 1990s. Throughout her work, Antoni has explored aspects of generational connection, often making art that addresses her experience as a daughter and as a mother. In the series *Inhabit* (2009) she mused about whether a spider could spin a web between her legs. As the concept evolved, the web morphed into a dollhouse, a surrogate for the womb. "From the beginning, I equated the spi-der and its web with my daughter, and myself, the mother, with the support struc-ture." [2] The performance videos of Kate Gilmore, whose relatively simple setups and goofy enactments of scenarios in which she creates a physical challenge for herself—roller skating up an incline, breaking her foot free from a bucket of plaster, or climbing out of a long, narrow box while adorned in feminine accoutrements of heels and fancy dresses—hearken back to Rosler's *Semiotics of the Kitchen* with their deadpan humor and direct message.

Much has changed in the world at large over the last forty years with re-gard to social organization, economics, politics, and communication. And while prog-ress for women's rights in much of the world is undeniable, change has also brought with it an entirely new set of problems, anxieties, and traumas that earlier feminist artists could not have imagined—not the least of which is the challenge of finding a viable relationship to domesticity now that so many of the old social constraints

[1] Christy Lange, "Bringin' It All Back Home," interview, *Frieze*, no. 95 (November/December 2005); revised by Martha Rosler in 2012.

[2] Douglas Dreishpoon, "Escape Hatch," *Art in America* 97, no. 9 (October 2009): 127.

affecting women have been transcended. Women have entered the workforce in great numbers leaving less and less time and energy for domestic pursuits which, in the not-too-distant past, were broadly viewed as a woman's obligation. Even as some conservatives try to reverse this trend, suggesting that a woman's proper place really is in the home, economic realities have made second incomes necessary for maintaining a middle-class lifestyle. A new elite has arisen consisting of educated women who have the luxury to stay home.

In a controversial 2012 article in the *Atlantic*, titled "Why Women Still Can't Have It All," academic and foreign-policy star Anne-Marie Slaughter offered an in-depth personal account of her frustration of balancing a stressful professional career with raising children. Slaughter, the first female director of policy planning at the US State Department, on leave from her position as dean of Princeton's Woodrow Wilson School of Public and International Affairs, derided herself for having conveyed the message to younger women that opportunities existed if you were committed and driven. As a second-wave feminist, Slaughter says, "I'd been part, albeit unwittingly, of making millions of women feel that they are to blame if they cannot manage to rise up the ladder as fast as men and also have a family and an active home life (and be thin and beautiful to boot)." [3] Slaughter acknowledges that the solution can only come if structures are set in place to help women compete in the work force as they raise children. The article inspired a fierce backlash of public comment centering on the brash pronouncement of the article's title. "No one gets to have it all?" rebutted the artist Jennifer Dalton. "Using that phrase makes legitimate feminist goals of equal opportunity seem childish, absurd and materialistic." [4] And yet, in works like *How Do Artists Live?* (2006; left), in which Dalton engages the same problem of gender inequity, she presents dispiriting results. A chalk-drawn detail titled "Will Having Children Hurt My Art Career?" reveals, through charted statistics, a sharp disparity for male artists versus female artists.

As Dalton, Slaughter, and others have acknowledged, their complaints of women's inequality in the workforce and the struggle to balance work with childrearing must be understood as a dilemma of educated and often privileged women. The artist Liza Lou engages directly with women at a remove

Jennifer Dalton, *How Do Artists Live?*, 2006 (detail). Chalk and black paint on paper; 19 x 24 in. | 48.3 x 61 cm. Private collection.

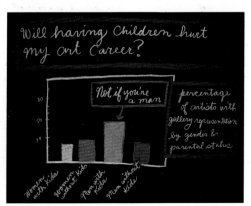

[3] Anne-Marie Slaughter, "Why Women Still Can't Have It All," *The Atlantic*, July/August 2012: http://www.theatlantic.com/magazine/archive/2012/07/why-women-still-cant-have-it-all/309020/2/.

[4] Jennifer Dalton on the "Having It All Debate," *Artinfo*, July 19, 2012.

Lisa Hoke, *Recollections*, 1992.
Shower curtain, buttons, and tulle;
dimensions variable.

from this social-economic context in the process of making her work. Lou is best known for large-scale installations that often recreate conventional domestic spaces with household objects made to scale and totally covered with tiny beads. Uncanny replicas of kitchen appliances, lunch, barbed wire, a bottle of Jack Daniels—all elaborately beaded—speak to craft and decoration and can be both beautiful and menacing. After winning a MacArthur Fellowship, Lou moved to Durban, South Africa, where she currently works with thirty local Zulu artisans on economically sustainable projects while continuing her own work.

Born in the mid-1950s, Lisa Hoke provides a segue into the work of Sarah Sze and Tara Donavan, who also engage in the use of serialization of commercially available products in large installations. In the early 1990s, as she began to move away from casting objects, Hoke looked to her domestic life in search of material (left). She first used recyclables, like aluminum cans, baby food jars, soda bottles, and milk cartons, as well as the throwaway: coffee filters that had been used for a month made up a new drawing, popsicles melting on a napkin became part of another piece. In the process, the artist's daily experience in and out of the studio became one. "What was shifting for me," she says, "was the notion that I had to separate the privacy of my domestic life from my studio life. Removing these barriers led to new thinking in my studio." [5]

Rachel Whiteread also began by casting objects, or more accurately, casting the negative space held by an object, which resulted in shapes that were more like the memory of the object than the object itself. A primary influence on Whiteread is Bruce Nauman—one can find an obvious connection in Whiteread's *Untitled (One Hundred Spaces)*, from 1997, in which she made casts of the underside of chairs. However, one cannot help make a connection between *Womanhouse* and

[5] Lisa Hoke, interview by the author, August 2009.

DOMESTIC DISTURBANCES

Rachel Whiteread, *House*, 1993. Cast concrete in East London. No longer extant.

Whiteread's *House* (1993; left), a concrete cast of the interior of an entire Victorian House that was located in East London, for which she won the Turner Prize in 1993—the first woman to be awarded the honor. In *House*, outlines of doorknobs, moldings, even rubbings of wallpaper, all speak of an absence of a life or lives once lived.

One legacy of *Womanhouse*, as both Hoke and Whiteread illustrate, is the license to expand on scale and complexity. As an artist coming of age post-2000, Josephine Halvorson reverses this tendency with intimate paintings that garnered critical acclaim early on in her career. If Halvorson's still lifes offer meditations on the everyday—images of two slabs of dough, a pile of books, a hearth (opposite), machine parts, doorways, and window sashes—her intention is to give primacy to the materiality of the paint. But even as she embraces the historic tradition of still life painting as a way to explore the quotidian, she rejects the clichéd notion that still life has a lesser position for being associated with the domestic and the feminine. "Because there has been little or no distinction between my work and home life, I have never experienced domesticity as a form of entrapment. Therefore, it's never made sense to subvert it or disturb it. For me, the ideology of domesticity has never been an actuality." [6] And yet, the very act of claiming this realm of painting as her own—almost in defiance of its somewhat ghettoized position—is, in its own way, a subversion born from the freedom that younger women have to range freely across all traditions and mediums, certainly an important legacy of *Womanhouse*. [7]

Catherine Opie, whose photographs are both painfully personal and quietly political, is perhaps the most significant voice to both broaden and question the definition of family and domestic life in America. Opie first made a name documenting the gay leather culture of San Francisco and in subsequent work has continued this examination of subgroups and communities. Particularly moving and germane to this discussion is Opie's *Domestic Series* (1995–98), for which the artist traveled cross-country photographing lesbian couples and their families going about their daily domestic lives—relaxing in the kitchen, swimming. The images present, as Holland Cotter observed, "families that America knew nothing about." [8] Opie makes the domestic even more personal in the series, *In and Around Home*

[6] Josephine Halvorson, interview by the author, August 2009.

[7] Norman Bryson, *Looking at the Overlooked: Four Essays on Still Life Painting* (London: Reaktion Books, 2004). Halvorson rejects Bryson's essay "Still Life and Feminine Space," in which he maintains that still life painting references interior space normally inhabited by women, where "the basic routines of self-maintenance take place." Halvorson fully understands that from the time of imperial Rome until the eighteenth century, it was mostly women who painted interior still lifes.

(2004–5), which documents her family life with artist Julie Burleigh and their young son, who is pictured in one photograph standing on a chair and wearing a tutu.

If Opie has expanded conceptions of domesticity through the re-picturing of the family in alternative domestic arrangements, Andrea Zittel presents ingenious options for living by reconfiguring the physical arrangements of home. When she first emerged in the early 1990s, Zittel found inspiration in the quotidian, making uniforms and objects meant to simplify and transform the complexity of daily life. Her early "Living Units" reduced necessities for living into a 200-square-foot structure and her "Escape Vehicles" were pods meant to help escape from the world. Now based in the desert of Joshua Tree, California, at her own "A–Z West" corporation, Zittel operates outside the conventional parameters of the art world—and the history of art—by examining the systems of living by which we define ourselves at home, work, and play.

Contemporary attitudes toward domesticity have shifted from the concerns of the second-wave feminists; for many younger women artists, the domestic sphere is no longer a prison to escape but rather something unattainable, whether that be home ownership, intimate relationships, or even a sense of security in the world. The artist Stuart Hawkins addresses the destruction of the American middle-class dream of home ownership, which has been exported abroad at the same time that the international economic crisis has made that dream ever more unattainable. An American who has lived much of the last fifteen years in Nepal,

Josephine Halvorson, *Hot Coals*, 2008. Oil on linen; 16 x 19 in. | 40.6 x 48.3 cm. Private collection.

Hawkins captures on video and camera semi-staged settings that elucidate the absurdities and folly of capitalism. Performance and installation artist Klara Liden explores the anxiety of urban living, often scavenging detritus from city streets and remaking them into personalized living areas in galleries and museums. Much of Liden's work can be seen as a rejection of the conventional comforts of home, including, for example,

[8] Holland Cotter, "A Retrospective of Many Artists, All of Them One Woman," review of Catherine Opie, *New York Times*, September 26, 2008, http://www.nytimes.com/2008/09/26/arts/design/26opie.html?pagewanted=almost%20all.

Sarah Sze, *Untitled (Portable Planetarium)*, 2009. Mixed-media installation. Installation view, *The Spectacle of the Everyday*, Biennale de Lyon, France, 2009–10.

her video *Bodies of Society* (2006), in which she destroys her bicycle with a metal rod inside of an apartment; the work speaks of frustration misdirected at an inanimate object, essential for her own mobility. In her 2007 video *Ohyra*, set in a kitchen, Liden smashes things up in an even more overtly self-destructive manner.

What might be the most distressing domestic disturbance of all, and certainly in the forefront of public consciousness today, is our home the planet, under threat. Hoke recycles with the environment in mind and certainly Zittel's A–Z project takes as a point of departure a commitment to cutting out the excess waste of everyday living. Sze's early sculptural installations of biomorphic creatures conjured from spit and toilet paper extend the possibilities of transforming insignifi-

cant and ephemeral materials into art in a way that recalls *Womanhouse*. Sze went on to use objects readily available in hardware stores or supermarkets—tape measures, match sticks, lamps and fans, plastic bottles, screwdrivers, and wires—creating architectural structures that transcended their objecthood by creating worlds of their own (opposite). Sze is a world builder, and her deliberate use of delicate material acknowledges the fragility of the planet.

How much has changed on the domestic front in the past forty years? Though the conversation is more transparent, the trajectory appears to be circling back on itself. The personal as political is as relevant today as it was when the first feminists took up the cry. Women's issues, specifically abortion rights and issues surrounding family and personal autonomy, remain at the heart of many current debates, in a way not seen for decades. The glass ceiling may have moved up a few notches, but it nevertheless remains intact. How fitting that, decades later, Rosler revisits the dichotomy of war abroad and peace at home in her series *House Beautiful: Bringing the War Home* (2004; below), once again juxtaposing images from war, this time in Iraq and Afghanistan, with the prosperity at home.

Martha Rosler, *Saddam's Palace (Febreeze)*, from *House Beautiful: Bringing the War Home*, new series, 2004. Photomontage.

Before and during the exhibition of *Womanhouse*, Miriam Schapiro and Judy Chicago led the participants through consciousness-raising sessions, intense group interactions to get at the heart of their domestic concerns. When she revisited the project thirty years later with *At Home: A Kentucky Project* (2001), Chicago replaced the term "consciousness-raising" with "content search," to take into account the "paradigm of the art world," with its contemporary commitment to theory, art history and tradition, among other things. [9] Clearly, younger women artists working today develop their practice through the lens of art history. The domestic quandaries explored by *Womanhouse* and *Semiotics of the Kitchen* may have morphed but they have not been solved. The issues continue to provide a rich source for these younger women artists, who come to the endeavor changed yet emboldened by their predecessors.

[9] Dr. Viki D. Thompson Wylder, "At Home," *The Journal of Gender Issues in Art and Education*, 81. Chicago also revised her viewpoint that the feminist pedagogy meant that only female artists could participate and included the work of male artists in the project.

KATE GILMORE

IN JUNIOR HIGH SCHOOL, KATE Gilmore broke her leg. Undaunted, with cast and crutches, she ran for class treasurer, performing for her classmates a rendition of the song "Working 9 to 5" while wearing a shirt with a pin that said "Vote for Kate." Gilmore lost the election but this snippet from real life has within it the seeds that make her work so compelling: a willingness to portray vulnerability and desire while balancing humiliation and humor.

Gilmore's narratives, which most often are performed by herself for video, typically revolve around a female character struggling with or against something. The performances are thematically connected by physical exertion: swinging a sledgehammer through plaster or wood, doggedly pulling herself up a shaft, roller skating up an incline, or carrying excruciatingly heavy blocks of plaster. Most often she is dressed in high heels, an evening gown, or a cocktail dress, highly coded clothing better suited for sipping tea or drinking champagne than ripping out drywall.

Gilmore earned her MFA in sculpture from the School of Visual Arts, in New York, in 2002. But before graduation, she realized she was more interested in portraying movement than making sculpture. She first tried interacting with her sculptures in photographs, but found the work too static. Gilmore noticed that visitors to her studio were more interested in the peripheral detritus than the work itself, more attracted to "my humor, my messiness, my disasters," which was not coming out in the work. [1]

Early influences, such as iconic female sculptors Kiki Smith, Eva Hesse, and Louise Bourgeois gave way to an interest in performance and video, as she gravitated to the hardcore performance artists of the 1960s and '70s like Chris Burden, Carolee Schneeman, VALIE EXPORT, and Marina Abramović, all of whom "used their bodies in extreme ways to transform themselves, a space, or those who come in contact with the performance." [2] Eventually, she began performing for the camera.

Although Gilmore ostensibly performs as herself, there is an element of dressing-up that runs throughout her work, lending a thin veil of characterization. Some of her early characters had the look of a prom queen, a Martha Stewart-type, or, as her sister Jennifer Gilmore observed, "women who resembled Hillary Clinton, who I think is a proxy for our mother, a career woman who went to Wellesley." Kate admits, "There is something that has always fascinated me about that generation of women. . . . I see Hillary and that type of woman as being the future, as progress. Transformation." [3]

[1] Lyra Kilston, "Kate Gilmore," *Artinfo*, February 26, 2009, http://www.artinfo.com/news/story/30354/kate-gilmore.

[2] Kate Gilmore, interview by the author by e-mail, July 19, 2011.

[3] Jennifer Gilmore, "Jennifer and Kate Gilmore," Bomblog, *Bomb*, March 10, 2011, http://bombsite.com/issues/1000/articles/4936.

In her early years, Gilmore was unaware of radical feminist ideas in the art world; she was not even born when the *Womanhouse* project happened in 1972. Like many in her generation, Gilmore was exposed to feminism less as a cause than as a lifestyle, through the model of her mother. "I feel very connected to the feminist movement in general. I am baffled how any woman cannot feel connected with this essential part of history. Growing up with a mother who was involved with the ERA and not having a 'traditional' domestic experience, I have always had strong views on women's multi-various roles in society. In terms of the art movement, I feel that it is part of our history and something that, for me, has to exist in the work, but somehow illustrate the present." [4]

Unscripted and shot in a single take, Gilmore's performances have an improvised, live-action quality to them, and often an unpredictable outcome. "Chance is a big part of the work," Gilmore notes. "This is the exciting and terrifying part. I am interested in a genuine reaction to a situation. Acting isn't something that particularly interests me." [5]

Gilmore learned the hard way in *My Love Is an Anchor* (2004; below). Alone in her studio, she sank her foot deep into a decorated plastic bucket filled with quick-drying plaster. Dressed in a black cocktail dress and black hose, she "performs" against a backdrop of ochre-green wall hung with a silver heart, out of which drapes

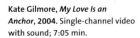

Kate Gilmore, *My Love Is an Anchor*, 2004. Single-channel video with sound; 7:05 min.

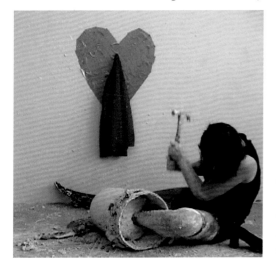

a blood-red cloth. She works doggedly to escape, banging her foot against the wall and vigorously hammering the bucket and plaster, freeing only a few tiny chunks at a time. At times, Gilmore's frustration borders on terror, as the hopelessness of the task becomes palpable. Though the edited version is just over seven minutes, it took more than two-and-a-half hours for Gilmore to break free. The video ends with the camera fading to black, Gilmore still stuck in plaster.

The early sets were simple. In *With Open Arms* (2005), her character, dressed in a violet cocktail dress and wearing a flower in her hair, strikes an open-armed pose—a "Ta-da" moment—against a pale yellow backdrop covered with silver stars crudely cut from aluminum foil. She smiles at the audience, shimmering with hope, when the first rotten tomato is hurled from offstage. The tomatoes come faster

[4] Interview with the author.

[5] Ibid.

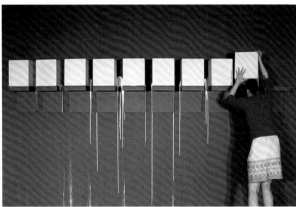

TOP
Kate Gilmore, *Star Bright, Star Might*, 2007. Single-channel video with sound; 7:36 min.

BOTTOM
Kate Gilmore, *Blood from a Stone*, 2009. Single-channel video installation with sound; 8:09 min.

and harder, and when Gilmore takes a brief moment to compose herself and wipe off the sticky juice or dodge an incoming missile, she cheerfully returns to the smile and pose. This is a rare case where Gilmore uses an offstage aggressor; her opponent is usually the set-up itself.

Gilmore explores a similar narrative revolving around a painful quest for recognition in *Star Bright, Star Might* (2007; left). The scene opens with a close-up of a rough piece of plywood spray-painted orange-red, out of which the shape of a star has been crudely cut. Gilmore, her lipstick matching the orange–red of the wood, peers from behind the cutout as she hesitantly takes measure of the situation. With growing determination she presses against the star, eventually straining and biting at the wood. Her face reddens with effort. Scrapes and scratches mar her face and neck, which glisten with sweat as she slowly makes headway. Gilmore finally pushes through, exhausted by the effort, staring at the camera with a plaintive look, as if to say, "At what cost?"

A break-through for the artist was the 2009 *Blood from a Stone* (left), performed at the Brooklyn Museum of Art as part of the exhibition *Reflections on the Electric Mirror: New Feminist Video* and later acquired by the museum. Gilmore, dressed in a fifties-style skirt and orange cardigan sweater, lifts seventy-five-pound cubes made of solid plaster, carries them across the room, and heaves them onto a high shelf. The effort is intense. The shelves are covered in runny white paint which splatters against the wall and drips slowly to the ground with each newly placed block.

While *Blood from a Stone* can be read, like many of Gilmore's works, as an antic dramatization of the struggles of working women, in discussing the work Gilmore also evokes art history. "I directly deal with certain art-historical movements," she says. "This piece has cast plaster cubes, clearly referencing Minimal-

Kate Gilmore, *Standing Here*, 2010.
Single-channel video with sound;
10:48 min.

ism, tight structures and contained spaces. When I placed the cubes on the shelves, they bled their color. I see it as referencing expressionism, or an out-of-control aspect to making art. By using these different art-historical 'moments' within the same piece, I am trying to reconcile histories. I am sure there were women making this type of work at the same time, but where are they in art history? The drips and expressionistic movement reflect the untold stories." [6]

Gilmore debuted *Standing Here* at the 2010 Whitney Biennial (left). The scene opens with the viewer looking down an empty chute, likened by one critic to an "upstanding birth canal." [7] Gilmore, at the bottom of the chute, pushes in an edge and crawls into the space. Wearing a red dress with white polka dots, black hose, shoes, and leather gloves, she kicks and punches holes in painted plaster, creating toeholds to climb up the sides. Gilmore works feverously, as if understanding time is a factor for both completion and performance. The task gets more difficult as she ascends, the video ending with her reaching the top and stopping, exhausted, a woman artist being born into the world.

In *Walk the Walk* (2010; opposite), Gilmore used performers for the first time. Sponsored by the Public Art Fund and staged outdoors at Bryant Park in Manhattan, *Walk the Walk* featured seven women dressed in lemon-yellow dresses and tan high heels (and pink sweaters when the temperature dropped) walking, marching, and jostling each other atop an eight-foot cube, an homage to the working women in this city famous for the pedestrian. If one doubts the physical rigor involved with this piece compared to the pain and endurance demanded of Marina Abramović, it should be noted the distance covered by the women each shift equals the distance of a half-marathon. Visitors could step inside the cube to hear the stomping and shuffling of the women overhead, perhaps an unintended riff on Vito Acconci's *Seed Bed* (1972). The critical response was mixed. The *New York Times* critic Roberta Smith found it transitional, lacking the usual energy and goofiness of the heroine, but nevertheless applauded Gilmore "for facing the inevitable and plunging fearlessly ahead." [8]

[6] Ibid.

[7] Anna Watkins Fisher, "Like a Girl's Name: The Adolescent Drag of Amber Hawk Swanson, Kate Gilmore, and Ann Liv Young," *The Drama Review* 56, no. 1 (Spring 2012): 58.

[8] Roberta Smith, "Artist Struts Her Stuff," *New York Times*, May 12, 2011.

Gilmore's second directorial endeavor, *Through the Claw* (2011; p. 128) debuted at Pace Gallery, New York, as part of the group show *Soft Machines*, inspired by William S. Burroughs's 1961 novel of the same name. Five women dressed in yellow shifts fell upon a 7,500-pound cube of wet clay, grabbing at the clay and flinging it at the wall. Some viewers commented on the fecal quality of the clay and the zeal and aggression with which the performers threw it. [9] This sculptural moving-of-matter from whole to fragments, order to mess, not only suggests an exchange of energy but also visually presents a juxtaposition of the stasis of Minimalism versus the gesture of action painting.

In the first decade of her career, Gilmore has been exceptionally prolific, completing over forty videos and performances. While her premises have remained relatively simple, her sets have become increasingly complex. Unlike the changeability of that great chameleon Cindy Sherman, who places herself at the center of her art, exploring identity by altering her visage through costuming and make-up, Gilmore's actions expose, rather than conceal, the hopes, desires, struggles, and failures of Everywoman. She is a heroine of the quotidian. — SUE SCOTT

Kate Gilmore, *Walk the Walk*, 2010. Performance in Bryant Park, New York, with wood, metal, paint; commissioned by The Public Art Fund.

[9] Carly Gaebe, "Body Conscious: 'Soft Machines' at the Pace Gallery," *Art In America*, July 22, 2011, http://www.artinamericamagazine.com/news-opinion/news/2011-07-22/soft-machines-pace-gallery/.

JUSTINE KURLAND

"ANOTHER GIRL, ANOTHER PLANET," the 1999 group exhibition that helped launch Justine Kurland's career, borrowed its title from a song by a British punk-rock band. The music's angry disaffection was modulated to a kind of adolescent anomie in much of the photography included, almost all of it made by young women and featuring even younger ones. But for Kurland, the title's reference to distant worlds and their utopian residents was the more apt. She has consistently explored communities and individuals that are not just off the grid but out of step in the march of history: commune-dwelling hippies; train-hopping hobos; participants in itinerant Renaissance festivals.

The work Kurland included in "Another Girl" (it was co-organized by Gregory Crewdson, who had been her teacher at Yale) was, Kurland said, "a Huckleberry Finn narrative" for girls. [1] In color photographs of young girls bathing naked in an emerald-green swimming hole (*Bathers*, 1998; opposite), wandering the woods, tossing balls, and blowing bubbles, as seasons change and terrains shift, Kurland staged pastorals that reminded critics of historical precedents ranging from Arthur Rackham's woodland nymphs to Thomas Eakins's bathing boys. In other photographs of the same period, Kurland's girls wear what look like school uniforms; occasionally they are ranked in regular formations, but more often they seem blissfully undisciplined. This is no gynotopia; there are boys whom the girls flirt with and taunt, but there is little friction in these early photos and scant evidence of modern life, and there are no adults at all.

The innocence of the girls' circumstances, and characters, gives way

in a few early images where they seem not so much woodland sprites as seasoned foragers. In *Roadkill* (2000), a girl in cargo pants and a sweatshirt strides through a yellowed field beside a nondescript road, a huge dead fowl in one hand and a no-nonsense look in her eyes. *Battlefield* (2001; left), which presents slumbering young girls in school uniforms strewn across a grassy field,

[1] Justine Kurland, quoted in "So They All Get Naked and Play, Like Mom Did," by Carol Kino, *New York Times*, Feb. 25, 2007.

evokes the Civil War photography of Mathew Brady (and also, perhaps, Jeff Wall's much-noted staged-war photographs of 1992). But it was when Kurland began to seek out real-life escape artists in the world, rather than fashioning them for the camera, that her work attained its full emotional complexity. "Songs of Experience," a 2005 exhibition of photographs made over the preceding few years that included gelatin-silver-print portraits of Renaissance fair participants, introduced both greater objectivity and an explicitly autobiographical element.

Born in 1969 in Warsaw, New York (near Buffalo), Kurland was raised by a single mother who began in the mid-seventies to sell hand-sewn clothing at Renaissance festivals around the country, often taking Justine and her sister along. "Occasionally they would camp in the woods, and the girls would hunt for fairies. Perhaps that's why the sensibility of Victorian fairy painting frequently flickers through her photographs," [2] Carol Kino suggests. As a teenager, Kurland chose to live with a

[2] Ibid.

**Justine Kurland, *The Milk Sucker*,
2006. C-print; 40 x 30 in. | 101.6 x
76.2 cm.**

relative in New York City so she could attend a rigorous high school there. (She received a BFA in 1996 from the School of Visual Arts, and an MFA from Yale two years later.) But she revisits her peripatetic childhood with considerable sympathy in the photographs of fair participants, their faces mostly hidden by their accoutrements—metal helmets, chain mail—as they take up arms against modernity. Kurland's mother has moved to a farm in the Blue Ridge Mountains, in an area welcoming to the kind of back-to-the-land communes that have also appeared in Kurland's photographs. It may have a bearing on Kurland's work as well that, as she says, "My mom just naturally wanders around naked." [3] A survey in the early 2000s of enclaves of frolicsome latter-day hippies, dedicated nudists, and other communards took Kurland from upstate New York to Virginia, Tennessee, and California (where she shot the San Francisco Diggers). In many of these color photographs, such as *Fire Eaters* (2003; opposite), the human subjects are dwarfed by the landscape, fusing with the environments in which they have taken shelter from urban life.

In 2004 Kurland had a son whom she named Casper, after the Romantic German landscape painter Caspar David Friedrich. In several interviews she has given since, she talks remarkably freely about being a mother. She doesn't make it sound easy, and she doesn't hide her resentment of men who can enjoy the benefits of parenthood but skip out on its non-stop responsibilities. "I've often wondered what Brice Marden's paintings would look like if he were to hold his child on his hip while he painted," [4] she has said. Her first body of work after Casper's birth was exhibited in 2007 under the title *Of Woman Born*. It features roving bands of pregnant and nursing women, shown nude against richly evocative landscapes, their children gamboling around them (above). The title's allusion to Adrienne Rich's 1976 manifesto on motherhood must be partly ironic; in skewering the myths of a primal maternal sisterhood, and of innate female inclinations to nurturance, Rich wrote, "Certainly the commune . . . has no special magic for women." But she also proclaimed, in a statement Kurland's

[3] Ibid.

[4] Justine Kurland, afterword to *Justine Kurland: This Train Is Bound for Glory* (New York: Ecstatic Peace Library, 2009), 127.

Justine Kurland, *Playing with Trains While Waiting for Trains*, 2008. Unprinted.

DOMESTIC DISTURBANCES KURLAND

Justine Kurland, *Astride Mama Burro, Now Dead,* **2007.** C-print; 40 x 50 in. | 101.6 x 127 cm.

photographs plainly support, "We need to imagine a world in which every woman is the presiding genius of her own body." [5]

This Train Is Bound for Glory is the name of the 2009 exhibition for the photographs that followed, which were even more directly shaped by motherhood, though there is nothing superficially feminine about them. "I'm a feminist, and my work is feminist. But I think it was more about being a mom, and I'm the mom of a boy, and this is his boy world with trains that I was delving in," [6] Kurland said in explaining the genesis of this body of work, which features modern-day descendants of the down-and-outers championed by Woody Guthrie (who is acknowledged in the title). Although there are systematic ways for twenty-first-century train hoppers to stay in touch, mostly by listening in to radio dispatchers, Kurland preferred traveling at random to favored rail yards—in a Chevy Astro minivan with satin damask curtains sewn by her mother—and waiting. It became, she says, "my own kind of gypsy American nomadic thing." [7] The photographs that result capture makeshift encampments, weather-beaten vagabonds, gray skies, and beauty abounding. *Land of the Lost* (2008) features a fiddle-playing hobo, his rolled-up pants and brimmed hat completing a figure that seems straight out of a cheerful genre painting by George Caleb Bingham. On the other hand, *No Cover Over 21* (2007) shows a sadly flimsy shelter, a portion of which is the titular sign, its promise (free entry if you're of drinking age) translated into a demonstration that this lean-to can't provide adequate cover for anyone.

One recurring subject in "Bound for Glory" is a man called Cuervo (above), at once mythic and altogether profane, about whom Kurland says, "[he] embodies the American West and the outlaw and Thoreau. But then he's also been to jail

[5] Adrienne Rich, *Of Woman Born: Motherhood as Experience and Institution* (New York: W. W. Norton & Company, 1995).

[6] Justine Kurland, interview by Nicole Rudick, *Vice*, n.d., http://www.vice.com/read/an-interview-with-justine-kurland.

[7] Ibid.

and he does tweak and is gross as shit."[8] Writes Jonathan Raymond, "It is Kurland's great poise as a photographer that she is able to capture both the real and imagined Cuervo in a single picture." [9] It is hard to imagine a place for a toddler in a world of men like Cuervo, but Casper, when he appears in Kurland's photographs, seems perfectly at ease (pp. 138–39). As with Catherine Opie's child, Kurland's son has become part of her work, and part of what she is learning, and expressing, about the constitution of kinship. All her subjects, in one way or another, are alternative families.

Kurland can seem a bit of a wayward angel, and one senses that in her work (and perhaps in her life as well) trouble—poverty, drugs, danger—has often been just off-frame. Her choice of subjects has caused her to be associated with outsider artists (she was represented in the exhibition "Dargerism: Contemporary Artists and Henry Darger," at the American Folk Art Museum in 2008); she was linked, in a 2012 *Art in America* article titled "Off the Grid," with Alec Soth, for his photos of extreme survivalists, and James Benning, who is exploring (with replica cabins) the connection between Thoreau and "Unabomber" Ted Kaczynski, while living deep in the woods himself. [10] But the associations Kurland invokes include those with the perfectly urbane writers named in exhibitions' titles (and elsewhere; she corresponded with novelist and essayist William Vollmann in researching train-hoppers); notable, too, are her photographs' clear references to art-historical sources (Courbet and Bierstadt, for instance, as well as those mentioned above). Her sophistication is evident above all in her imagery's painstaking composition and technical achievement. (Though her work can be called documentary, she has continued to stage her photographs in the sense that she generally uses a large-format camera requiring long exposures and willing subjects.) But perhaps the scope of her ambition, and the stakes of her art, are clearest when she claims, "We who are brave enough (or stupid enough) to become explorers today, when all available land has been conquered and occupied, can still be, I believe, the builders of a new world and a new consciousness." [11] Or, in more prosaic terms, "There's something political about creating a world that you want to exist." [12]

— NANCY PRINCENTHAL

[8] Ibid.

[9] Jonathan Raymond, foreword to *Justine Kurland: This Train Is Bound for Glory*, 5.

[10] Anne Doran, "Off the Grid," *Art in America* 100, no. 10 (Nov. 2012): 130–39.

[11] Justine Kurland, *Justine Kurland: This Train Is Bound for Glory*, 127.

[12] Kino.

KLARA LIDEN

IN ONE OF HER BEST-LOVED essays, written in 1929, Virginia Woolf declared, "A woman must have money and a room of her own if she is to write fiction." [1] With this memorable phrase, Woolf underscores the relationship between domestic stability, economic security, and creativity. Five hundred pounds a year and a room of one's own stand for her as shorthand for the conditions necessary for imaginative freedom. Given the historical circumstances of women's relative poverty, lack of power, and immobility, she sees insecurity and instability as states particularly endemic to women.

Fast-forward eight decades. While it is indisputable that women's situation vis-à-vis men has improved, life for everyone feels far more volatile. *Precarity* is a word originally coined to describe the unstable condition of nomadic unskilled laborers in a post-industrial economy. But as safety nets shrink, jobs migrate to places like China and India, freelancing becomes the norm, and many workers are a paycheck away from eviction, uncertainty has also trickled upward to encompass a broad swath of the developed world's population. The result is a society in which Woolf's conditions seem for many an increasingly impossible dream.

Born in 1979 in Stockholm, Swedish artist Klara Liden is a child of this new reality. She presents environments cobbled together from urban detritus, devises domestic spaces that mirror the makeshift ingenuity of squat living, and stars in low-budget videos and performances that celebrate an anarchy born of the new precarity. Considering the sense of futility and frustration lurking just below the comic exterior of these works, curator Helen Molesworth asks, "Are Liden's hidden rooms and curious constructions a proposition about what a room of one's own might look and feel like today, eighty-two years after the need for one was first made public?" [2]

It is an intriguing question. Liden, who studied architecture at the Royal School of Technology in Stockholm before becoming an artist, creates works that appear to undermine any lingering confidence in the benevolence of institutions or the permanence of social ties. Her first ventures into art involved the creation of parallel social structures, like a do-it-yourself postal service in Stockholm or a subterranean shelter hidden beneath a facade of sod beside the River Spree in Berlin. While they echoed the works of earlier artists (one thinks of Vito Acconci's 1970 *Service Area*, in which his mail was forwarded to the Museum of Modern Art, and Robert Smithson's *Partially Buried Woodshed* from the same year), they lack those artists' social orientation. Liden's work seems more private; her embrace of the pro-

[1] Virginia Woolf, *A Room of One's Own* (New York: Harcourt, Brace and Co., 1929).

[2] Helen Molesworth, "In Memory of Static: The Art of Klara Liden," in *Klara Liden: Bodies of Society*, ed. Massimiliano Gioni and Jenny Moore (New York: New Museum, 2012), 38.

Klara Liden, *Paralyzed*, 2003. Video with sound; 3:05 min.

visional is less a challenge to existing institutions than a retreat into a secret world where only her own rules apply.

Paralyzed, a 2003 video (left), suggests this privatizing of public space. It opens with Liden sitting hunched in a seat of a Swedish commuter train wearing a hooded military coat. Suddenly, to a punk soundtrack, she gets up and breaks out into a frenzied dance while gradually stripping down to a pink shirt and shorts. She jumps in and out of seats, rolls on the floor, swings from the handrail, and at one point attempts to stuff herself into the luggage rack. Her actions are carried out with a complete lack of interest in her train-car audience, which consists of a smattering of weary commuters who seem equally uninterested in her. The whole thing is humorous in a weirdly disorienting way—Liden's private catharsis creates only a mild and quickly dissipating ripple in the dull sameness of public peace.

550 Jamaica Avenue, created a year later, presents the flip side to this appropriation of public space. In this video, Liden brings us into an apparently unoccupied apartment still cluttered with the absent tenant's possessions. She makes herself at home, riding an exercise bike shirtless and playing the piano. It's not clear if she is a trespasser or a new resident bringing the place back to life.

Liden's time-based works are often permeated with a sense of impotence. *Bodies of Society* (2006; opposite) is a three-minute video which takes us into a small unfurnished apartment bedroom where Liden is engaged in smashing her bicycle to bits. The performance has a premeditated air—Liden circles her prey several times before beating it with ever-more savagery. In the end it lies broken and vanquished on the floor. Again one thinks of precursors—there are echoes of Nam June Paik smashing his piano in concert or Pipilotti Rist insouciantly breaking car windows with a metal flower-rod in *Ever Is Over All* (1997). But the public dimension of those works is absent from Liden's video. Instead of symbolically challenging the social order,

*I haven't visited grandma
in so fucking long .*

she indulges in an action that is ultimately self-destructive, as she has shattered her means of transportation.

In Liden's 2007 *Ohyra* (below), anger turns inward. This video, which bears superficial resemblance to Martha Rosler's 1975 *Semiotics of the Kitchen*, opens with Liden washing dishes in her sink. She begins to castigate herself while literally beating herself up with her fists. She enumerates things she has not done, or has done poorly, including not seeing her grandmother and not washing the dishes. But unlike Rosler's satirical critique of gender roles through an inventory of kitchen utensils, Liden here gives a picture of a more profound sense of alienation that cuts across all divisions of society.

In an era of ever-more high-resolution and polished artist videos, Liden's works are deliberately unrefined and homemade looking. The same can be said of her installations, which generally involve recycled materials, including scavenged advertising posters, stolen garbage cans and police barriers, and the contents of her own apartment. She assembles these to create environments that are often claustrophobic, chaotic, and slightly threatening.

Liden has created a number of provocative installations in the space of Reena Spaulings, her New York gallery. Her 2004 *Benign* was a loft space, elevated above the floor and accessible only by a ladder, created from iron pipes and bundles of cardboard. In 2006 she built a bunk bed from police barriers and woven fabric. For a 2008 exhibition at the gallery, she presented *Elda för kråkorna*, a Swedish apho-

rism that translates as "heating the crows," referring to a home so overheated that it keeps the birds outside warm. For this work she invited the viewer through an apparently unfinished gallery space into a small room at the back where one could sit on a plush leather loveseat and hear the cooing of pigeons on the other side of the wall. And in 2012 she created another semi-private space in the gallery, this time filled with discarded and progressively threadbare Christmas trees, which she titled *S.A.D.* (p. 142).

These installations all present two kinds of spaces, one linked visually and literally to the prosaic outside world and the other suggesting a more hidden, private reality. This dynamic came to a head in *Teenage Room*, her installation for the 2009 Venice Biennale. The viewer encounters a white wall and closed door. Hanging on a rope alongside is an axe. Passing through (which, thankfully, does not require breaking the door down, but does cause the axe to rise and fall), one is thrust into a small room with a bunk bed created from scaffolding, as well as various items (clothing, a laptop, a quilted blanket) that one might expect to find in a young person's room. All are spray painted black, giving the ensemble a somewhat menacing look. Near the floor is a small open hatch that offers a possible escape route.

In videos and installations like those discussed above, Liden colonizes spaces and found objects, injecting an aura of pathos and mystery into quotidian realities. For *Unheimlich Maneuver* (*Uncanny Maneuver*; opposite), presented in 2007 at the Serpentine Gallery in London, Liden directed this operation toward her possessions. The raw material for the installation consisted of the entire contents of her Stockholm apartment. Here, as in many of her works, there were art-historical echoes. Among them are Lucas Samaras's 1964 reinstallation of his bedroom in Pace Gallery, and Tracey Emin's 1998 presentation of her own unmade bed. However, while Samaras and Emin replicated their personal environments, Liden chose to pack her worldly goods together into a solid mass that nearly filled the gallery. Thus, instead of exposing her most intimate space to outside viewers, Liden rendered her personal effects inaccessible, even to herself.

Klara Liden, *Projects 89*, 2009. Installation with plasterboard, roofing material, cardboard recycled from the Museum of Modern Art, and video; dimensions variable. Installation view, The Museum of Modern Art, New York.

Klara Liden, *Unheimlich Maneuver
(Uncanny Maneuver)*, 2007.
Installation with everything in the
artist's apartment; dimensions
variable. Installation view, Moderna
Museet, Stockholm.

Liden created a similar monolith in 2009 in the Museum of Modern Art in New York by placing bales of tar paper and cardboard from the museum's recycling bin atop a white sheetrock cube that almost filled the gallery (opposite). As with *Unheimlich Maneuver*, the dissonance between the gallery's white-box aesthetic and the messy materials of everyday life became another way to infiltrate and repossess public space.

Throughout her short career, Liden has continually borrowed strategies that were employed by an earlier generation to question social norms and suggest alternative arrangements. Liden operates without that kind of overtly political agenda. Instead, she immerses herself and the viewer in a state of open-ended precarity. In doing so, she drives home a truth about the inescapable insecurity of contemporary life.

— ELEANOR HEARTNEY

LIZA LOU

OPPOSITE
Liza Lou, *Kitchen*, 1991–96. Glass beads, wood, wire, plaster, and found objects; 96 x 132 x 168 in. | 243.8 x 335.3 x 426.7 cm. Whitney Museum of American Art, New York; Gift of Peter North.

BELOW RIGHT
Liza Lou, *Back Yard*, 1996–99. Glass beads, sequins, wood, wire, plaster, and found objects; 264 x 288 in. | 670.6 x 731.5 cm. Foundation Cartier pour l'art contemporain, Paris.

WHEN LIZA LOU WAS IN art school, she discovered that few things will earn an aspiring artist more disdain than working in a genre considered outmoded, déclassé, or worst of all, domestic. Her medium is the glass bead and over the years she has glued together hundreds of millions of them to create sculptures, installations, tapestries, and "paintings" that express a complex vision drawn from art history, politics, religion, and her own autobiography. Yet, despite the fact that she is an internationally celebrated artist and the winner of a MacArthur "genius" grant, for many in the art world, Lou remains "the bead lady," a term that continues to exude a scent of disapproval.

Lou's work can be parsed many ways, but running throughout is a meditation on the many meanings of home, family, and community. These concerns manifest themselves overtly in early works like her beaded *Kitchen* and *Back Yard* (opposite and below). They also are inscribed in the medium she employs and in the communal way that her works are created. Looked at across the arc of the last two-and-a-half decades, her art consistently probes the physical and psychological dimensions of home and asks questions about the nature of family and the ways in which we position ourselves in society and in the world.

Born in New York in 1969, Lou grew up first in Minnesota and then, following her parents' divorce, in San Diego, California. She was raised in an evangelical, working-class milieu and, following high school, spent a year in Bible college before enrolling in the art program of a local community college. A scholarship brought her to the San Francisco Art Institute, but she only lasted two months there, in part because she felt too out of place given her background and her desire to work with

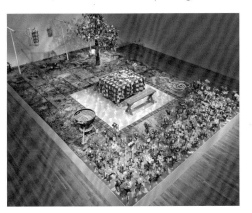

the unpopular medium of beads. She has noted, "This was possibly the worst thing I could have done. I had somehow transgressed into the realm of craft." [1]

Lou moved to Los Angeles and worked on her own. Her breakthrough came in 1996 with the exhibition of *Kitchen*, a full-scale bead-covered replica of a suburban kitchen, complete with checked tablecloth, Formica cabinets, a sink full

[1] Liza Lou, interview by Lawrence Weschler, *Liza Lou* (New York: Rizzoli, 2011), 107.

of dirty dishes, and a cherry pie popping from an open oven. It had taken her five years and thirty million beads to complete, and she notes that she did all the work herself, painstakingly gluing beads to every inch of the installation.

Kitchen was conceived as a monument to women's work. Lou inscribed the side of the stove with lines from Emily Dickinson describing a wife's sublimation of her secret life to the demands of her family. As she told Lawrence Weschler, Lou was inspired by "this idea that inside this activity of endless washing of dishes, endless making of pies, maybe this woman in the 19th century was someone brilliant. Maybe she was an artist. Maybe she was a writer. . . . So, in her pies lay her depths." [2]

Though *Kitchen* may have appeared beyond the pale of 1990s style postmodernism, it had antecedents in such 1970s era feminist icons as *Womanhouse* and Judy Chicago's *Dinner Party*. Like *Kitchen*, these works celebrated craft and acknowledged the complexities of traditional female roles. With her next work, Lou also drew on the collective aspects of these forerunners. She completed *Back Yard* in only

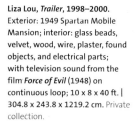

Liza Lou, *Trailer*, 1998–2000. Exterior: 1949 Spartan Mobile Mansion; interior: glass beads, velvet, wood, wire, plaster, found objects, and electrical parts; with television sound from the film *Force of Evil* (1948) on continuous loop; 10 x 8 x 40 ft. | 304.8 x 243.8 x 1219.2 cm. Private collection.

[2] Ibid.

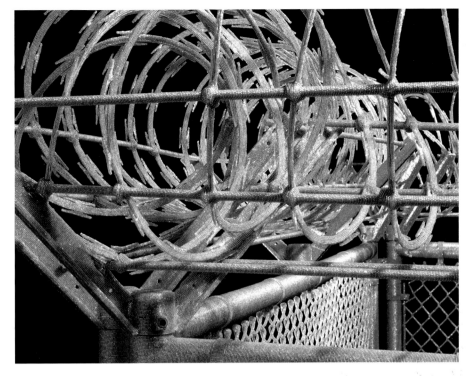

two years, thanks to a series of communal beading parties. It was equally detailed, including a charcoal grill, a laden picnic table, a crushed beer can, lawnmower, and 250,000 individually beaded blades of grass. *Back Yard* provided a counterpart to *Kitchen*, presenting the suburban yard as the quintessential male preserve.

As her work progressed, it became darker. In 1999 Lou unveiled *Trailer* (opposite), a work that suggested the underside of the fantasies embodied in *Kitchen* and *Back Yard*. This forty-foot-long Airstream trailer was suffused with a narrative of violence and vice. While its exterior was covered in shiny silver beads, the interior was realized in a subdued pattern of grey and brown, deliberately designed to suggest the grisaille palette of film noir. The cave-like interior was littered with beaded girlie magazines, hunting knives, bottles of Jack Daniels, fishing boots, and rifles, as well as an obstructed view of a rumpled bed on which rested a supine leg and a discarded handgun.

Lou exhibited *Trailer* in 2002 alongside other beaded works, among them a snarling German shepherd, a child in an open coffin, and a man in the throes of ecstatic possession. These works introduced issues of class, religion, and fear that seemed far from the sunny insouciance of *Kitchen* and *Back Yard*. Their significance was clarified with Lou's presentation in 2004 of a remarkable semi-autobiographical performance titled *Born Again*, later transferred to video (p. 154). It presents a monologue in which Lou describes an evangelical childhood shadowed by domestic turmoil, violence, and a fear of Satan, but also illumined with moments of joy and ecstasy.

By this time, external events were intruding on her work. In 2002 a prestigious MacArthur fellowship gave Lou a measure of financial freedom. Meanwhile, the attacks of September 11, 2001, and the wars it provoked moved her work in a more overtly political direction. Having rejected the hellfire and brimstone of her childhood, she began asking how it was possible to feel at home in a world suffused with chaos, violence, and hate. Her new works included a beaded scaffold and noose, several security fences topped with razor wire, and a prison cell (p. 151 and above). The latter, in particular, revealed the distance she had traveled since the beguiling decorativeness of *Kitchen*. White and silver beads mimicked the crumbling cinderblock walls and blotchy concrete floor of an enclosure the same dimensions as a cell in the San Quentin State Prison. A bead-covered bucket sat in one corner. This austere work recalls Elaine Scarry's comments about how torture cells are perverted versions of

Liza Lou, *Born Again*, 2004. Video featuring single-take monologue written and performed by Liza Lou; directed by Mick Haggerty; 50 min.

domestic settings: "The room . . . is converted into a weapon . . . made to demonstrate that everything is a weapon, the objects themselves, and with them the fact of civilization, are annihilated: there is no wall, no window, no door, no bathtub, no refrigerator, no chair, no bed." [3]

Lou notes that these works were made in response to reports of prisoner abuse at Abu Ghraib and Guantanamo Bay. In 2005 she moved to Durban, South Africa, following what was supposed to be an exploratory visit to establish a satellite operation in a country with a long tradition of beadwork. She was entranced by the joyful exuberance with which her Zulu workers faced the adversities of their lives, and decided to stay. She has noted, "Most of the people I work with have lost their parents, lost their children, many of themselves are very sick, and yet they are the most joyous powerful people I've ever been around in my life." [4] Her works began to resonate with the political and social insecurity of her new home.

In 2006 Lou and her artisans embarked on a series of works titled *Reliefs*, which consist of variations on Islamic Prayer rugs. *Axis Defeat* (2007–8; p. 153), for instance, presents a glowing blue, red, and yellow pattern that is relatively coherent at the top but quickly begins to deteriorate and fade away as it descends. Breaking across the bottom half is a red tear that suggests a bloodstain. It becomes a

[3] Elaine Scarry, *The Body in Pain: The Making and Unmaking of the World* (New York: Oxford University Press, 1985), 41.

[4] Liza Lou, interview by Charles Schultz, *Whitehot Magazine*, October 2008, http://whitehotmagazine.com/articles/2008-interview-with-liza-lou/1631.

graphic symbol of the disintegration of social order. This theme runs throughout the *Relief* series. Prayer rugs, in themselves beautiful, have in the West become symbols of the excesses and violence of radical Islam. In Lou's hands they become landscapes riven with catastrophe, sometimes resembling sections of human skin blistering with glittering wounds.

Subsequent works have continued this theme in ever-more minimalist formats. In 2012 Lou unveiled a group of white-on-white beaded "paintings" that pay homage to personal heroes and heroines like painters Agnes Martin and Robert Ryman. In these works the geometric structures of Western modernism appear subtly ripped and broken, their disintegration suggesting a celebration of the beauty of imperfection.

Lou reports that with her new community in Durban, she feels she has come full circle. Her South African studio, filled each day with the sounds of singing, communal work, and shared tribulations, offers the kind of fellowship that her parents may have been seeking when they obliterated their past and pulled up the stakes for Minnesota. The homey domesticity of *Kitchen* and the ordered universe promised by the old-time religion of her childhood have been replaced by a sense of a world beset by chaos, irrationality, and insecurity. Yet even within this confusion, there is comfort in the sharing of work, joys, and sorrows. Reflecting on her process, she has written, "And the patient slow minutia of beadwork, being made in a place with so much chaos puts order to our day. Control the smallest thing. Take comfort here. Solve the problem of a tangled piece of cotton, or a needle that won't thread. Make something beautiful. Making something beautiful becomes a political act. Insist on beauty in spite of everything. We toi toi, we march for beauty." [5]
— ELEANOR HEARTNEY

[5] *Liza Lou: Durban Diaries* (London: White Cube, 2012).

CATHERINE OPIE

CATHERINE OPIE HAS MADE SOME of the most challenging photographs ever exhibited in a mainstream art museum, and also some of the most irresistible. But for all its variety, her entire body of work addresses, in one way or another, the question of how family is defined, and how it relates to community and place. In a 1996 interview, she said, "The underlying basis of all my work has been about . . . how communities begin to form," and went on to explain that in conventional suburbia, "the family is defined by the individual house. In the gay and lesbian S/M community, family is defined by those . . . who are close friends." [1]

Five years earlier, Opie had made thirteen portraits of young women—her friends—trying things on, literally: they sported fake mustaches and boyish facial jewelry (opposite). The photographs are close cropped, chin to hairline, and shot against a golden background, like religious icons. All the subjects stare straight at the camera. Their nicknames appear in little medallions on the frame; the one called Bo, with a heavy black mustache and a searching gaze, is Opie. The title of this series, *Being and Having*, speaks of a difference—or, perhaps, a continuum—between what one is born with and what one has gotten by an act of will, of creativity. As curator Jessica Blessing notes in an essay for the catalogue accompanying a 2008 survey of Opie's work at the Guggenheim Museum, the writing of Judith Butler helps contextualize the gender fluidity at issue in these photographs. "Gender is always a doing," Butler wrote in 1990, "though not a doing by a subject who might be said to preexist the deed." [2] Constructed and contingent, sexuality is not reducible, Butler continued, to the binary positions of hetero- or homosexuality, and neither is it in any way "natural" or fixed. "Thus, gay is to straight *not* as copy is to original, but rather, as copy is to copy." [3]

Opie's next series, *Portraits* (1993–97), extends what she termed her "royal family" to include men as well as women. Their expressions varying and their attention often focused away from the camera, the sitters are shown full-figure against intensely colored backgrounds; Opie names Holbein's portraits as a major influence for the composition of these images. Bo is here again, with mustache, plaid shirt, shit-kicker boots, and the tasseled end of what may be a whip hanging from one pocket of his jeans. "I started developing personas when I began playing in the leather community in the early '80s, and Bo's a character I just fell in love with," Opie has explained. "He represents the quiet, psychopath side of me and is a way for me to play with ideas Cathy would never be able to play with. I kind of think of

[1] Catherine Opie, "How I Think, Part I: An Interview with Catherine Opie, February 1996," by Russell Ferguson, in *Catherine Opie: American Photographer* (New York: Guggenheim Museum, 2008), 104.

[2] Judith Butler, *Gender Trouble* (New York: Routledge, 1996), 34.

[3] Ibid., 43.

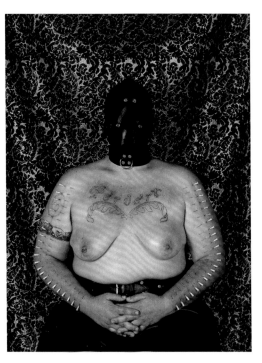

him as a serial killer from the Midwest who's a used aluminum–siding salesman." [4]

While not every viewer would have recognized Bo to be Opie, the first two photographs identified as self-portraits fall within this period, too, and they are eyeball scrapers. One shows Opie with her ample back to us; cut into it with razor blades, and still bleeding, is a stick-figure rendering of two smiling women holding hands, along with a tree and a cloud from which a sun is peeking out (*Self-Portrait/Cutting*, 1993). The next presents Opie frontally, although a leather hood entirely covers her face. Into her bare chest, the word "pervert" has been carved—it is still raw—in graceful script and underlined with a flourish; forty-six big steel needles are threaded through her arms (*Self-Portrait/Pervert*, 1994; above). Behind Opie in both portraits is a backdrop of rich brocade, as in Holbein, or heraldry; one thinks of pennants carried into battle. The last self-portrait she has made in this format is *Self-Portrait/Nursing* (2004; opposite), and the contrast could hardly be greater. Against another lush brocade backdrop, the bare-chested Opie is again seated, this time nursing an eager, happy, well-fed naked baby. They're connected by eye contact, too, and by Opie's expression, weary but serene.

Some of the artists brought to mind by these photographs—Robert Mapplethorpe, Nan Goldin, Nancy Grossman—have similarly explored regions of sexuality that had previously gotten little exposure. In Opie's next portrait series, she sought out something closer to the mainstream, while still focusing on lesbians. *Domestic* (1995–98) took her on a three-month, nine-thousand-mile road trip, during

[4] Catherine Opie, "Welcome to Opie's World," by Kristine McKenna, *Los Angeles Times*, June 26, 1994, Calendar Section, 8.

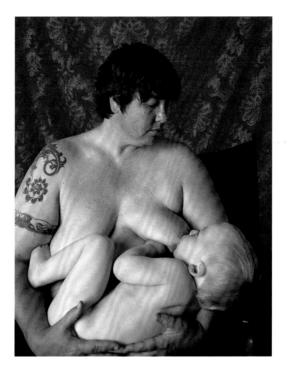

which she documented the variety of ways that women establish families together. Choosing as foil an acclaimed portrayer of the well-heeled and socially established, Opie has said, "[I] felt I was having a conversation with Tina Barney. I felt that she had become, in a way, the most prominent photographer of the family. I wanted to introduce a queer element to those representations." [5] Opie worked with a large-format (8 x 10) camera for *Domestic*, and the long exposures it required meant that the scenes she shot were to some extent staged, despite their seeming informality. For *In and Around Home* (2004–5), she came back home, to what was now a two-parent family (Opie's partner is the painter Julie Burleigh) with a young child and two dogs. This series also includes images of Opie's mixed-income, multiethnic Los Angeles neighborhood, along with screen-grab Polaroids of election-year coverage: Bush and Cheney, Terri Schiavo and Pope John Paul II, New Orleans under water. When we see Opie, in the background, amidst the furnishings of domesticity, she is out of drag, and her face is unconcealed.

To date, this is the last series that takes the artist as a subject. But portraiture continues—as does her concern with other subjects. As she explained in 1996, Opie's work has been divided almost from the beginning between people and places. *Freeways* (1994–95; overleaf) celebrates—or, perhaps, mourns—Los Angeles's early hospitality to visionary Modernist design. A series of small platinum prints devoid of people and even, mostly, of cars, it is equally indebted to Ed Ruscha's deadpan highways and Eugene Atget's melancholic Paris streets. Opie was born in the

[5] Catherine Opie, "How I Think, Part II: An Interview with Catherine Opie, May 2000," by Russell Ferguson, in *Catherine Opie: American Photographer*, 141.

rust-belt city of Sandusky, Ohio, in 1961; when she was thirteen the family moved to southern California, where she has stayed. It has long nourished her work. *Minimalls* (1997–98) is a series of black-and-white photographs of Los Angeles budget retail strips that tell their stories in polyglot signage: fresh produce, medical care, auto alarms, and aquariums are offered in Chinese, Korean, Spanish, and English. The black-and-white series *American Cities* (1999–2000) took her to (arguably) more monocultural locations—New York's financial district, Minneapolis's skyways—for early-morning shots again empty of people. Even more resolutely unpopulated are the big color photographs in *Houses* (1995–96): picturing affluent homes in Beverly Hills and Bel Air, they are dominated by doors, gates, fences, security system signs, and nearly windowless facades. Even the carefully pruned greenery looks guarded.

With *Icehouses* (2001; opposite), Opie's compositions reached a point of nearly abstract emptiness. These images show vast white vistas of snow-covered lake beneath a cold white sky, with a line of flimsy, transient dwellings becoming progressively invisible as the series proceeds, the camera receding to leave the houses perched on the horizon and nearly swallowed by blowing snow. But even here, Opie was interested in community—in a seasonal encampment of determined, self-styled outliers, setting up shacks on open territory and grabbing a few months of sublimity. As these images suggest, the polarities of empty landscape and in-your-face portraiture that shaped Opie's early work have steadily given way. The series *High School Football* (2007–10; overleaf), shot in seven states from Louisiana to Alaska, alternates between close-ups of players and long shots of teams—

Catherine Opie, *Leon* from *High
School Football*, 2008. C-print;
40 x 30 in. | 101.6 x 76.2 cm;
edition of 5.

another species of family—out on the field, in afternoon sunlight or under dramatic Friday-night lights. They're big images (roughly 4 x 5 feet) that show the adolescent athletes balanced precariously between the children they just lately were and the combat-ready superheroes they are dressed to play, bulked up with shoulder pads and helmets. Opie, the mother of a boy, clearly sympathizes with these variously long-haired, crew-cut, muscle-bound, and camera-shy teens as they strive to meet the expectations associated with this peculiarly American sport.

Opie's recent subjects vary widely; they include a Boy Scout jamboree, a Tea Party rally and a gay rights parade. One series captures a variety of public responses to President Obama's first inauguration. Another features daily sunsets on a ten-day freighter-ship voyage from Busan, South Korea, to Long Beach, California. If the former suggests the political-activism documentation of Sharon Hayes, the latter evokes the gorgeous black-and-white seascapes of Hiroshi Sugimoto. Opie is a fastidious technician who does most of her own printing and makes no substantial digital alternations. She says that waiting—longing—for the right things to appear, in a landscape, a community, or a person, is an important part of the emotional character of her work. [6]

It would seem that the urgency to express outlaw solidarity has abated for Opie, but that would simplify even her earliest photographs. Helen Molesworth has written, with respect to Opie, that "community, far from being a model of inclusion, is a very precise exercise in exclusion; a device to monitor the borders." [7] Early on, being an artist put Opie at odds with many friends who, she says, had "never even been into a museum. I was the one who left the community. . . . I chose not to be a full-time leather dyke like most of them did." [8] At the same time, she says, she felt excluded by more mainstream lesbians. Just as her own affiliations have shifted, Opie has shown that community, family, and home are all always subject to fracture. And she continues to reassemble them in ways both provocative and deeply generous.

— NANCY PRINCENTHAL

[6] Catherine Opie, "I Have Represented This Country: An Interview with Catherine Opie, December 4, 2007," by Russell Ferguson, in *Catherine Opie: American Photographer*, 261.

[7] Helen Molesworth, "Social Problem: Helen Molesworth on Catherine Opie and 'theanyspacewhatever,'" *Artforum* 47, no. 7 (March 2009): 101.

[8] Opie, "How I Think, Part I," 105.

ANDREA ZITTEL

Andrea Zittel, *A–Z Uniforms* (from left): *Spring/Summer 1993* and *Fall/Winter 93/94*, both 1993. *S/S*: linen and faile; *F/W*: wool, satin, and leather suspenders.

ANDREA ZITTEL'S CAREER BEGAN WITH repairs made to discarded household goods she found in South Williamsburg, Brooklyn, where she lived and worked in the early 1990s. These "Repair Works," careful but matter-of-fact, are early evidence of her concern with material economy. They were soon followed by "Breeding Works" (both series date to 1991), which included incubators designed for the genetic selection of greater flying ability in chickens (feed was moved incrementally higher, in stepped boxes) or for the suppression of special plumage (an arrangement of boxes that forced breeds to mingle). Flirting on the one hand with eugenics, the most extreme form of social planning, and on the other with the egalitarian averaging of heritable advantage, while at the same time tinkering with the design of ideal habitats—with family residences—this series was a radical statement of ideas that have continued to impel Zittel's work.

Within a year of completing an MFA, at the Rhode Island School of Design in 1990, Zittel had established the label A–Z, under which she launched an "Administrative Apparel" line (opposite); "A–Z Administrative Services" followed in 1991. Along with clothing that favored material simplicity and the stripped-down geometry of Constructivist costume design, she offered collectors daily regimens meant to enhance their social and professional lives. For instance, the *A–Z Jon Tower Life Improvement Project* (1991–92) featured a daily plan written out in a ring binder; the *Collector's Coat for Frank Kolodny* (1993) included a detachable pocket for the international edition of *Gallery Guide*. By 1993 Zittel had begun to create portable modular rooms made of steel frames, inexpensive wood panels, and simple commercial appliances. The "A–Z Living Units," "Comfort Units," and various other function-based modules (bedrooms, bathrooms, offices) are visually refined and spatially thrifty, like the interior fittings of boats or RVs; indeed "A–Z Travel Trailer Units" and "Escape Vehicles," both customizable by their owners, appeared in the mid-1990s. Sometimes multiple uses are compressed past the point of comfort, whether physical or psychological, as in the *Body Processing Unit* (1993; overleaf); its shelves, hot plate (for bodily intake), sink, and commode (output) are stacked in a narrow structure that can be collapsed to the size of a steamer trunk. There are dining tables with depressions in their wooden tops that serve as built-in "dishes," perhaps for serving meals prepared using the "A–Z Food Group" (1993), whose twelve "essential ingredients"—grains, legumes, fruits, and vegetables—can be eaten raw, stewed, formed into patties, or baked as a loaf.

Not concerned just with designs that optimize utility in minimal space, or with shaping so-cial—and solitary—domestic behavior, Zittel is also interested in using materials in ways that reduce her environmental footprint while promoting conceptual purity. Thus the initial line of apparel, lean shifts and jackets expertly tailored from commercial textiles including taffeta, tulle, and wool, was followed by uniforms cut from single bolts of fabric and shaped only with a single seam, or a safety pin, and then by the flowing, freeform "A–Z Single-Strand Uniform" (1998–2001), crocheted from unbroken lengths of yarn. Ultimately she dispensed with even the crochet hook, and crocheted the yarn using her fingers. Most recently, Zittel developed a line of hand-felted clothing, using a pre-industrial method that produces garments riddled with irregular holes. The eccentricity reflects her evolving ideas of how form should express function: the "Escape Vehicles," she has noted, "look mass-produced in order to critique how situations of escape and leisure are so completely mediated by a recreation 'industry.'" On the other hand, the recent uniforms are "quite organic and hand-made because I want to suggest a way that uniformity could still be intimate and expressive." [1]

All of Zittel's work has been driven as much by the language with which she frames it as by the forms she chooses, and the promotional materials she has developed, including posters, brochures, and websites, deliberately employ the unmistakable voice of mainstream advertising. Conceding that the position it stakes out is paradoxical, she has explained, "Ads allow me to say what I believe or hope that the products will do, and since everybody understands the language of advertising as one of fantasy, I don't feel like I am leading people on or lying to them." [2] Nonetheless, the utopian implications of Zittel's work, its resourceful pragmatism, and its increasing emphasis on harmony with the natural world, have led critics to invoke, as forebears, such pillars of American thought as Thoreau, Emerson,

TOP
Andrea Zittel, *Prototype for Processing Unit*, 1993. Wood, metal, Plexiglas, black vinyl, A–Z Food Group sample, and lighting fixture; closed: 36 x 36 x 18 in. | 91.4 x 91.4 x 45.7 cm; open: 72 x 18 x 18 in. | 182.9 x 45.7 x 45.7 cm.

OPPOSITE
Andrea Zittel, *A–Z Deserted Islands I–X*, 1997. Fiberglass, wood, plastic, flotation tanks, vinyl seat, and vinyl logo; each: 36 x 90 x 90 in. | 91.4 x 228.6 x 90 cm. Installation view, Central Park South Pond, New York, May–September 1999; commissioned by The Public Art Fund.

[1] Jacqueline Khiu, "Life's Work," *Surface: Annual Design Issue*, no. 59 (Summer 2006): 106.

[2] "Andrea Zittel in Conversation with Allan McCollum," Tema Celeste Editions, Gabrius Spa, Milan, 2002, 4.

[3] See Robert Cook, "New Deeds: A Frontier Practice," in *Andrea Zittel: Critical Space* (Munich: Prestel; Houston, Contemporary Arts Museum; and New York: New Museum of Contemporary Art, 2005), 30–35.

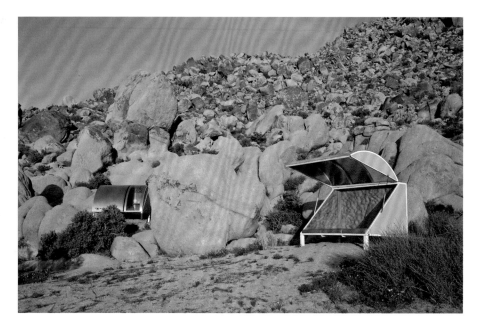

Wagon Stations in situ at A–Z West, April 2011. Left: *A–Z Wagon Station customized by Connie Walsh and Chris Young WGNSTN*, 2003. Powder-coated steel, MDF, aluminum, and Lexan; closed: 61 x 82 x 57 in. | 154.9 x 208.3 x 144.8 cm; open: 91 x 82 x 57 in. | 231.1 x 208.3 x 144.8 cm. Right: *A–Z Wagon Station customized by Giovanni Jance*, 2003. Powder-coated steel, MDF, aluminum, Lexan, cushions, iPod Nano, headphones, and solar iPod chargers; closed: 61 x 82 x 57 in. | 154.9 x 208.3 x 144.8 cm; open: 91 x 82 x 57 in. | 231.1 x 208.3 x 144.8 cm.

and John Dewey, [3] as well as paradigmatic English and European integrations of the fine and applied arts: William Morris's Arts and Crafts movement, the Wiener Werkstätte, the Bauhaus. (The uniforms and dietary regimens that Johannes Itten developed for his Bauhaus students seem especially relevant.) More recent peers include the sculptor/designers Atelier Van Lieshout, Jorge Pardo, and Liam Gillick, and Rirkrit Tiravanija in his guise as public chef.

But there is also, arguably, a gendered aspect to Zittel's explorations, and important precedents in the commitments to communal domesticity represented, and enacted, by activist women artists of a preceding generation. Connie Butler writes, "I read this investigation-cum-life project in feminist terms and propose that Zittel's work occupies a curious conceptual space somewhere between Robert Smithson's invention of the non-site and what I'll call the 'collective domestic,' an impulse forged by Zittel's feminist predecessors in the 1970s." [4] For her part, Zittel says she is more interested in revealing the distance between what we want and what we have than in realizing any vision of social or physical melioration. "One of the great misconceptions about my work," she says, "is that I'm interested in im-

[4] Cornelia Butler, "Live/work Space," in *Andrea Zittel: Critical Space*, 59.

Andrea Zittel, *A–Z Homestead Unit* with *A–Z Raugh Furniture*, 2001–5. Exhibition view, *Andrea Zittel: Critical Space*, Albright Knox Gallery, Buffalo, N.Y., 2006–7.

proving functionality. In reality, I'm interested in the rhetoric of 'improvement' because it expresses so much desire about the way we wish the world could function. It seems to me that there is little inherent purpose, order or justice in this world." [5]

Having lived in New York for nearly a decade, Zittel moved her focus of operation to her native California in 2000 (she was born in Escondido in 1965), investing $40,000 to buy five acres of desert near Joshua Tree and establishing A–Z West there (the last of her several Brooklyn bases, which she retains, has been named retroactively A–Z East). She has expanded an old homestead into her residence, and built a big new studio (after working in a trio of shipping containers). Through the High Desert Test Site (HDTS) program, she hosts visiting artists and students; as of spring 2012, construction was underway on a communal kitchen/bathhouse for temporary residents. Recycling and repurposing are increasingly important to her work, which since the late 1990s has included "A–Z Raugh Furniture," roughly hewn (with an electric kitchen knife) from slabs of dense gray foam (above). In the past few years she has begun to make wall units fashioned from cardboard boxes stiffened with plaster-imbued bandaging material.

[5] Khiu, 106.

Being back in California refocuses attention on a performative element that has been part of Zittel's work from the outset, and emphasizes questions about whether her projects can be seen not just as provocative design prototypes, but also as a species of film sets, expressly illusory. These ambiguities were explored as early as the "Carpet Furniture" of 1992 (below): rugs patterned with geometric representations of beds, chairs, sofas, tables. Placed on the floor, they indicate positions for domestic activity. But they can also hang on the wall. "I like the way that the Carpet Furniture spins around a painterly dispute between representation and literalism," [6] Zittel explained. And, talking more generally about her presence in Joshua Tree, "The more direct I became, the less distinction I felt between what is real and what is not real." [7] Along with the renewed proximity to Hollywood, the desert itself promotes these questions. The A–Z West site is stunningly beautiful, but it is remote and austere, and characterized by extremes of temperature that accentuate the sense of departure from the quotidian. In this context, the "Wagon Stations" (2003–ongoing; p. 168) that dot the landscape, solitary sleeping pods with curved Plexiglas hatches, seem especially space-age, and perhaps a little martial. Reinforcing that association is the nearby Twenty-nine Palms Marine Corps base (the nation's largest); in early 2012, troops were training there at a mock Afghan village.

Andrea Zittel, *A–Z Carpet Furniture (Table with Two Chairs)* and *A–Z Carpet Furniture (Brown and Red Double Bed)*, 1993. Silk and wool dye on wool carpet; each 94½ x 72 in. | 240 x 182.9 cm.

[6] "Andrea Zittel in Conversation with Allan McCollum," 6.

[7] "A–Z Drive Thru Conversation: Beatriz Colomina, Mark Wigley, and Andrea Zittel," in *Andrea Zittel: Critical Space*, 45

Retreat from the social and commercial demands of the New York art world is certainly one impulse behind Zittel's move; there were personal ones as well. Describing a childhood that included venturesome and sometimes hair-raising family travel, Zittel has said, "All I wanted was to feel safe and secure when I grew up, because I never felt like that when I was a kid. Everything was so precarious, all the time." [8] Her many efforts to carve out privacy—if not stability—began with a series of *Deserted Islands*, single-occupancy white fiberglass floes (each had a vinyl seat) that appeared in a lake in Munster (as part of its Sculpture Project) in 1997, and a pond in New York's Central Park in 1999 (under the auspices of the Public Art Fund; see p. 167). These first islands were only notionally functional. But in 2000 she created the fully habitable *Pocket Property*, a concrete island in the waters north of Copenhagen that she expected to be a retreat from a hectic social season. Instead, she found herself the focus of attention from seaborne visitors. "After a while I just felt so overexposed that for the next project I've chosen a piece of land out in the desert, where no one will see me and I can finally be completely alone," she told an interviewer just before moving to Joshua Tree. [9]

Once again, however, she finds herself a tourist attraction at A–Z West, and has grown used to people driving up and peering in her window. And having a public presence, or at least a social one, is surely part of the point. Her home in Brooklyn was also a studio and proving ground where she hosted weekly gatherings; the HDTS projects, low-budget and highly improvisational, are similarly convivial, though their embrace is not just of fellow artists but also of the local community and natural environment. "From the start," Zittel says, "there was an awareness that art has both a positive and a somewhat corrupting effect on the landscape." And they are undertaken with knowledge that the desert pushes back: "Weather plays a big role in what is actually possible—it demolishes the ambitious projects and favors the fluid ones." In short, flexibility is a paramount requirement. "If the events could be described in two words," Zittel says, "*chaos* would be both of them." [10]

A son born in 2004 has also necessarily taken Zittel into her community in a new way, even though she is home-schooling him; just as surely, parenthood invites chaos. Alternating between the poles of a tightly rule-bound, ascetic life, and one of wildly unpredictable communal activity, Zittel has introduced a wholly unfamiliar set of parameters for domesticity, privacy and the public realm.

— NANCY PRINCENTHAL

[8] Stefano Basilico, "Andrea Zittel," *Bomb* no. 75 (Spring 2001): 5–6, http://www.bombsite.com/issues/75/articles/2381.

[9] Basilico, 6.

[10] Lisa Anne Auerbach and Andrea Zittel, "A Text About High Desert Test Sites," *Artforum* 44, no. 10 (Summer 2005): 284.

HISTORY LESSONS

by Helaine Posner

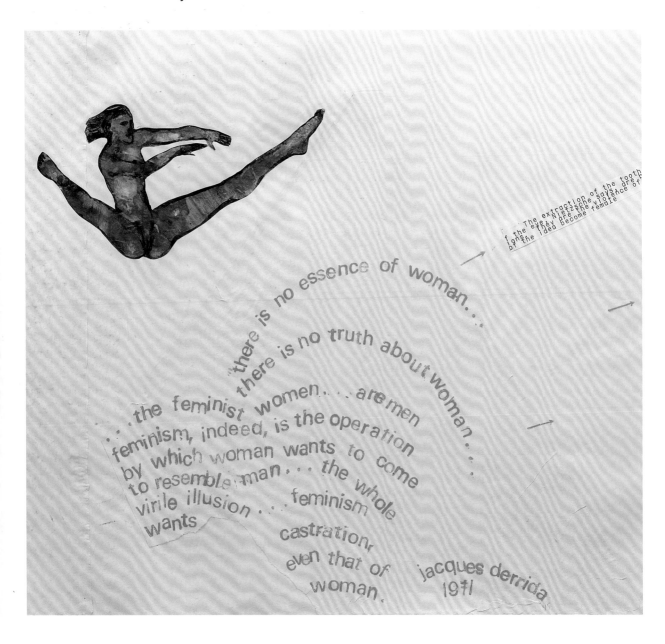

...there is no essence of woman...

...there is no truth about woman...

...the feminist women...are men

feminism, indeed, is the operation by which woman wants to come to resemble man...the whole virile illusion...feminism wants castration, even that of woman.

jacques derrida 1971

The extraction of the tooth of the eye...Nietzsche says...long...they are the violence of...of the idea become female or of

In the 1970s artist and activist Nancy Spero created an epic work of feminist art titled *Torture of Women* (1976) documenting women's pain and victimization across cultures and times in a series of fourteen delicate hand-printed and collaged works on paper. In these scrolls, Spero combined mythological tales and figures with contemporary media accounts to reveal a hidden history of atrocities committed against women around the globe. Fueled by a rage both personal and political, Spero's panels bear witness to the physical and psychological trauma of torture and rape used against women as a method of state control.

Spero expanded her study of victimage in *Notes in Time on Women* (1976–79; opposite and below), a chronicle of the history of subjugation and denigration of women in all its manifestations. This monumental work, measuring 215 feet in length over twenty-four panels and containing a total of ninety-six typewritten statements, includes accounts of the torture and murder of women compiled by Amnesty International, as well as quotations from male writers and philosophers throughout the ages, such as Hesiod, Pliny, Nietzsche, Derrida, and Levi-Strauss, that blatantly express the misogynist thinking that pervades much of Western culture. The artist quotes the Roman philosopher and naturalist Pliny, who "warned that menstruating women could cause bees to abandon their hives, pregnant women to miscarry," as well as the disturbing title of Oskar Kokoschka's theater work *Murderer, Hope of Women* (1909), printed in bold red letters. In one of the more telling quoted passages, the influential French philosopher Jacques Derrida declares that "there is no essence of woman ... there is no truth about woman ... the feminist women ... are men / feminism, indeed, is the operation by which woman wants to come to resemble man ... the whole virile illusion ... feminism wants castration, even that of woman."

Spero countered this litany of abuse with her most powerful weapon—imagery of the unfettered female body in motion. Drawn from ancient myth through modern times, these figures boldly dance, run, and leap across the scrolls using their energy, strength, and sexuality to disrupt the text and actively assert their autonomy: a nude woman leaps over the Derrida quote with legs thrust apart in a spirited rejection of its message; Artemis, Greek goddess of the hunt, strides

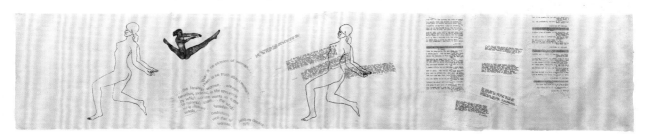

forward with her arm raised in a commanding gesture; a figure from an Attic amphora takes a stroll with an enormous dildo tucked under her arm; while a row of naked women run with arms flung back and chest thrown forward. In her most important and ambitious work to that date, Spero succeeds in bringing "history into art," vividly describing women's experience of pain and oppression under patriarchy while envisioning an alternative, more empowered, future. [1]

Notions of women's power and vulnerability, the construction of identity in the social field, and the intersection of political fact and imagined future continue to inform the socially aware, largely conceptual practices of the younger women artists featured in "History Lessons," as well as many of their peers. How-

Kerry James Marshall, *Great America*, 1994. Acrylic and collage on canvas; 103 x 114 in. | 261.6 x 289.6 cm. National Gallery of Art, Washington, D.C.; Gift of the Collectors Committee, 2011.

[1] Christopher Lyon, *Nancy Spero: The Work* (Munich: Prestel, 2010), 211.

Barbara Kruger, *Untitled (Your body is a battleground)*, **1989.**
Photographic silkscreen on vinyl; 112 x 112 in. | 284.5 x 284.5 cm.
The Broad Art Foundation, Santa Monica.

ever, unlike the artists of Spero's generation who commented on contested histories as outside observers from major world powers, the current generation of international women artists creates work from an insider's point of view. For these artists, the concept of personal identity politics, so central to the discourse of the 1970s and '80s, has receded as the self has come to be seen more often in relation to society at large. Typically, the artists who came of age in the 1990s shifted focus from the politics of women's oppression to a broader consideration of social and political concerns as seen through a feminist lens.

However, the cultural impact of identity politics and multiculturalism during the 1980s and beyond cannot be underestimated. It was in the 1980s that, for the first time, artists that were marginalized based on gender, race, ethnicity, and sexual preference began to gain major notice for work that challenged the Western canon, exposing it as a limited, exclusionary standard, dominated by white males. Artists such as Kerry James Marshall (opposite), Kiki Smith, and David Wojnarowicz brought overdue attention to the issues of racial, gender, and queer identity, respectively, through significant bodies of figurative art. Speaking in a variety of voices, and offering personal perspectives from multiple backgrounds, these artists conceived an artistic practice and, by extension, an art world, capable of reflecting the diversity and complexity of the real world. As obvious as this goal may seem today, it marked a sea change at the time and laid ground for the globalization of the art community in the twenty-first century.

At the same time, a number of women artists, such as Jenny Holzer, Barbara Kruger (above), Cindy Sherman, and Carrie Mae Weems, were exploring issues of gender identity and its representation in light of postmodern theory, creating works that revealed the self to be a social construction rather than an expression of one's essential nature. They suggested that the notion of individuality had become obsolete in the context of a media-saturated world in which advertising,

Krzysztof Wodiczko, *The Tijuana Projection*, 2001. Public projection at the Centro Cultural de Tijuana, Mexico; organized as part of the event InSite 2000.

television, and the movies shaped visual culture more powerfully than individual agency. These artists appropriated the visual languages of the mass media to unveil its codes and reveal embedded gender, sexual, racial, and class-based inequities. [2] Advances in communications, the growth of capitalism, and expansion of corporate culture that developed in the 1980s enabled forms of control, constraint, and manipulation of women that were more subtle and more pervasive, prompting an equally sophisticated response on the part of women artists of the time.

The issues concerning the artists presented in "History Lessons" reflect a general shift away from the politics of personal identity to a greater emphasis on the individual's responsibility to society and the world at large in the twenty-first century. This international group, from nations including Cuba, Ethiopia, Israel, Mexico, and the United States, explore a range of political, social, and cultural concerns that resonate both in their homeland and around the world. They are part of a larger phenomenon of globalization, a worldwide form of interdependence and exchange characterized in part by an unprecedented expansion of technology and information networks, and the opening up of markets and explosion of wealth in India and China, the world's biggest nations. And while globalization is acclaimed for breaking down barriers and creating access and opportunity across many fields, it is not without critics, many of whose detractions center on the leveling or homogenization of cultural difference, or the gradual Westernization of non-Western cultures effected by this phenomenon. [3] In short, they question whether the center will embrace or quash the periphery.

There are others who wish to dispense altogether with the dichotomy of center and periphery. In 2007 the Brooklyn Museum organized an exhibition titled *Global Feminisms* that looked at issues of multiplicity in a more democratic fashion. In the exhibition catalogue, curator Maura Reilly rightly characterized feminism, as it emerged in the 1970s, as a largely Western, white, heterosexual, middle-class movement whose primary aim was combating sexism and empowering women in the same social milieu. The strength of the movement's solidarity was predicated in large part, Reilly argues, through the movement's failure to ad-

[2] Helaine Posner, "Hot and Cool: Feminist Art in Practice," in *The Deconstructive Impulse: Women Artists Reconfigure the Signs of Power, 1973–1991*, ed. Nancy Princenthal (Munich: Prestel, 2011; Purchase, NY: Neuberger Museum of Art), 11.

[3] Eleanor Heartney, *Art & Today* (London: Phaidon, 2008), 292.

dress issues of racial, class, sexual, and other cultural differences between women that might complicate the aim of gender equality.

As the 1990s progressed, it became clear that in order to fully address the experiences and concerns of women from various places with necessarily diverse perspectives, "feminism" would need to expand to include multiple "feminisms." The concept of multicultural or transnational feminism emerged to reflect the interests of women from different economic and socio-cultural backgrounds, including those from developing countries as well as major world powers. [4] From this point on, feminism went global as feminists began to engage the world at large. In fact, today's widespread engagement with global social concerns may be traced in part to feminism, which helped validate the exploration of gender and racial identity, economic and class-based imbalances, nationalism and dislocation, and related topics.

This is the context from which the artists included in "History Lessons" and their peers emerged. Not surprisingly, these artists tackle a wide range of subjects, from global issues to national concerns, in a world that has become increasingly mobile and interconnected. Artist Tania Bruguera, whose early performance and installation works deal with the intense political, psychological, and economic pressures of life in Cuba under Fidel Castro, has become something of a cultural nomad. She has traveled to such hot spots as Havana, Moscow, Bogotá, and the Palestinian territories to create politically engaged installations that explore cross-cultural issues of power and powerlessness, examining the impact of government authority on the lives of its citizens with the aim of raising awareness and encouraging social change.

In recent years Bruguera's work has grown increasingly participatory, as she employs performance as a way to catalyze audience response and reaction on social issues, while also embarking on an activist practice that uses art to seek solutions to social problems. Her current long-term project, *Immigrant Movement International*, is a socio-political movement formed in the ethnically diverse borough of Queens, in New York, to address the challenges faced by this ever-growing, often disenfranchised population. The ethi-

Doris Salcedo, *Noviembre 6 e 7, 2002*. Installation at the Palace of Justice, Bogotá, Colombia, 2002.

[4] Maura Reilly, "Introduction: Toward Transnational Feminisms," in *Global Feminisms: New Directions in Contemporary Art*, ed. Reilly and Linda Nochlin (London: Merrell Publishers; New York: Brooklyn Museum). See Reilly's essay for a fuller discussion of this subject.

Lida Abdul, *What We Saw upon Awakening*, 2006. 16mm film transferred to DVD; 6:50 min.

cal impulse to give voice to marginalized, disempowered communities, and the violence that may affect their lives, is shared by a number of international artists. They include Krzysztof Wodiczko, who projects slides and videos of politically charged images onto architectural sites revealing the trauma of homelessness, domestic abuse, rape, and industrial poisoning, among other calamities (p. 176); and Doris Salcedo, whose sculptural objects and installations address the effects of war, political oppression, and other violent acts in her native Colombia (p. 177).

The plight of those dispossessed from their homelands due to government action such as war or occupation is the subject of the video, performance, and conceptual work of Lida Abdul and Emily Jacir. Afghani artist Abdul's multimedia art is a poetic reflection on the devastation wrought by decades of invasion, civil war, violence, and political instability in her native land. A former refugee who fled Afghanistan a few years after the Soviet invasion, Abdul returned to Kabul in 2001 where she produced several videos using her birthplace as a backdrop. In *What We Saw upon Awakening* (2006; above), the artist attempts to comprehend the destruction of her country and the trauma of its people using ruined architecture to symbolize all that was lost. In this work a group of black-robed men pull on ropes attached to a bombed-out structure in a seemingly futile effort to tear it down and, in so doing, erase painful memories and clear a path to the future. The dream of reclaiming a sense of national identity in a battered land seems elusive at best in Abdul's *What We Have Overlooked* (2011), a two-channel video originally presented as part of the Afghani contribution to Documenta 13, in which a man tries to plant a flag in a shallow lake near Kabul, repeatedly loses his footing, and slowly is submerged.

In *Where We Come From* (2001–3; opposite), Palestinian-American artist Emily Jacir poses the simple question "If I could do anything for you anywhere

in Palestine, what would it be?" to more than thirty Palestinians living within the occupied territories and in exile in Lebanon and Syria, and across the United States and Europe. She collected the responses and fulfilled their wishes by proxy, documenting these actions in series of conceptual photograph-and-text works. Requests ranged from the everyday, such as, "Go to Haifa and play soccer with the first Palestinian boy you see on the street," to acts that reveal the deep pain of diaspora, as in, "Go to my mother's grave in Jerusalem on her birthday and place flowers and pray." With an insider's perspective and the freedom afforded by an American passport, Jacir sheds light on the toll that occupation and displacement has taken on her people, about half of whom live as stateless refugees.

In the essay accompanying the 2010 exhibition *And Europe Will Be Stunned*, curator Joa Ljungberg describes Israeli video artist Yael Bartana's works as "foreboding mediations on the identity forming rituals of Israeli society." He observes: "In recent productions she portrays the predicament confronting her homeland with increased complexity, taking us back in history and forward to an imagined future" [5] recalling Spero's *Notes in Time*. Like Bruguera, Bartana founded a movement, in this case more symbolic than real, named the Jewish Renaissance Movement in Poland, calling for the return of 3,300,000 Jews to Poland, the popula-

Emily Jacir, *Where We Come From*, 2001–3 (detail). American passport, 30 texts, 32 c-prints, and video; text (Jihad): 9½ x 11½ in. / 24 x 29 cm; photo (Jihad): 10 x 10 in. / 25.4 x 25.4 cm.

[5] Joa Ljungberg, "A Dizzying Appeal for Reconciliation," in *Yael Bartana: And Europe Will Be Stunned* (Berlin: Revolver Publishing), 10.

tion living there on the eve of the Holocaust. In the epic *Polish Trilogy* (2007–11), a sequence of three video works, she traces the arc of the movement's progress from a rally at a Polish stadium, through the construction of a kibbutz, and, finally, to the (fictional) assassination of the movement's leader. Bartana's project takes the viewer on a telling journey through the fraught history of Europe and the Middle East in the twentieth and twenty-first centuries, proposing that we look beyond the conventional limits of nationalism toward the utopian possibilities of unity and reconciliation within and across borders.

Painter Julie Mehretu takes a more abstract look at issues of global exchange in the twenty-first century. She employs a dynamic visual vocabulary to build densely layered paintings that convey the speed and energy of the urban environment. Her work engages architecture, geography, history, and urban life through schematic drawings of maps, architectural plans, and urban grids, which she overlays with vibrant shapes and colors recalling the Italian Futurists, Russian Constructivists, and other early modernists. Born in Addis Ababa to an Ethiopian father and an American mother, raised in Michigan, and now living in New York, Mehretu is truly a world citizen. This fact is reflected in paintings that seem to compress time and place as the artist blends the real with the imaginary to create what she calls "story maps of no location." [6]

While Bruguera, Bartana, and Mehretu tackle global issues from varied perspectives, artists Teresa Margolles, Kara Walker, and Sharon Hayes focus on domestic concerns with implications beyond national borders. For Mexican artist Teresa Margolles, the primary subject is death, specifically, the devastating impact of increasing drug-related violence on the poor and disenfranchised of her country. Her startlingly visceral installations and objects, which make use of human blood and body parts, among other materials, draw attention to a national tragedy that claims thousands of lives each year and shows no signs of abating. Margolles's work offers a compassionate commentary on local strife, while also pointing to the "dark side of globalization"—in particular, the corrosive impact of the North American Free Trade Agreement (NAFTA), which devastated Mexico's rural economy and inadvertently strengthened the drug cartels which thrive on social instability. [7]

American artists Kara Walker and Sharon Hayes explore the ways in which racial and sexual identity intersect with the public sphere. Walker is best known for using the eighteenth-century art form of cut-paper silhouette to create

[6] Julie Mehretu quoted in the artist's page on the White Cube gallery website, http://whitecube.com/artists/julie_mehretu.

[7] See Eleanor Heartney's discussion of the artist in this book, 204–11.

room-size tableaux that examine issues of race and power, from the shame of slavery in the antebellum South to the racist legacy that haunts the United States to this day. In her hands, this genteel medium is transformed into a type of historical burlesque in which sex and violence, desire and shame, and power struggles of all kinds play out in highly provocative, sexually explicit scenarios. Walker's silhouettes serve to uncover the darker side of America's history, exposing racial and gender biases that we prefer to ignore.

Sharon Hayes literally injects the personal voice into the public realm. Her work recalls the idealism of 1960s protest movements and their faith in the power of language to change hearts and minds. Her performance and video works often take the form of public speeches, protest marches, and demonstrations evoking a time when political beliefs, typically anti-war and pro-social justice, were more freely expressed in the public arena. However, the private expressions of longing and desire that are her "message" are more clearly the product of the present day, when the distance between private and public space has nearly collapsed. In the performance *I March in the Parade of Liberty, but as Long as I Love You I'm Not Free* (2007–8), for example, the artist walked to several sites in lower Manhattan known for public speaking, such as Tompkins Square Park and Washington Square, and addressed a romantic monologue to an absent lesbian lover. Similarly, in *Everything Else Has Failed! Don't You Think It's Time for Love?* (2007–8), Hayes voiced secret desires along with political concerns outside the corporate headquarters of UBS bank in midtown Manhattan during lunchtime. She refers to these works as "speech acts" in an acknowledgement of the transformative power of language to effect real world change.

Hayes's charged combination of politics, public speech, and private emotion is both poignant and bold. Like each of the artists featured in "History Lessons," she has a deep personal investment in the social and political issues she chooses to explore. These issues, including immigration, asylum, poverty, violence, racism, and sexism, among others, reflect the interests of a group of artists who are mindful of the past while being fully engaged in the present. And like Nancy Spero, whose epic history of women's oppression forms the cornerstone of this chapter, the socially conscious work of these artists is also a form of cultural activism in which each artist, in her own way, attempts to make a difference in the world.

YAEL BARTANA

IN AN ESSAY WRITTEN FOR the exhibition catalogue *Wherever I Am: Yael Bartana, Emily Jacir, Lee Miller*, British novelist and journalist Linda Grant notes, "There is in Israel a vitality and a sadness, a violence and longing for escape from violence, a need to be normal despite everything, and the knowledge that nothing is normal or ever was. If things were normal you would not have to send your son to Gaza or Nablas, you would not worry when your daughter takes the bus to school, you would not worry if your country will survive, or if it will survive but only by strangling another. If anything was normal you would be in Warsaw or Fez or Paris or Vilnius or Shiraz or Baghdad where your parents and grandparents were. And yet the whole point of being here was to be normal." [1] A keen observer of Israel's present and past, Grant vividly captures the ongoing tensions and contradictions that describe daily life in this contested land. It is the complicated terrain explored by Israeli-born video artist Yael Bartana, initially in works documenting the rituals that shape her native country and, more recently, in imaginative narratives critically examining the history of Europe and the Middle East in the twentieth and twenty-first centuries.

As an Israeli who has studied, lived, and worked in the United States and Europe, Bartana comments on the memorial rituals, social diversions, and religious celebrations that define her country's national identity, from the perspective of a native and with the objectivity of an outsider. She has described herself as an "amateur anthropologist" who, like an immigrant, understands what it means to be a stranger in a strange land. This is a particularly compelling task in a country like Israel where public obligations such as military service define collective identity, and are critical to the nation's survival. In the video *Trembling Time* (2001; opposite), for example, the artist looks at a solemn state-sanctioned ritual meant to address the shared trauma of a militarized nation. From a vantage point above a Tel Aviv highway, she depicts the moment when a siren sounds and citizens across the country stop to observe two minutes of silence in remembrance of Israel's fallen soldiers. Using techniques such as slow motion and cross-fading to dreamlike effect, Bartana creates a haunting image of drivers slowing to a halt, emerging from their vehicles for a moment of mournful silence, and driving off into the night. *Trembling Time* provides a moving record of a ceremony commemorating the sacrifice and loss of a nation subject to constant conflict, while also offering a subtle critique of the individual's unquestioning conformity to the demands of the state.

[1] Linda Grant, *Wherever I Am: Yael Bartana, Emily Jacir, Lee Miller* (Oxford: Modern Art Oxford, 2004), 14.

Bartana takes a look at another revealing rite of Israeli society in *Kings of the Hill* (2003; above), a video documenting a weekly event in which Israeli men gather along the steep coastal hills outside Tel Aviv to drive their large sport utility vehicles up precipitous slopes. The title refers to the children's game now played by grown men in an aggressive and arguably empty demonstration of machismo. In the opening shots, the driver of a white jeep perched at a forty-five-degree angle literally spins his wheels and fails in his mission; later on, following a successful climb, a driver briefly savors his victory only to turn around and repeat the assault again. For adult and child, the goal remains the same—to lay claim to the land. This proves to be a Sisyphean task in a place where the contest over land is a perpetual problem, and in which even harmless social activities recall the brutal Israeli-Palestinian conflict. Significantly, this ritual also references an archetype of modern Israeli culture,

Yael Bartana, *Summer Camp*, 2007.
Two-channel video installation
with sound; 12:00 min. Sound by
Paul Dessau and Daniel Meir.

"the Revisionist ideal of the 'New Jew,' the fighting gentleman . . . whose motto is 'either conquer the hill or die.'" [2] This figure, born of the Zionist Labor Movement of the 1920s, is the strong young pioneer who came to physically reclaim and cultivate the land while building a modern society.

Zionist ideology, with its rallying cry "to build and be rebuilt," also informs Bartana's video *Summer Camp* (2007; below), her first work to employ a linear narrative and to borrow its visual style from Zionist propaganda films of the 1930s and '40s. In this video she documents the efforts of the Israeli Committee against House Demolition (ICAHD), an international group that includes Israelis, Palestinians, and other activists, as they reconstruct a Palestinian house in the village of Anata, previously demolished by the Israelis due to its location within the Occupied Territories. This is a largely symbolic act since Palestinians are not permitted to live within Jerusalem's borders and the house, once rebuilt, soon will be torn down by the authorities. In the installation, Bartana pairs her video with Helmar Lerski's 1935 Zionist propaganda film *Awodah* (or *Work*), celebrating the pioneering labors of early Jewish settlers in Palestine, to underscore the paradox of ICAHD activists applying the Israeli moral imperative to build as a form of resistance against the aggression of the state. In this way, Bartana draws attention to the sobering fact that Israel's

[2] Galit Eilat, "Thoughts about Place, Men and Technology following Yael Bartana's *Kings of the Hill*," in *Wherever I Am*.

utopian dream of a homeland has triggered a crisis for the Palestinian people and created an ongoing challenge for the Middle East.

Around 2006 Bartana embarked on a project whose approach may be familiar to readers of fiction such as Philip Roth's *Operation Shylock* and *The Plot against America*, and those who have seen Quentin Tarantino's film *Inglourious Basterds*, but is seldom seen in the realm of visual arts. In the epic *Polish Trilogy* (2007–11) Bartana presents an alternate history of Poland's and Israel's traumatic past as the springboard to an imagined future. The ghost of the Holocaust hovers over this project in which the artist employs narrative and aesthetic techniques from filmmaking to create a work that blends fiction with reality. In reality, of the six million Jews murdered during the Holocaust, over three million were Poles (of a total Polish-Jewish population of 3,300,000), including Bartana's grandparents. In response to this fact, she founded the semi-fictional Jewish Renaissance Movement in Poland with the utopian goal of establishing a new multicultural society in a country whose notorious history of anti-Semitism lingers to this day. Bartana's JRMiP's manifesto calls for Jews and others seeking asylum to return to Poland "to heal our mutual trauma once and for all… [and] welcome new settlers whose presence shall be the embodiment of our fantasy of a parallel history." [3] The artist presents this alternate

Yael Bartana, *Mary Kozymary* (*Nightmares*), 2007. Single-channel video installation with sound; 10:50 min.

[3] Yael Bartana, "The Jewish Renaissance Movement in Poland: A Manifesto," in *And Europe Will Be Stunned* (Malmo: Moderna Museet), 183–87.

Yael Bartana, *Mur i Wieza* (*Wall and Tower*), 2009. Single-channel video installation with sound; 15 min.

Yael Bartana, *Zamach* (*Assassination*), 2011. Single-channel video installation with sound; 35 min.

history in a series of videos tracing the progress of the movement from its inception at a rally in a Polish stadium, through the building of a kibbutz on the site of the former Warsaw ghetto, to the assassination of and memorial for the leader.

In the first video, titled *Mary Kozmary* (*Nightmares*, 2007; p. 186), Slawomir Sierakowski, an actual Polish activist and intellectual and the protagonist of the trilogy, echoes this call to return. Sierakowski strides into Warsaw's empty, rundown Olympic Stadium and delivers a rousing speech proclaiming, "Let the three million Jews that Poland has missed . . . chase away the demons. Return to Poland, to your country!" as a small audience comprised of a scout troop stencil the slogan "3,300,000 Jews can change the lives of 40,000,000 Poles" on the grass. While his speech brims with hope, possibility, and emotion, the film's setting and cinematography, and Sierakowski's rhetorical style, chillingly recalls Leni Riefenstahl's Nazi propaganda films, including *Olympia*, a documentary on Berlin's 1936 Olympic games, and *Triumph of the Will* (1935), a film of a Nazi Party rally commissioned by Adolf Hitler. It seems the desire for tolerance and reconciliation between longstanding adversaries may remain a distant dream, and the notion of a return to Poland—which is in a sense more a Jewish homeland than Israel—the illusion of a once-oppressed and displaced people who have proceeded to displace and occupy another. On the other hand, the Jewish Renaissance Movement in Poland may

provide a valuable model for thinking outside the conventional limits of nationalism in an increasingly global world.

In chapter two of Bartana's Polish Trilogy called *Mur i Wieza* (*Wall and Tower*, 2009; p. 187), members of the JRMiP answer the call and proceed to build Poland's first kibbutz, to the accompaniment of the Polish and Israeli national anthems. The Israeli anthem is played backwards as if to signify a historic reversal. [4] When construction is complete the young pioneers raise a flag whose emblem combines the Polish coat of arms, featuring a crowned eagle, with the Star of David in a decidedly fascistic hybrid.

The final chapter unfolds at the funeral of the movement's leader, who has been murdered by an unknown assassin. At an elaborately staged memorial ceremony attended by over a thousand of Sierakowski's supporters, the conflicting eulogies of his widow, of a Polish intellectual, an Israeli politician, and two followers, among others, are heard, as the concept of a Jewish return to Poland both is acclaimed as a "noble ideal of co-existence" and derided as "a brainless task." *Zamach* (*Assassination*, 2011; opposite) underscores the deep ambiguity of Bartana's project.

According to the artist, the leader's symbolic death also served as "a metaphor for the transition from fiction to real." [5] That transition began to take place at the 2012 Berlin Biennial when the First International Congress of the Jewish Renaissance Movement in Poland met to address the international concerns that underlie Bartana's project. Topics on the agenda included the European Union's treatment of those considered "the other," the role of Poland within a reimagined EU, and Israel's position within the Middle East. — HELAINE POSNER

[4] Joa Ljungberg, "A Dizzying Appeal for Reconciliation," in *And Europe Will Be Stunned*, 17. I am grateful to Joa Ljungberg for this insight into Bartana's work.

[5] Yael Bartana, "500 Words," transcribed by John Arthur Peetz, July 9, 2011, *Artforum*, http://artforum.com/words/id=28418.

OPPOSITE

Tania Bruguera, *Untitled (Kassel, 2002)*, 2002. Video performance–installation with sound, German citizens, guns, black outfits, wood scaffolding, forty 750-watt light beams, DVD disc and player, and projector; 19 ft. x 59 ft. 7 in. x 13 ft. | 5.79 x 217.93 x 3.96 m. Exhibition view, Documenta 11, Kassel, Germany. Collection Museum für Moderne Kunst, Frankfurt.

BELOW

Tania Bruguera, *Tribute to Ana Mendieta*, 1986–96 (conceived 1985). Re-creation of Ana Mendieta's artworks and unrealized projects, lectures, exhibitions, interviews, and texts. Exhibition view, *Anima. The Visible and the Invisible: Re-presenting the Body in Contemporary Art and Society*, St. Pancras Church, London, 1996. Performance with gunpowder, stones, and textile.

IN HER CONCEPTUALLY-BASED, SOCIALLY-ENGAGED PERFORMANCES, installations, and actions, artist Tania Bruguera examines the nature of political power structures and their effect on the lives of some of society's most vulnerable individuals and groups. During the 1990s Bruguera created viscerally charged, metaphoric performances that critiqued life in her native Cuba where the experience of censorship, repression, instability and, often, exile and displacement were commonplace. Since relocating to the United States in 1997 the artist has become a world citizen, living and working in such cities as Chicago, Paris, Havana, and New York, and traveling regularly and extensively to create her art and to teach. This transition is reflected in a body of work that remains rooted in and connected to her Cuban experience but has expanded to embrace a global perspective. The artist's international installation work and self-defined Behavior Art and Useful Art (*Arte de Conducta* and *Arte Útil*), created from 2000 to the present, challenge the audience to consider their personal relationship to power, creating situations that attempt to transform passive spectators into an engaged citizenry.

From the start, Bruguera has sought to break down the boundary between art and life in her potent, Cuba-inspired performance work. Her earliest series, *Tribute to Ana Mendieta* (1986–96; below), was a conceptual performance project in which the artist appropriated the work of another Cuban artist exiled from her homeland as a child in 1960. In homage to Mendieta, Bruguera re-enacted the artist's signature *Silueta Series* (1973–80), a group of earth-body works for which the artist placed her naked body, or its silhouette or outline, into the landscape.

Recreating Mendieta's mystical, ritualistic, corporeal performances was a significant cultural act, one that symbolically restored Mendieta to the Cuban collective-consciousness while posthumously fulfilling that artist's fervent desire for return. [1] For Bruguera's generation of artists, many of whom left Cuba in the early 1990s dur-

[1] Gerardo Mosquera, "Reanimating Ana Medieta," *Poliester* 4 (Winter 1995): 52. I am grateful to Gerardo for his insight into the impact of Bruguera's reenactment of Mendieta's *Silueta Series* in Cuba.

Tania Bruguera, *The Burden of Guilt*, 1997–99. Re-enactment of a historical event with decapitated lamb, rope, water, salt, and Cuban soil. Exhibition view, *Desde el cuerpo: Alegorias de lo femenino*, Museum de Bellas Artes, Caracas, 1998.

ing the so-called "special period" of political and economic pressure following the collapse of the Soviet Union, the decision to stay or to leave was the central dilemma. As Bruguera observed, "This made me reflect upon whether being Cuban meant solely living here, or whether it signified a condition beyond borders." [2] In fact, migration and its effects have remained a focus of her work.

In the late 1990s, Bruguera turned from embodying Mendieta to the creation of highly visceral performance works that comment on the history of the Cuban people, featuring the artist performing demanding rituals in the nude. Her physical and psychological feats of pain and endurance recall Mendieta's work as well as that of the pioneering performance artist Marina Abramović, who Bruguera greatly admires. Her iconic work of this period, *The Burden of Guilt* (1997–99; left), is a striking and intense performance based on a historic tale of collective suicide by indigenous Cubans during the Spanish occupation who, unable to resist the superior force of the armed invaders, decided to eat dirt until they died. In her performance, Bruguera re-created this solemn act, rolling bits of dirt into small balls and slowly ingesting them. She appeared naked, with the carcass of a slaughtered lamb hung from her neck like a gaping wound, as she repeatedly knelt, gathered dirt, rose, and ate. This historic tale resonates in contemporary Cuba where resistance or rebellion remains dangerous and obedience or submission, though shameful, also is the surest means of survival. Through image and metaphor, Bruguera captured the enduring social and political reality of the Cuban experience in which the utopian dream has been shattered by the hard facts of daily life.

In 2000 Bruguera was invited to participate in the 7th Havana Biennial, where she created the first of five related performances/installations to be presented internationally over the next ten years. In a break from her earlier performance work, Bruguera constructed a conceptually powerful, physically enveloping environment that fully engaged the audience as it alerted their senses of sight,

[2] Euridice Arratia, "Cityscape Havana," *Flash Art* 32, no. 204 (January/February 1999): 48.

sound, smell, and touch. At this time, she began to break down the boundary between the work of art and the audience itself, gradually making the spectator part of the work.

 Untitled (Havana, 2000) (originally titled *Ingenieros de Almas*; above) took place in a darkened tunnel at La Fortaleza de la Cabaña, a former military fortress where generations of Cubans had been imprisoned. An uneasy mood prevailed as viewers tramped through the dark and stumbled upon layers of rotting *bagazo*, or sugarcane husks, covering the prison floor and emitting the noxious stench of fermentation. A blue light in the distance came into focus as a small television monitor displaying archival footage of Fidel Castro in his prime. Unexpectedly, the shadowy figures of four naked men emerged from the darkness, each performing a single, repetitive gesture such as rubbing his body or bowing. *Untitled (Havana, 2000)* offered a subtle yet penetrating critique of Cuban life since the so-called triumph of the revolution. In hindsight, Bruguera suggests, the glorious past is revealed to have been nothing more than a series of "repeated rituals and empty gestures," and the foreigners so seduced by the ideal of Cuban revolution that they became blind to

[3] Nico Israel, "VII Bienal de la Habana," *Artforum* 39, no. 6 (February 2001): 148.

the repressive operations of power on the island. [3] The impact of this message was such that the installation was officially closed after one day.

Two years later Bruguera had the opportunity to test whether her work, which so far had been based on her Cuban experience, would translate to an international setting when she was asked to create an installation for Documenta 11 in Kassel, Germany. *Untitled (Kassel, 2002)* (p. 190) returned to the theme of social responsibility within a vastly different yet equally charged geopolitical site. Once again, the artist used light and darkness to examine such concerns as power and vulnerability, and historic memory versus cultural amnesia.

All elements of *Untitled (Kassel, 2002)* conspired to create a sense of vulnerability in the viewer, prompting memories of wartime and, given the location, World War II. A row of blazing 750-watt lights lit the installation, assaulting the viewer's eyes as if under interrogation. The metallic clicking sound of a man on patrol, loading and unloading a gun, was heard overhead. Suddenly the bright lights went out and the sound ceased and, for a few moments, the darkened space was dimly lit by a video projection successively displaying the names of one hundred places across the globe where political massacres have taken place since 1945. With the city of Kassel, once the site of an ammunition factory and a target of severe bombing, as background, Bruguera urged the audience to recognize the global reach of political violence as personal threat by placing them directly in the line of fire. She completed her *Untitled* works with *Moscow, 2007*; *Bogota, 2009*; and *Palestine, 2010*, the last a political proposal to transform Israel and Palestine into a single nation offering asylum to the world's refugees, concluding this series of installations on a bravely utopian note.

Bruguera continued to narrow the gap between art and life, and the work of art and the audience, with a new type of performance work she calls *Arte de Conducta*, or Behavior Art, in which she further explored and critiqued the relationship between power and the individual. In *Arte de Conducta*, the artist constructs dramatic situations or contexts that compel audience members to respond and react, not passively observe. The viewer is both witness to and participant in a staged action, as social behavior becomes the material of public art. The artist has employed various power strategies, from propaganda and crowd control to more subtle forms like an academic lecture and a declaration of the right to free speech in a closed society, in an attempt to rouse the viewer. Bruguera believes direct experi-

ence is the most effective way to raise awareness and, potentially, promote positive change through art.

A stunning example of Bruguera's new approach took place in 2008 on the bridge of Turbine Hall at Tate Modern in London where museum-goers were confronted by two uniformed policemen on horseback practicing a full range of crowd control techniques (above). Visitors responded to these imposing figures as they would in real life, yielding to the officers' verbal commands and to the animals'

forceful physical presence. The action did not appear to be an art event and the audience reacted predictably to this demonstration of power. Visitors became more aware of their reflexive passivity in the face of authority and were encouraged to reexamine their conditioned responses.

For *Tatlin's Whisper #6 (Havana Version)* (2009), created for the 10th Havana Biennial, Bruguera constructed a raised podium in the central courtyard of the Wifredo Lam Center, distributed 200 disposable cameras, and invited audience members to step up to the microphone and exercise freedom of speech for one minute each. This call tapped into deep emotions in a country that has repressed free speech for over fifty years and where the consequences of self-expression can be grave. During the performance, each speaker was flanked by two individuals dressed in military fatigues who placed a white dove on his or her shoulder, evoking the moment in 1959 when a dove alighted on Fidel Castro during a famous speech.

A variety of anti- and some pro-revolutionary voices were heard, a woman wept, and a young man said he never felt so free. Nearly forty people spoke

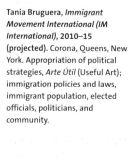

Tania Bruguera, *Immigrant Movement International (IM International)*, 2010–15 (projected). Corona, Queens, New York. Appropriation of political strategies, *Arte Útil* (Useful Art); immigration policies and laws, immigrant population, elected officials, politicians, and community.

Tania Bruguera, *Awareness Ribbon for Immigrant Respect Campaign*, 2010. Awareness campaign; metal pins, community meetings, letters sent to elected officials, and media.

in all. Their calls for freedom echoed for an hour, after which time the artist ended the performance by stepping up to the podium and thanking the Cuban people. By providing a public platform for the audience to speak out against censorship, to call for liberty and democracy, or to state whatever was on their mind, the artist tested the limits of acceptable behavior under a totalitarian regime in an attempt to create a socially useful forum.

In 2010 Bruguera initiated an ambitious five-year project that took her work outside established art and education venues and into the ethnically diverse, working-class neighborhood of Corona, Queens. With the founding of *Immigrant Movement International*, first conceived in 2006, she realized her dream of forming a socio-political movement to address issues faced by immigrants, as migration became an increasingly significant factor in twenty-first-century life. For more than a year the artist lived in an apartment in Corona with ten roommates and operated a community center/art studio in a storefront space (opposite). Through public workshops, community events, and actions, and with the aid of social service organizations, elected officials, and the press, the artist attempted to help immigrants in this multinational neighborhood improve their condition and their status. Bruguera calls her current practice *Arte Útil*, or Useful Art, the purpose of which is to seek solutions to social and political problems through "the implementation of art in society." [4]

Immigrant Movement International functions both as social intervention and as an extended work of conceptual art. This project seeks to create change in people's lives through such services as free legal consultations and English classes, and by raising awareness of immigrant issues. The Movement also provides a platform to address larger concepts and concerns like the effect of invisibility and exclusion on large marginalized populations, and strategies for gaining access to political power and achieving greater social recognition. It is Bruguera's most activist and utopian project to date. — HELAINE POSNER

[4] Tania Bruguera, *Immigrant Movement International* statement, 2010.

SHARON HAYES

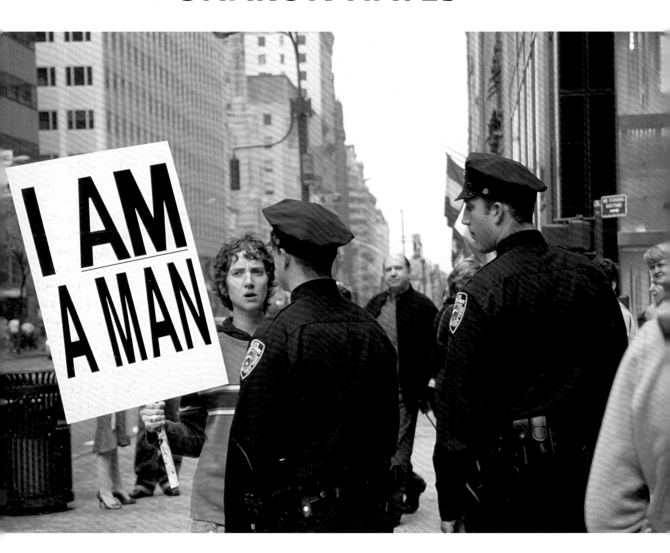

Sharon Hayes, *In the Near Future*, 2009. 35mm multiple-slide projection installation with thirteen projections.

THE SECOND DECADE OF THE twenty-first century might very well be remembered for the resurgence of political protest erupting around the world, from the Occupy Wall Street movement that began in New York's Zuccotti Park to the Arab Spring that has forced long-entrenched leaders out of countries across the Arab world. Widespread demonstrations against the culture of rape in India have resulted in proposals to change the laws behind which perpetrators have been hiding for centuries. Protesting at all levels was revitalized in a way that has not been seen in the US since the 1960s and '70s.

In this context, Sharon Hayes's 2012 solo show at the Whitney Museum of American Art, *There's So Much I Want to Say You* (overleaf), is in step with the zeitgeist, but Hayes has been interested in the history and language of protest since the early 1990s, when she first moved to New York City. The survey cum installation, which filled an entire floor at the Whitney Museum, replicated an occupation of sorts. A one-hundred-foot white curtain printed with the words "Now a chasm has opened between us that holds us together and keeps us apart" blocked the entrance to the exhibition, which encompassed Hayes's performance work from throughout the previous decade and included video, installation, photography, and sound pieces.

Hayes discovered the power of performance as a student at Bowdoin College, where she studied anthropology and participated in journalism as an extracurricular activity. In a dance class her junior year, she met performance artist Dan Hurlin, who expanded her world. "I realized that performance allowed me to entertain all the curiosities of journalism and anthropology without the limitations that I experienced in the practice of either: in the case of journalism, the necessity to simplify the complex impact of various events in the world, and, in the case of anthropology, the fraught historical dynamic between the ethnographer and his or her subject." [1] It is this confluence of journalism and anthropology realized through performance that provided the foundation of her work. Hayes also studied with Mary Kelly at UCLA and attended the Whitney Museum's Independent Studio Program.

Already a feminist, Hayes came out while at Bowdoin. After graduating in 1991, she moved to New York City, where the AIDS crisis, then at critical mass, was a fulcrum for activism. As a gay, feminist artist, Hayes picked up the drumbeat of the earlier feminist creed "the personal is political," as she came to understand, "the myriad ways in which most aspects of our lives as queer people are political." [2] Throughout her performances, Hayes indirectly channels other artists who have mined the

[1] Roger Cook, "Speech Acts, An Interview with Sharon Hayes," *Frieze*, January 1, 2010: 1.

[2] Ibid.

Exhibition view, *Sharon Hayes: There's So Much I Want to Say to You*, Whitney Museum of American Art, New York, 2010.

political potential of performance, among them Carolee Schneemann's groundbreaking work which centered on the politics of gender, and Marina Abramović's 1997 *Balkan Baroque* performance, in which the artist scrubbed 1,500 bloody cattle bones in a commentary on ethnic cleansing.

Hayes is interested in manifestations of the spoken word and over the years has researched archives and collected historical documents related to political activism of all kinds, primarily in the United States. She has gathered together spoken-word LPs dating from the 1940s through the 1980s which include oral histories, speeches by famous personages such as Eleanor Roosevelt, Lyndon Johnson, John F. Kennedy, and Malcolm X, as well as a self-produced album by an unknown citizen

Sharon Hayes, *Symbionese Liberation Army (SLA) Screeds #13, 16, 20 and 29*, 2003. Four-channel video projection with sound.

named Bud Berman, who created "For Too Long I Have Remained Silent" (1967), an anti-Vietnam recording that he sent to politicians and prominent Americans of the day.

For the Whitney show, Hayes presented her extensive collection of albums under the title, "An Ear to the Sounds of Our History," using the album covers to form a gridded background in one section of the installation. The work was also shown in the Danish Pavilion at the 2011 Venice Biennale as part of *Speech Matters*, and was featured in a performance by Hayes at the Guggenheim Museum as part of *Haunted: Contemporary Photography/Video/Performance* in 2010. For this five-hour performance, Hayes functioned as DJ, selecting and playing spoken-word recordings from her collection that mostly focused on speeches and poems from the 1960s Civil Rights era, with the album covers displayed as a backdrop for her DJ booth.

Hayes collects signs, flyers, posters, and pictures of posters, often delving into archives for her material. She reaches back into history for texts, speeches, and other documentation of social and political events and contextualizes them in the present, allowing the viewer to speculate how much has stayed the same and/or how little has changed. For her 2006 performance at PS1 Contemporary Art Center, New York, *My Fellow Americans*, she took President Ronald Reagan's economic addresses to the nation and performed, or, what she calls "re-spoke," the text while sitting behind a simple desk as if addressing the nation from the Oval Office. The written text from Reagan's February 5, 1981 address eerily shape-shifts across time; "I regret to say that we're in the worst economic mess since the Great Depression." [3]

One of the most compelling works in the Whitney exhibition was *Symbionese Liberation Army (SLA)* (2003; above), completed the year Hayes earned her MFA from UCLA. For this video, Hayes re-spoke statements made by newspaper-heiress Patty Hearst during her kidnapping by the SLA in 1974, in which she assured her parents that she was well and made appeals for the social causes of her captors, which Hearst had apparently internalized. Hayes attempts to speak the text from memory in front of a small audience, not shown in the video, whose role it is to prompt Hayes when she misspeaks or forgets the text. Addressing the camera in

[3] Sharon Hayes, "My Fellow Americans: 1981–88, script," *Sharon Hayes: There's So Much I Want to Say to You* (New York: Whitney Museum of American Art, 2012), 41.

[4] Sharon Hayes, text for "Beyond, research still, New York, 2012," *Sharon Hayes: There's So Much I Want to Say to You*, 86.

Sharon Hayes, *I Saved Her a Bullet*,
2012. Overhead projection.

near close-up, Hayes does indeed need help with the text. Her delivery is marked by awkward pauses and a general flatness, the overall effect being an ironic distancing from the context and meaning of Hearst's original impassioned delivery.

"I've been thinking a lot about rage in relation to speech," [4] Hayes said, in reference to her photo projection *I Saved Her a Bullet* (2012; above), for which she appropriated an image of Anita Bryant pied in the face at a press conference in Des Moines, Iowa, in 1977. Bryant, a former Miss Oklahoma and popular singer, was then a prominent anti-gay spokesperson focused on defeating anti-discrimination legislation in Dade County, Florida. At a press conference about Bryant's activism, Thom Higgins, a gay rights activist, interrupted Bryant by throwing a pie in her face on camera, bringing the proceedings to a messy halt. As political theater, there is something both lighthearted and startling about the situation; after being pied, Bryant quips, "At least it's a fruit pie"; she then begins to pray for the perpetrator before bursting into tears.

In this work, among others, Hayes shows an interest in portraying the way activist speech has historically been curtailed or censored. Traditionally, one thinks of censorship as something inflicted on the masses by a larger, possibly faceless, power. By singling out Higgins's personal and emotional attempt to block Bry-

ant's right to speak her mind, Hayes exposes the complications and irony involved in the full spectrum of free speech. The photograph also holds interest as a historical document of pre-ACT UP creative queer activism. [5]

For the series of video performances *In the Near Future* (2005–9), which were initially presented through Performa 5 and Art in General, Hayes stood on various sidewalks located throughout Manhattan —Wall Street, midtown—over nine successive days holding signs with slogans mined from earlier protests. Her anachronistic signs draw attention to the rhetorical operations of protest slogans. Some of the signs revealed telling moments in the history of activism, the verbiage calling into question the relative success or failure of past protest. For example, the sign "Ratify E.R.A. Now!" refers to the Equal Rights Amendment which was introduced in the US the 1920s and reached a fever pitch of controversy in the 1970s, but to this day has yet to be passed. Other signs took on new, sometimes ambiguous, meaning through the change in context, such as "I Am a Man," which came from a 1968 strike in Memphis of black sanitation workers protesting discrimination (p. 198). The slogan morphs into something completely different, if not altogether clear,

Sharon Hayes, *Everything Else Has Failed! Don't You Think It's Time for Love?*, **2007.** Audio installation with five PA speakers and five works on paper (spray paint on paper).

[5] Jenni Olson, text for "Anita Bryant pied by Thom Higgins at press conference, Des Moines, Iowa, October, 1977," *Sharon Hayes: There's So Much I Want to Say to You*, 52.

when held today by a white woman. Signs bearing words like "Nothing Will Be as Before," "Strike Today," and "Actions Speak Louder than Words," are more generic, their ambiguity perhaps spurring viewers to consider their own social context and agency as political beings.

Hayes continued the performances across Europe, including in Brussels, London, Warsaw, Vienna, and Paris, carrying signs translated into the native language. She documented the performances with 35mm slides and later showed the entire series of performances at the Guggenheim in 2011, where thirteen projections were simultaneously played, juxtaposing a profusion of various languages and causes.

Hayes's exploration of activist language in shifting contexts took a more personal turn in *Everything Else Has Failed! Don't You Think It's Time for Love?* (2007; p. 203), for which Hayes stood outside the UBS building in midtown Manhattan at noon holding a microphone and addressing a nameless, absent lover. Extremely personal missives—"Nothing is real but you," and "I am so much yours, I am not mine"—were interwoven with impersonal observations on war and politics. One

Sharon Hayes, *Revolutionary Love: I Am Your Worst Fear, I Am Your Best Fantasy*, 2008. Multi-channel video installation with sound; ten PA speakers, five projection screens, helium balloons, and colored light bulbs.

critic observed that many of the passersby were oblivious to Hayes's pleas, thus making her efforts ineffective. [6] Yet, that might just be Hayes's point in her exploration of the dynamics of communication in the public sphere. Do people really listen?

Commissioned by Creative Time in 2008 to perform both at the Democratic National Convention in Denver and the Republican National Convention in Minneapolis–St. Paul, Hayes created *Revolutionary Love: I Am Your Worst Fear, I Am Your Best Fantasy* (2008; opposite), in which she solicited participants from the LGBT community to recite political slogans, many from the early gay-rights campaigns of the 1970s. The participants speak in highly personal language, as if addressing a nameless lover, when in fact addressing a large anonymous audience.

How one speaks—quietly or through a megaphone—and who listens, has fascinated Hayes throughout her career. "There is a such a cacophony of sound in the world," Hayes writes. "Even before I recognized myself as a political person, I felt overrun by things I listen to, things I couldn't help but hear. . . . It's oddly difficult to direct one's listening . . . desire is not always a good teacher." [7]

Her four-channel video installation presented at the 2010 Whitney Biennial, *Parole* (2010), reversed conversational engagement by focusing on the listener, rather than the speaker. In each of the performances the actress Becca Blackwell records what people are saying. Never speaking herself, she nevertheless communicates her reactions through body language and facial expressions. The title of the installation derives from Ferdinand de Saussure, the early twentieth-century Swiss linguist who famously distinguished between the act of speech and the larger, public system of language from which speech is derived.

In the fifteen years of her career, Hayes's performances and installations have focused on activism and yet the lens through which she views this activism has as much to do with how we communicate than what we communicate. "I want to get further in understanding the way in which speech is deployed," Hayes says. "By whom and to what end? The transit and travel of a given speech act." [8] This exploration has laid the foundation for work that one can only imagine will continue to be more layered and expansive. — SUE SCOTT

[6] Paul David Young, "Time for Love: Sharon Hayes at the Whitney," *Art in America*, June 27, 2012, http://www.artinamericamagazine.com/news-opinion/news/2012-06-27/sharon-hayes-whitney/.

[7] Hayes, text for "Beyond, research still, New York, 2012," 86.

[8] Ibid.

TERESA MARGOLLES

Teresa Margolles, *What Else Could We Talk About? Cleaning*, 2009. The daily mopping of the exhibition floors with a mixture of water and blood from murder victims in Mexico. Exhibition view, *What Else Could We Talk About?*, 53rd Venice Biennale, Mexican Pavilion, 2009. Photograph by the artist.

VISITORS ENTERING A GALLERY IN New York's PS1 Contemporary Art Center are enveloped in steam, which, they learn, has been generated from water used for washing corpses. At the Art Basel Miami Beach fair, offerings include artist-designed jewelry whose glitter is somewhat dimmed by the fact that it was created from shards of glass removed from dead bodies involved in drive-by shootings. At the Liverpool Biennial reddish threads stretched across the wall turn out to be remnants of thread used to sew up bodies after an autopsy. At the Venice Biennale, the official Mexican contribution includes the daily mopping of the floor of an abandoned villa with rags soaked in blood and mud from crime scenes in Mexican cities.

In each case, an apparently innocuous environment or object is made profoundly disturbing by its proximity to death. The author of these works is Mexican artist Teresa Margolles, who has degrees in both art and forensic medicine and whose studio for many years was in a morgue in Mexico City. Margolles's focus on death has multiple roots; it is an outcome of her personal experience, her cultural background, and her political sympathies.

Shocking though her work often is—and it has been assailed as sickening, perverse, and inhuman—it is rooted in the venerable Western art tradition of the *memento mori*, which literally means "Remember your mortality." The motif of the skeleton or death's head originated in the classical era and gained momentum during the Middle Ages, when war, pestilence, and famine served as reminders of the fleeting nature of life. Contemporary artists who have played with this theme include Andy Warhol, whose *Death and Disaster* paintings were based on tabloid photographs of the victims of violent deaths; Damien Hirst, whose *For the Love of God*, a real skull encrusted with diamonds, makes the link between death and luxury; and Andres Serrano, whose *Morgue* photographs present bodies of people felled by accidents, suicides, murder, and disease transfigured in ways that suggest masterpieces of religious art.

Margolles's interest in the *memento mori* is no doubt heightened by the Mexican tradition of the Day of the Dead, a holiday which combines Christian and Aztec beliefs, during which people gather in cemeteries, present offerings to the dead, and create surprisingly light-hearted sculptures of skeletons and skulls. But for Margolles, a deeper impetus comes from her desire to explore what one curator has called "the economics of death." [1]

This issue is particularly pertinent in Mexico, which is suffering from

[1] Cuauhtemoc Medina, ed., *What Else Could We Talk About?*, catalogue for the Mexican pavilion, 53rd International Art Exhibition La Biennale di Venezia, (Barcelona: RM Verlag, 2009).

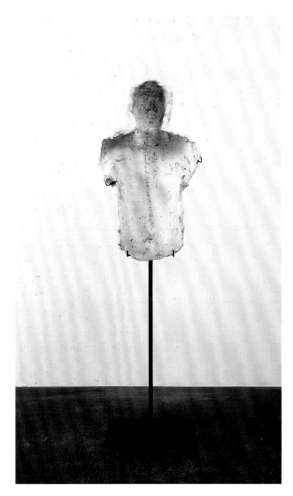

Teresa Margolles, *Catafalco* (*Catafalque*), 1997. Organic matter adhered to plaster, oxidized metal base; plaster: 21¼ x 31½ x 9½ in. | 54 x 80 x 24 cm; overall: 64⅛ x 31½ x 9½ in. | 163 x 80 x 24 cm.

an ever-escalating tsunami of drug-related violence as drug cartels and law enforcement officials find themselves locked into a bloody conflict that claims thousands of victims each year and has made some Mexican cities virtually unlivable. In many ways, the drug war is a manifestation of the dark side of globalization, as trade liberalization between the US and Mexico has spurred economic collapse on the south side of the border, allowing criminal cartels and the lucrative drug trade to fill the void. As a result, the murder rate in Mexico now surpasses that of many war zones around the world. Margolles has a personal stake in this situation, both through her background as a native of the Mexican city of Culiacán, Sinaloa, a city deeply scarred by the drug trade, and her current residence in Mexico City, which is also being rocked by drug-related violence.

Margolles began working in morgues in 1990, as a founding member of the group SEMEFO (Servicio Médico Forense/Forensic Medical Service), whose members used the physical refuse of crime as art material. By 1994–95, an economic crisis had unleashed a pandemic of crime in Mexico, leading to a string of political assassinations. Both independently and as a member of SEMEFO (which finally disbanded in 1999), Margolles created works like *Catafalco* (*Catafalque*, 1997; left), a negative relief cast created by draping plaster-soaked sheets over corpses, *Dermis* (*Skin*, 1996), which consisted of ten linen sheets marked with imprints from having been used to wrap corpses in the city hospital, and *Entierro* (*Burial*, 1999), a small concrete block containing the body of a stillborn child which would otherwise have been disposed of by the hospital.

With such works, Margolles honed her interest less in the departed individual than in the corporeal traces left behind after death. She investigates, in other words, the social life of corpses. Her work demonstrates that the social inequalities suffered by the poor and disenfranchised continue after death. Far from

Teresa Margolles, *Lengua* (*Tongue*), 2000. The pierced tongue of a teenager murdered in a street fight. Photograph by the artist.

wiping away all hierarchies, death reinforces them when victims of violence are buried in mass graves, or stillborn children disposed of by hospitals because their families cannot afford to bury them.

Following the disbanding of SEMEFO, Margolles's work began to focus more specifically on the deadly consequences of the drug war. One particularly visceral work in this vein is *Lengua* (*Tongue*, 2000; left), in which she preserved the pierced tongue of a young heroin addict killed in a street fight. She gained access to this relic by offering his family money for burial expenses. More symbolic is *Anden* (*Sidewalk*, 1999), created in the Colombian drug center of Cali, for which she opened up and then paved over a sidewalk with mementos given to her by the families of victims of drug violence.

At this time, Margolles also began to shift away from the bodies themselves to more symbolic residues. Describing her trajectory in 2003, she told an interviewer, "Since the start of my career early in the '90s, I have been working on an aesthetic approach less about death than about corpses in their various phases and their socio-cultural implications. . . . I began by showing the corpse in terms of direct violence. Finally I came to the cleansing of objects, which I let express a symbolic content or other factors." [2]

In part, this shift was necessitated by her move into a more international arena where rules and regulations limit the use of actual human matter. The trade off, for Margolles, has been greater visibility for her issues. One work that has been shown in numerous locations is *En el aire* (*In the Air*, 2003; overleaf), which employs machines of the sort used in night clubs to fill a gallery with bubbles made from water used to wash corpses before an autopsy in the Mexico City morgue. An-

[2] Teresa Margolles, interview by Gerald Matt in *Teresa Margolles*, ed. Lukas Gehrmann and Gerald Matt (Vienna: Kunstahlle Wein Project Space, 2003), 2–23.

other is *The Papeles* (*Papers*, 2003), a grid of one hundred sheets of watercolor paper washed in the same kind of run-off water, thereby creating what Margolles refers to as "a wall of mourning."

In 2009 Margolles was invited to represent Mexico at the Venice Biennale. Her contribution's title, *What Else Could We Talk About?*, challenged the celebratory and promotional orientation of the typical national pavilion. Margolles chose to focus on her country's most spectacular failings. In the name of Mexico, she subtly intervened in the spaces of a dilapidated palazzo, as a young man mopped the floor daily with rags soaked in blood and mud collected from Mexican crime scenes (p. 206), bolts of fabric used to scrub murder sites were hung in an empty corridor like abstract paintings, and ten thousand invitations bearing an image of a murdered man's bashed-in body on one side, and the instructions "Card to cut cocaine" on the other, were distributed during the biennale's press preview.

At the same time that she was creating works like these for international art audiences, Margolles was also focusing on more local audiences. A film titled *Corporización de la ausencia* (*Embodiment of the Absence*, 2010; above) documents a performance in schoolyards of the drug-torn Mexican towns of Guadalajara and Ciudad Juárez with a gathering of local children and teens standing in for the young people, many of them their friends, who were murdered in a single month.

Teresa Margolles, *Pintura de Sangre* (*Painting of Blood*), **2008. Canvas dyed with blood collected from the scene of a drug-related murder in Culiacán, Mexico; 58 x 58 in. | 147.3 x 147.3 cm.** Exhibition view, *Operativo*, Y Gallery, Queens, New York, 2008.

She later exhibited this, along with actual bullet-riddled walls removed from Mexican cities, at the Kunsthalle Fridericianum in Kassel, Germany.

Another exhibition with local resonance was *Operativo* (2008). This two-part exhibition was shown at Y Gallery, a small storefront gallery in Jackson Heights, Queens. The show included an abstract painting made by soaking a canvas in the blood of a murder victim from Mexico (opposite), and a text scrawled on the wall replicating the message left by drug dealers with the corpse of their murder victim. Jackson Heights is a neighborhood with a large population of Mexican immigrants, some of them refugees from the drug violence on the other side of the border. By choosing to site her first solo show in New York in a small gallery far from the mainstream art world, Margolles signaled her desire to reach outside the usual art audience, and instead to engage people more directly involved in the problems she highlights.

For Margolles, death is inseparable from politics and economics, and, especially in Mexico, from the apparently interminable war on drugs. In her hands, art offers catharsis to victims' families and a reminder, to those who might feel untouched by the drug related mayhem, of their own complicity in this ongoing tragedy. Reviewing her career, she notes, "At the beginning I was trying to find out what happens to the body as a social entity after death. There I discovered that a morgue is a thermometer of society. Looking at the dead, you see society." [3]

— ELEANOR HEARTNEY

[3] Teresa Margolles, video interview, 2006 Liverpool Biennial, September 14, 2006, http://www.tate.org.uk/context-comment/video/teresa-margolles-liverpool-biennial-2006.

JULIE MEHRETU

Julie Mehretu, *Stadia I*, 2004. Ink and acrylic on canvas; 108 x 144 in. | 274.3 x 365.7 cm. San Francisco Museum of Modern Art; Fractional gift of Dominique Levy and purchase through the Accessions Committee Fund with the additional support of Gay-Lynn and Robert Blanding, Jean and James E. Douglas, Jr., Ann and Robert S. Fisher, and Pat and Bill Wilson.

IN HIS FASCINATING BOOK ENTITLED *The Swerve: How the World Became Modern*, Stephen Greenblatt tells of the discovery in 1417 of Lucretius's ancient poem *On the Nature of Things* on the shelf of a German monastery. The book had been lost for more than a millennium and its rediscovery, Greenblatt asserts, was critical for the future of enlightened thinking. In addition to extolling the virtue of pleasure, the harm of evoking religious fear among the masses, and disavowing the need for gods, Lucretius understood the dynamics of energy, which he called a swerve or in Latin, *clinamen*—"the unexpected, unpredictable movement of matter." [1]

Two thousand years after Lucretius and a universe away, Julie Mehretu's layered, spatially complex, gestural, and symbolic works are very much in conversation with Lucretius's notion of the movement of matter and its effect on the world. Her work tracks the global peregrinations of people, money, and goods while engaging with history of place. Form is as slippery as content: within each painting, some areas are carefully planned while others develop intuitively. Mehretu employs a level of abstraction that deflects straightforward subject matter and interpretation, while at the same time showing an interest in the way content, shapes, color and gesture resonate subconsciously and poetically within each viewer.

Mehretu was born to move between worlds. She was born in 1970 in Addis Ababa, Ethiopia, the daughter of a European-American and an Ethiopian college professor, who met in Washington, D.C., when he was a graduate student at Johns Hopkins University. Mehretu's family fled Ethiopia when she was six, because of political unrest, and moved to Lansing, Michigan, where her father taught economic geography at Michigan State University. After high school, Mehretu attended Kalamazoo College in Michigan, earning a BFA in 1992, but spent her junior year abroad in Dakar, Senegal. Following college,

[1] Stephen Greenblatt, *The Swerve: How the World Became Modern* (New York: W. W. Norton and Co., 2011), 7.

Julie Mehretu, *Untitled*, 1999. Ink and acrylic on canvas; 59¾ x 71¾ in. | 151.8 x 182.2 cm. Private collection.

she came with friends to New York and, several years later, attended the Rhode Island School of Design on a full scholarship, graduating in 1997.

It was as a student of Michael Young's at RISD that Mehretu not only began drawing incessantly, but also came to see the marks in her drawings as repre-

senting communities, cities, and people. This correlation to mapping is clearly connected to her father's work as a geographer, but it is the sense of agency, of placing humans in situ and tracking their activity, that gives her work its conceptual underpinnings.

After graduation, she was selected as a resident for the CORE Program, at the Glassell School of Art, Museum of Fine Arts, Houston, a prestigious residency known for indentifying promising artists early in their careers. The Houston residency was critical to Mehretu's development. Her large studio enabled her to increase the scale of the work. She began projecting and tracing architectural drawings and blueprints onto the canvas. A colleague taught her to use a spray gun, which allowed her to layer her work by spraying a silica and acrylic solution on the surface. She created depth by sanding each layer. As a result, some of her marks are completely buried under the layering, some can be discerned through the shallow space, while others float on top. The main elements of her work—architectural drawing, topographic sketches and marks, and colorfully-painted abstract shapes—exist separately as layers but singularly as a composition.

By the time she returned to New York in 1999, Mehretu was making works such as *Untitled* (1999; opposite)—a relatively simple composition with fragmented architectural drawings forming the background and layered with geometric shapes, stencils, and colored lines. There is a lot of room to breathe in these works and a lot of movement. The viewer is both drawn in to examine the detail of the marks—indications of staircases and walls—and then obliged to stand back to absorb the breadth and depth of the overall composition.

Mehretu's critical rise was meteoric. In 2000 she was chosen for a residency at the Studio Museum in Harlem and selected for the prestigious *Greater New York* exhibition at PS1 Contemporary Art Center in Queens. She was included in biennials around the world—in 2004, in the Whitney Biennial and the Carnegie International, among them—and in 2005 she was named as a MacArthur Fellow.

Meanwhile the work was becoming progressively more complex and ambitious in scale. Mehretu's visual sources—images of malls, subways, highways, and airports which she would trace onto canvas from projection—though they may be specific to a place, are also generic structures that define and contain human activity. The marks included Japanese calligraphy, graffiti, and references to comics. Emblematic of this period is *Empirical Construction, Istanbul* (2004; overleaf), which was included in the Whitney Biennial and later acquired by MoMA. The painting is

TOP (DETAIL) AND RIGHT
Julie Mehretu, *Empirical Construction, Istanbul*, 2004. Ink and acrylic on canvas; 120 x 180 in. | 304.8 x 457.2 cm. The Museum of Modern Art, New York; Fund for the Twenty-First Century.

HISTORY LESSONS MEHRETU

fifteen feet wide by ten feet high. Compared to the work of just a few years previ-
ous, it is incredibly dense and complex in its layering of marks and colorful shapes.
Straight lines perspectively move the energy of the painting from the edge toward
the center, which coalesces into a circular shape made up of letters that resemble
the Arabic alphabet; white, red, and blue triangular flags; rows and rows of short
marks; and gestural black lines that look like smoke or clouds.

Mehretu has been compared to the Italian Futurists in the way her
work captures the dynamism of the city. Because she also layers the work with ren-
derings of architectural ruins, the paintings, as Calvin Tomkins notes, "carry a sense
of embedded time." [2] Also completed at this time and similar in composition was
Stadia 1 (2004; p. 214), part of a series of work that drew inspiration from stadiums—
public places where all manner of human actions, games, and rituals were carried
out, both celebratory and nefarious.

Mehretu was awarded a residency at the American Academy in Berlin

[2] Calvin Tomkins, "Big Art, Big Money," *New Yorker*, March 29, 2010, 62.

in 2007 and also commissioned by Deutsch Guggenheim to create a series of seven paintings, which she titled *Grey Area* (2008–9). For the series, of which *Berliner Plätze* (2009; opposite and below) is a part, Mehretu looked to the rich history of Berlin, both the peak of its accomplishments and depth of its destruction. At the time, she was having trouble with a painting in the studio in which she felt the color compromised the work. She went back into it, sanded out the top layers, and realized that this act of erasure was generative rather than destructive. That painting, *Vanescere* (2007), became the catalyst for the paintings that made up *Grey Area*. In these somber, simplified tonal paintings, many of which were based on the facades of beautiful nineteenth-century buildings destroyed in World War II, one gets the sense of buildings in the process of disappearing, much like the history of the city she was depicting. "I was interested in a vision of the city at a moment before that physical

erasure took place in the city, which is still very evident," she said. [3] Collapsing the past with the present, Mehretu also uses scenes of destruction from the wars in Afghanistan and Iraq. A selection of the paintings was shown at the Guggenheim Museum in New York in 2010.

That same year, Mehretu won a commission by Goldman Sachs to create a significant public work for their office building in downtown New York. Mehretu collaborated with Laurence Chua, a doctoral candidate in architectural history and artist and architect Beth Stryker on her proposal. They put together a plan for the mural, which they described as "the layered confluences and contradictions of the world economy in a mural." [4] *Mural* (2009; below), measures twenty-three by eighty feet wide. The sheer scale, the 215 distinct colors, the cacophony of marks and lines and the hard-edged shapes and stencils colliding against one another are

Julie Mehretu, *Mural*, 2009 (detail). Ink and acrylic on canvas; 22 x 80 ft. | 6.71 x 24.38 m. Collection Goldman Sachs, New York.

[3] Andrew Russeth, "All That's Solid Explodes Into Air: An Interview with Julie Mehretu," *Artinfo*, June 6, 2010, http://www.artinfo.com/news/story/34746/all-thats-solid-explodes-into-air-an-interview-with-julie-mehretu.

[4] Tomkins, 68.

Julie Mehretu, *Mogamma (A Painting in Four Parts)*, 2012 (detail). Ink and acrylic on four canvases; each 180 x 144 in. | 157.2 x 365.8 cm.

dazzling on a level of pure abstraction. But the brilliance of the work is that, in addition to existing as a dynamic abstract composition, the marks also refer to maps, trade routes, the history of banking, and the evolution of cities. "That was looking back at ten years of work," Mehretu said of the piece. "It was a symphonic effort, trying to deal with that language in a different way, on a different plane." [5]

Given the global subject of her work, it is not surprising that Mehretu participated in Documenta 13 (2012), an international art survey held every 5 years in Kassel, Germany. Her installation, *Mogamma (A Painting in Four Parts)* (2012; left), consisted of four monumental paintings, and took its name from the largest government building in Cairo, which was blockaded during the 2011 uprisings in Tahrir Square. Mehretu used images of architectural fragments from the Mogamma building as well as from other sites of social revolution across the globe [6] as her departure point for the foundation of the canvases, layered them with tar-black gestural drawings and scribbles that float against a white canvas, accented occasionally with hard-edged colored shapes and lines. In Arabic, *mogamma* means a place that simultaneously houses a church, a mosque, and a temple. Thinking about the psychic and spiritual energy generated in a mogamma and how it might be depicted brings to mind Lucretius's notion of the swerve and visualizing what an expected and unpredictable movement of matter might look like. The concept is powerful and as with all of Mehretu's work, is geared at making sense of the world, for both herself and her viewers. — SUE SCOTT

[5] Russeth.

[6] In all, *Mogamma* incorporates imagery related to thirty-four public squares that have served as sites of large-scale protests, from recent demonstrations of the Arab Spring and Occupy Wall Street movements to historical demonstrations—from Meskel Square in Addis Ababa and Zuccotti Park to Tiananmen Square, Red Square, Place de la Bastille, Plaza de la Revolución in Havana, and the Zócalo in Mexico City, to name just a few.

KARA WALKER

THE RECKONING

Kara Walker, *Gone, An Historical Romance of a Civil War as It Occurred Between the Dusky Thighs of One Young Negress and Her Heart*, 1994. Cut paper on wall; approx. 13 x 50 ft. | 3.96 x 15.24 m. Collection of The Museum of Modern Art, New York; Gift of the Speyer Family Foundation in honor of Marie-Josée Kravis. Opposite: Installation view, *Kara Walker: My Complement, My Enemy, My Oppressor, My Love*, Walker Art Center, Minneapolis, 2007.

D EFTLY WIELDING AN X-ACTO KNIFE to create her signature black-paper silhouettes, Kara Walker cuts images that are themselves precision instruments: they serve the unsparing evisceration of cultural pieties concerning race, sex, politics, history, and their interrelationships.

Now a resident of New York, Walker was born in Stockton, California, in 1969. In 1983, the family moved to the suburbs of Atlanta, where Walker's father, an artist, assumed directorship of the art department at Georgia State University. Confronting the racism that lingered in the South was a formative experience for Walker, who is African-American. So was coming across Thomas F. Dixon's 1905 novel *The Clansman: An Historical Romance of the Ku Klux Klan*, which she read as a graduate student at the Rhode Island School of Design. In it, she says, "I found Lydia Brown—described as a tawny vixen, the unruly mistress of the carpetbagger lead character. I adopted her persona as my own—I called her Negress." [1] She was also reading first-person accounts of slavery, noting that "genuine slave narratives have a rough, manhandled quality, full of sex and violent material, which was often cleaned up for readers—black and white—in polite society." [2]

Both sources are reflected in Walker's first exhibited cut-paper mural, *Gone, An Historical Romance of a Civil War as it Occurred Between the Dusky Thighs of One Young Negress and Her Heart* (opposite and below), which was shown at New York's Drawing Center in 1994 (the year she completed her MFA). Fifty feet long and thirteen high, its figures slightly larger than life-size, the mural depicted, among other things, a very young black girl fellating an equally young boy; a child holding a fowl by its wrung neck; a skinny boy lofted into the air by his grotesquely inflated penis; a pigtailed child lifting her leg to drop a couple of babies; and a young white woman primly leaning into her suitor's kiss, while someone else lurks beneath her

[1] "In the Studio: Kara Walker with Steel Stillman," *Art in America* 99, no. 5 (May 2011): 91.

[2] Ibid., 92.

dress (the extra pair of legs gives it away). Spanish moss hangs from an old oak tree, and a full moon shines above.

With its polymorphous libidinousness and decorously precise renderings of the antebellum South, *Gone*—its title begins with a reference to *Gone with the Wind*—introduced the highly combustible mix that has fueled much of Walker's subsequent work. The incendiary combination of vicious racism and frank eroticism is made the more provocative by Walker's remarkable graphic facility, which is itself deeply seductive. She takes ownership of this vocabulary with full knowledge of its risks. Agency—a term warmly embraced by the art world to mark claiming and expressing one's identity—is a word borrowed from commerce; seen against a legacy of buying and selling humans for hard labor, and further exploiting them for sexual

[3] Its practitioners included Samuel Metford and Auguste Edouart, whom Walker included in "After the Deluge," a post-Katrina exhibition she organized at the Metropolitan Museum of Art that mingled her own work with works from the museum's collection. Moses Williams, a "cutter of profiles" and a slave owned by the artist Charles Wilson Peale, has also been noted as a source. Philipe Vergne, "The Black Saint Is the Sinner Lady," in *Kara Walker: My Complement, My Enemy, My Oppressor, My Love*, by Philippe Vergne et al. (Minneapolis: Walker Art Center, 2007), 10.

purposes, it has a sinister cast of which Walker seems acutely aware.

Black-paper silhouettes were popular in the nineteenth century, [3] the period in which many of Walker's narratives are set, but the technique also recommends itself to Walker because of the way it literally flattens its subjects, depriving them—as does racism—of substance and identifying detail. "The silhouette says a lot with very little information, but that's also what the stereotype does. So I saw the silhouette and the stereotype as linked," she has said. [4] And although the color of the black-paper silhouettes was originally race-neutral, there is racial valence in their relationship to shadows: they are tracings of subjects that aren't there. The literary figure of the invisible man is essential in the representation of blackness, a register of the unseen or marginalized.

Cut-paper silhouettes have gendered associations as well, being historically linked with the kinds of genteel arts appropriate to educated young women. In contemporary parlance, on the other hand, "cutting" is shorthand for self-injury. There is probably an only ironic connection between Walker's choice of medium and the criticism leveled at her by some among an older generation of black women artists who see self-hatred in her imagery with regard to race. [5] The same criticism, of course, has been leveled at many provocative artists who use satire to oppose the prejudice directed at them, from Lenny Bruce to Richard Pryor to Glenn Ligon (who has incorporated Pryor's scathing jokes into his paintings). It is central to Walker's sensibility that she courts this kind of criticism, preferring the solitary risks of ambiguity and impropriety, political as well as sexual, to the solidarity of simpler expressions of anger.

In any case, Walker is interested not only in slavery and its aftermath but in other forms of injustice and brutality, including those involving class and gender. The difficult migration of African-Americans from the rural South

Kara Walker, *They Say Water Represents the Subconscious in Dreams* from *American Primitives*, 2001. Gouache and cut paper on board; 8 x 11 in. | 20.3 x 27.9 cm. Collection of Rachel and Jean-Pierre Lehmann.

[4] Kara Walker, quoted in Kathy Halbreich, foreword to *Kara Walker: My Complement*, 1.

[5] In 1997, the year Walker received a MacArthur Award, Betye Saar initiated a campaign against her, accusing Walker (whose husband is white) of pandering to her wealthy patrons, many of them white, too. Some critics have accused Walker of a lack of clarity (as if ambiguity was a privilege of white artists); Robert Storr counters that when ugly things remain fluid and dreamlike, they avoid racism; it is when they are hardened and repeated that they don't. Storr, "Spooked," in *Kara Walker: My Complement*.

to the industrial North, the challenges facing female singers of the Jazz Age (p. 226), the consequences of Hurricane Katrina, and the abuses by American soldiers at Abu Ghraib and elsewhere have joined the hoop-skirted, cravat-wearing men and women of the plantation era as subjects for Walker's work, which has become diversified by medium as well. Among the sources she credits are fiction both high and low, including "bad romance novels and porno, because it's a given that the reader should experience titillation." [6] Just as important to her are historical precedents for mixing up politics and art: "Though my line is cartoony, my gods are Goya, Daumier and Hogarth," she has said. [7] Nancy Spero is certainly part of her lineage, too; so are the representations of sexual violence in the early work of Sue Williams.

Although many of her multitudinous drawings are small, Walker tends toward the epic in both narrative scope and scale. In 1997, she created a cut-paper installation in the round that she said was inspired by such nineteenth-century cycloramas as the 360-degree *Battle of Atlanta*, a painting on permanent display in that city. Panoramic painting was a pre-cinematic form of popular entertainment; in another use of a proto-cinematic technology, Walker began in 2000 to employ overhead projectors that cast colored shapes onto cut–paper wall works, creating installations that are hybrids of moving and still imagery (opposite). Walker's first film,

Kara Walker, *Fall Frum Grace, Miss Pipi's Blue Tale*, 2011. Single-channel video with sound; 17 min.

Testimony: Narrative of a Negress Burdened by Good Intentions (2004), was followed by the apocryphal history *8 Possible Beginnings or: The Creation of African-America, a Moving Picture by Kara E. Walker* (2005). The savage but mesmerizing *Fall Frum Grace, Miss Pipi's Blue Tale* (2011; left) uses photographs as well as the cut-paper puppets that appear in all the films. Occasionally revealing the hands pulling these puppets' strings—the association to masters and slaves is inevitable—these films are as transparent in technique as they are densely layered in meaning.

That she favors technically antiquated mediums is also apparent in many of the works Walker has made that are partially

[6] Kara Walker, quoted in Sander Gilman, "Confessions of an Academic Pornographer," in *Kara Walker: My Complement*, 32.

[7] "In the Studio," 92.

Kara Walker, *Darkytown Rebellion,*
2001. Cut paper and projection on
wall; approx. 15 x 33 ft. | 4.57 x
10.06 m. Collection of Musée d'art
moderne Gran-Duc Jean, Madam
Luxembourg. Installation view,
Walker Art Center, Minneapolis,
2007.

Kara Walker, *Big House* from
American Primitives, 2001.
Gouache and cut paper on board;
8 x 11 in. | 20.3 x 27.9 cm.
Collection of Rachel and
Jean-Pierre Lehmann.

or wholly composed of text, including *Many Black Women (Certain Types)* (2002), a series of thirty-three typed index cards. Walker here revisited an old-fashioned mainstay of scholarship—or, perhaps, of late-1960s Conceptualism—with notes that mock the idea of objective history. One reads, "MANY BLACK WOMEN WEAR A GAME FACE / MANY BLACK WOMEN FEEL THEIR VOICES ARE NOT HEARD," another: "MANY BLACK WOMEN DON'T DATE BLACK MEN / MANY BLACK WOMEN WEAR THONG UNDERWEAR / MANY BLACK WOMEN SWALLOW." The range of ostensibly typical characteristics is sufficiently wide to demonstrate the absurdity of summarizing race-based identity; at the same time the features are described sharply enough to skewer an enormous variety of largely unspoken assumptions. The use of index cards may also be a play on the notion of the indexical—of signs that are, like the shadows that silhouettes traditionally trace, based in a physical impression made by the subject.

Among the forms that writing has taken in Walker's work is a much-quoted typed missive—it has been exhibited as if it were a standard exhibition wall

label—that begins, "Dear you hypocritical fucking Twerp" (1998) and proceeds to excoriate and indulge its addressee in equal measure; there are also hand-penned ruminations in dozens of ink, gouache, graphite, and/or colored-pencil drawings. The many epistolary texts find in the reader a "you" that may be us, her viewers, although—as with Barbara Kruger's hortatory photo-text works—we are also invited to put ourselves in the writer's position; either way we are forced to choose sides, which is the more difficult since Walker's tone, target, and even diction often shift dramatically within a single piece of writing. A series of large text works from 2010–11 was made by cutting out letters and block-printing them individually on large sheets of paper, creating run-in words of considerable physical presence that evoke Christopher Wool's early paintings. In these, the text sources range from baleful Wikipedia entries about such female vocalists as Louise Beavers, Nina Simone, Billie Holiday (all stress personal hardship, including drug use, drinking, and abusive relationships) to a prediction about Barack Obama (*He Will Be Executed by a Mob*, 2010).

"Writing—which half the time is just letting the sound of the typewriter accompanying the voice in my head—is often the first step to making drawings," Walker has said. [8] It is a surprising account from an artist with her graphic range and power. But it is clear that she is impelled by ideas as much as images, and adept with inflammatory language both verbal and visual. Most of all, she is concerned to say, and show, things that aren't generally seen or spoken. Faced with suffering, whether proximate and ordinary or distant and obscene, we generally don't know what to say—everything seems wrong. Walker exploits that inescapable discomfort, while admitting that she feels it herself. Without claiming exemption from the approved history of race, class, and gender relations in the United States, she has created room for representing feelings about it that ramify broadly precisely because they seem so personal. — NANCY PRINCENTHAL

[8] Ibid.

APPENDIX

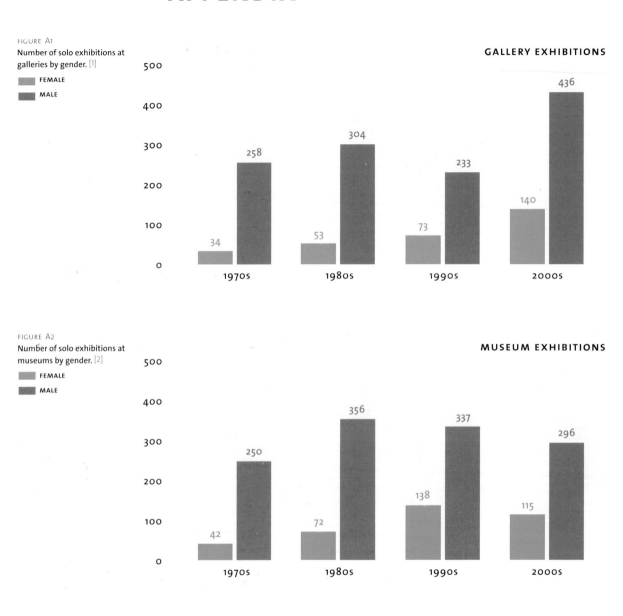

FIGURE A1

Number of solo exhibitions at galleries by gender. [1]

FEMALE
MALE

GALLERY EXHIBITIONS

500
400
300
200
100
0

1970s: 34 / 258
1980s: 53 / 304
1990s: 73 / 233
2000s: 140 / 436

FIGURE A2

Number of solo exhibitions at museums by gender. [2]

FEMALE
MALE

MUSEUM EXHIBITIONS

500
400
300
200
100
0

1970s: 42 / 250
1980s: 72 / 356
1990s: 138 / 337
2000s: 115 / 296

[1] Originally published in the authors' *After the Revolution: Women Who Transformed Contemporary Art* (2007) and updated for the 2013 revised edition, this chart compiles solo exhibitions from twenty-four prominent New York galleries specializing in primary market sales.

[2] Compiles solo exhibitions from the following US museums: Carnegie Museum of Art, Pittsburgh; Henry Art Gallery, Seattle; High Museum of Art, Atlanta; Museum of Contemporary Art Chicago; The Museum of Modern Art, New York; Institute of Contemporary Art, Philadelphia; Wexner Center for the Arts, Columbus, Ohio; and the Whitney Museum of American Art, New York.

Number of MFA graduates
by gender.

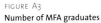

FEMALE

MALE

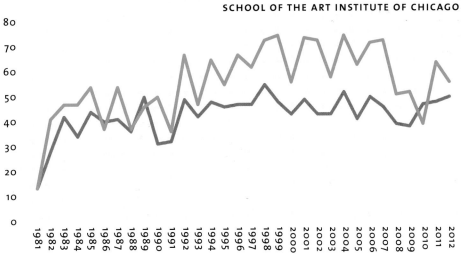

SCHOOL OF THE ART INSTITUTE OF CHICAGO

Number of MFA graduates
by gender.

FEMALE

MALE

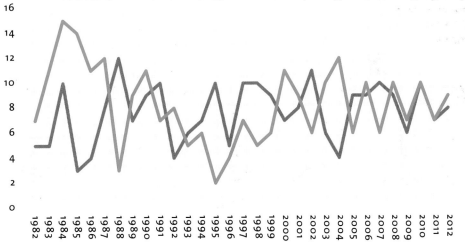

UNIVERSITY OF CALIFORNIA, LOS ANGELES (UCLA), DEPARTMENT OF ART

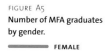

FIGURE A5
Number of MFA graduates
by gender.
FEMALE
MALE

GOLDSMITHS, UNIVERSITY OF LONDON

60

50

40

30

20

10

0

2007 2008 2009 2010 2011 2012

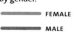

FIGURE A6
Number of MFA graduates
by gender.
FEMALE
MALE

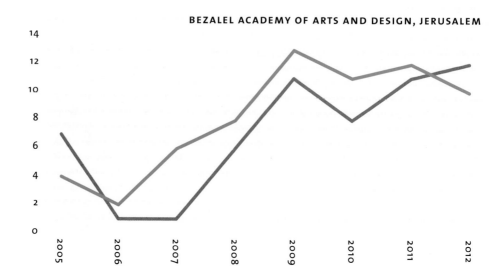

BEZALEL ACADEMY OF ARTS AND DESIGN, JERUSALEM

14

12

10

8

6

4

2

0

2005 2006 2007 2008 2009 2010 2011 2012

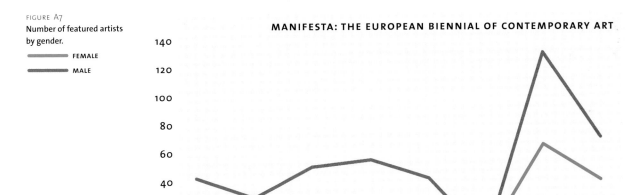

BIBLIOGRAPHY
GENERAL REFERENCE

Books and Exhibition Catalogues

About Time: Video, Performance, and Installation by 21 Women Artists. London: Institute of Contemporary Arts, 1980.

Allmer, Patricia, ed. *Angels of Anarchy: Women Artists and Surrealism.* Munich: Prestel, 2009.

American Women Artists: Part I: 20th Century Pioneers. New York: Sidney Janis Gallery, 1984.

American Women Artists, the 20th Century. Knoxville, Tenn.: Knoxville Museum of Art, 1989.

Antin, Eleanor, et al. *It Is Almost That: A Collection of Image & Text Work by Women Artists & Writers.* Los Angeles: Siglio, 2011.

Armstrong, Carol M., and Catherine de Zegher, eds. *Women Artists at the Millennium.* Cambridge, Mass.: MIT Press, 2006.

Attie, Dotty, and Sharyn Finnegan. *Better Than Ever: Women Figurative Artists of the '70s SoHo Co-Ops.* Brooklyn: Long Island University, 2009.

Aycock, Alice, and Ferris Olin. *Artists on the Edge: Douglass College and the Rutgers MFA.* New Brunswick, NJ: Rutgers, 2005.

Bad Girls: Helen Chadwick, Dorothy Cross, Nicole Eisenman, Rachel Evans, Nan Goldin, Sue Williams. London: Institute of Contemporary Arts, 1993.

Barlow, Margaret. *Women Artists.* New York: Universe, 2008.

Beckett, Wendy. *Contemporary Women Artists.* New York: Universe, 1988.

Bohm-Duchen, Monica, and Vera Grodzinski, eds. *Rubies & Rebels: Jewish Female Identity in Contemporary British Art.* London: Lund Humphries, 1996.

Breaking the Veils: Women Artists from the Islamic World, U.S. Tour: An Exemplary Exhibition of Contemporary Fine Art. Atlanta: ArtReach Foundation, 2008.

Brodsky, Judith K., and Ferris Olin. *How American Women Artists Invented Postmodernism, 1970–1975.* New Brunswick, NJ: Margery Somers Foster Center, Mabel Smith Douglass Library, 2006.

Brodsky, Judith K., Ferris Olin, and Margot Badran. *The Fertile Crescent: Gender, Art, and Society.* New Brunswick, NJ: Rutgers, Institute for Women and Art, 2012.

Broude, Norma, and Mary D. Garrard, eds. *Claiming Space: Some American Feminist Originators: November 6, 2007–January 27, 2008.* Washington, DC: Katzen American University Museum, College of Arts & Sciences, 2007.

———. *The Power of Feminist Art: The American Movement of the 1970s, History and Impact.* New York: Abrams, 1994.

———. *Reclaiming Female Agency: Feminist Art History after Postmodernism.* Berkeley and Los Angeles: University of California Press, 2005.

Brown, Betty Ann, and Arlene Raven. *Exposures: Women and Their Art.* Pasadena, Calif.: NewSage Press, 1989.

Brownlee, Andrea Barnwell, and Valerie Cassel Oliver. *Cinema Remixed and Reloaded: Black Women Artists and the Moving Image since 1970.* Houston: Contemporary Arts Museum; Atlanta: Spelman College Museum of Fine Art, 2008.

Butler, Cornelia H., and Alexandra Schwartz, eds. *Modern Women: Women Artists in the Collection of the Museum of Modern Art.* New York: Museum of Modern Art, 2010.

Butler, Cornelia H., and Lisa Gabrielle Mark, eds. *WACK!: Art and the Feminist Revolution.* Los Angeles: Museum of Contemporary Art; Cambridge, Mass.: MIT Press, 2007.

A Celebration of American Women Artists: Part II: The Recent Generation. New York: Sidney Janis Gallery, 1984.

Chadwick, Whitney. *Women, Art, and Society.* Fourth ed. New York and London: Thames & Hudson, 2007.

Collet, Penelope Josephine. *The Life Histories of Five Contemporary Welsh Women Artists: The Interweaving of Art into Living and Living into Art.* Lewiston, NY: Edwin Mellen Press, 2012.

Comini, Alessandra, et al. *In Passionate Pursuit: Capturing the American Women's Movement in Art.* New Brunswick, NJ: Rutgers, 2006.

Conklin, Jo-Ann, ed. *The Louise Noun Collection: Art by Women.* Iowa City: University of Iowa Museum of Art, 1990.

de Zegher, Catherine, ed. *Inside the Visible: An Elliptical Traverse of 20th Century Art in, of, and from the Feminine.* Cambridge, Mass.: MIT Press, 1996.

DeMonte, Claudia. *Women of the World: A Global Collection of Art.* San Francisco: Pomegranate, 2000.

Dysart, Dinah, and Hannah Fink, eds. *Asian Women Artists.* Roseville East, NSW: Craftsman House, 1996.

Elles@centrepompidou: Women Artists in the Collection of the Musée national d'art moderne, Centre de création industrielle. Paris: Centre Pompidou, 2009.

Fadda, Reem. *Art in Palestine: Palestinian Women Artists / Arte en Palestina: artistas palestinas.* Jerusalem: Palestinian Art Court—al Hoash; Seville: Fundación Tres Culturas, 2007.

Farrington, Lisa E. *Creating Their Own Image: The History of African-American Women Artists.* Oxford: Oxford University Press, 2011.

Farris, Phoebe, ed. *Women Artists of Color: A Bio-Critical Sourcebook to 20th Century Artists in the Americas.* Westport, Conn.: Greenwood Press, 1999.

Fiber and Form: The Woman's Legacy: Hannelore Baron, Lee Bontecou, Nancy Grossman, Eve Peri, Anne Ryan, Betye Saar, Lenore Tawney. New York: Michael Rosenfeld Gallery, 1996.

Fields, Jill. *Entering the Picture: Judy Chicago, the Fresno Feminist Art Program, and the Collective Visions of Women Artists.* New York: Routledge, 2012.

Fort, Ilene Susan, and Teresa Arcq, eds. *In Wonderland: The Surrealist Adventures of Women Artists in Mexico and the United States.* Los Angeles: Los Angeles County Museum of Art; Munich: Prestel, 2012.

Fortnum, Rebecca. *Contemporary British Women Artists: In Their Own Words.* London: I.B. Tauris; New York: Palgrave Macmillan, 2007.

Frankel, Dextra. *Multiple Vantage Points: Southern California Women Artists, 1980–2006.* Los Angeles: Southern California Women's Caucus for Art: Southern California Council of the National Museum of Women in the Arts, 2007.

Fuller, Diana Burgess, and Daniela Salvioni. *Art, Women, California 1950–2000: Parallels and Intersections.* Berkeley and Los Angeles: University of California Press, 2002.

Grinnell, Jennifer, and Alston Conley, eds. *Re/Dressing Cathleen: Contemporary Works from Irish Women Artists.* Chestnut Hill, Mass.: McMullen Museum of Art, Boston College, 1997.

Grosenick, Uta, and Ilka Becker. *Women Artists in the 20th and 21st Century*. Cologne: Taschen, 2011.

Growing Beyond: Women Artists from Puerto Rico. Puerto Rico: Mujeres Artistas de Puerto Rico, 1988.

Harding, James Martin. *Cutting Performances: Collage Events, Feminist Artists, and the American Avant-Garde*. Ann Arbor: University of Michigan Press, 2010.

Harnoncourt, Marie-Therese, et al. *Eva Schlegel: L.A. Women*. Cologne: Walther König, 2006.

Heartney, Eleanore, Helaine Posner, Nancy Princenthal, and Sue Scott. *After the Revolution: Women Who Transformed Contemporary Art*. Revised edition. Munich: Prestel, 2013.

Hershman-Leeson, Lynn, Kyle Stephan, et al. *W.A.R. Women Art Revolution*. New York: Zeitgeist Films, 2012, 2010.

Hassan, Salah M., ed. *Gendered Visions: The Art of Contemporary Africana Women Artists*. Trenton, NJ: Africa World Press, 1997.

Hayden, Malin Hedlin, and Jessica Sjöholm Skrubbe, eds. *Feminisms Is Still Our Name: Seven Essays on Historiography and Curatorial Practices*. Newcastle upon Tyne: Cambridge Scholars, 2010.

Henkes, Robert. *Latin American Women Artists of the United States: The Works of 33 Twentieth-Century Women*. Jefferson, NC: McFarland, 1999.

Hillhouse, Susan. *Expressions from the Soul: Bay Area Korean-American Women Artists*. Santa Clara, Calif.: Triton Museum of Art, 1998.

In the Lineage of Eva Hesse: January 23–May 1, 1994: The Aldrich Museum of Contemporary Art. Ridgefield, Conn.: Aldrich Museum of Contemporary Art, 1994.

Inglot, Joanna, and Lyndel Saunders King. *WARM: A Feminist Art Collective in Minnesota*. Minneapolis: Weisman Art Museum, 2007.

Isaak, Jo Anna. *Feminism and Contemporary Art: The Revolutionary Power of Women's Laughter*. London: Routledge, 1996.

Jobling, Paul. *Bodies of Experience: Gender and Identity in Women's Photography since 1970*. London: Scarlet Press, 1997.

Jones, Amelia, ed. *The Feminism and Visual Culture Reader*. London: Routledge, 2010.

———, ed. *Sexual Politics: Judy Chicago's "Dinner Party" in Feminist Art History*. Los Angeles: Hammer Museum; Berkeley and Los Angeles: University of California Press, 1996.

Khan, Fareda. *Between Kismet and Karma: South Asian Women Artists Respond to Conflict*. Manchester: Shisha, 2011.

King-Hammond, Leslie, ed. *Gumbo Ya Ya: Anthology of Contemporary African-American Women Artists*. New York: Midmarch Arts Press, 1995.

Kintanar, Thelma B. *Filipina Artists in Diaspora*. Manila: Anvil, 2011.

———, and Sylvia Mendez Ventura. *Self-Portraits: Twelve Filipina Artists Speak*. Quezon City, Philippines: Ateneo de Manila University Press, 1999.

Lahs-Gonzales, Olivia, and Lucy R. Lippard. *Defining Eye: Women Photographers of the 20th Century: Selections from the Helen Kornblum Collection*. St. Louis, Mo.: Saint Louis Art Museum, 1997.

Lim, Lucy. *Six Contemporary Chinese Women Artists*. San Francisco: Chinese Culture Foundation of San Francisco, 1991.

Mancoff, Debra N. *Danger!: Women Artists at Work*. London: Merrell, 2012.

Marignoli, Duccio K., and Enrico Mascelloni. *A Thousand and One Days: Pakistani Women Artists*. Milan: Silvana Editorale, 2005.

Martha Wilson Sourcebook: 40 Years of Reconsidering Performance, Feminism, Alternative Spaces. New York: Independent Curators International, 2011.

Mary H. Dana Women Artists Series 1971–1996: 25th Year Retrospective. New Brunswick, NJ: Rutgers University Libraries, 1996.

Mesa-Bains, Amalia, and Constance Cortez. *Imágenes e historias / Images and Histories: Chicana Altar-Inspired Art*. Medford, Mass.: Tufts University Gallery; Santa Clara, Calif.: Santa Clara University, 1999.

Meskimmon, Marsha. *The Art of Reflection: Women Artists' Self-Portraiture in the Twentieth Century*. New York: Columbia University Press, 1996.

Mind, Body, and Spirit: Celebrating Regional Women Artists. Adelphi, Md.: University of Maryland University College, 2010.

My Little Pretty: Images of Girls by Contemporary Women Artists: Kim Dingle, Judy Fox, Nicky Hoberman, Inez van Lamsweerde, Judith Raphael, Lisa Yuskavage. Chicago: Museum of Contemporary Art, 1997.

Nashashibi, Salwa Mikdadi. *Forces of Change: Artists of the Arab World*. Lafayette, Calif.: International Council for Women in the Arts; Washington, DC: National Museum of Women in the Arts, 1994.

Neumaier, Diane, ed. *Reframings: New American Feminist Photographies*. Philadelphia: Temple University Press, 1995.

Nochlin, Linda, and Maura Reilly, eds. *Global Feminisms: New Directions in Contemporary Art*. London: Merrell; Brooklyn: Brooklyn Museum, 2007.

The Offering Table: Women Activist Artists from Korea. Ha Insun, Je Miran, Jung Jungyeob, Kim Myungjin, Kwak Eunsook, Rhu Junhwa, Yoon Heesu. Oakland: Mills College Art Museum, 2008.

Original Visions: Shifting the Paradigm, Women's Art 1970–1996: Magdalena Abakanowicz, Mary Beth Edelson, Janet Fish, Agnes Martin, Pat Steir, Carrie Mae Weems. Chestnut Hill, Mass.: McMullen Museum of Art, 1997.

Pachmanová, Martina. *Behind the Velvet Curtain: Seven Women Artists from the Czech Republic: Erika Bornová, Milena Dopitová, Lenka Klodová, Zdena Kolečková, Alena Kotzmannová, Michaela Thelenová, Katerina Vincourová*. Prague: Academy of Arts, Architecture, and Design, 2009.

Perez, Pilar, ed. *At the Curve of the World: Mariana Botey, E.V. Day, Anne Fishbein and Laurie Dahlberg, Diana López, Gertrudis Rivalta, Elena del Rivero, Sandra Vivas*. Santa Monica: Smart Art Press, 1999.

Perrone, Fernanda. *Bridging Generations: Women Artists and Organizations from Rutgers' Collections*. New Brunswick, NJ: Rutgers University Libraries, 2009.

Princenthal, Nancy, ed. *The Deconstructive Impulse: Women Artists Reconfigure the Signs of Power, 1973–1991*. Purchase, NY: Neuberger Museum of Art, Purchase College; Munich: Prestel, 2011.

Puerto, Cecilia. *Latin American Women Artists, Kahlo and Look Who Else: A Selective, Annotated Bibliography*. Westport, Conn.: Greenwood Press, 1996.

Reckitt, Helena, ed. *Art and Feminism*. Revised edition. London: Phaidon Press, 2012.

Reflections: Woman's Self-Image in Contemporary Photography: Photographs by Ellen Carey, Judy Dater, Judith Golden, Anne Noggle, Starr Ockenga, Joyce Tenneson. Oxford, Ohio: Miami University Art Museum, 1988.

Robinson, Jontyle Theresa, and Maya Angelou, eds. Bearing Witness: Contemporary Works by African American Women Artists. New York: Spelman College; New York: Rizzoli, 1996.

Roth, Moira, ed. The Amazing Decade: Women and Performance Art in America, 1970–1980. Los Angeles: Astro Artz, 1983.

Sachs, Sid, and Kalliopi Minioudaki, eds. Seductive Subversion: Women Pop Artists, 1958–1968. Philadelphia: University of the Arts; New York: Abbeville, 2010.

Schneider, Rebecca. The Explicit Body in Performance. London: Routledge, 1997.

Schor, Gabriele. Donna: Avanguardia femminista negli anni '70: dalla Sammlung Verbund di Vienna. Milan: Electa, 2010.

Seigel, Judy. Mutiny and the Mainstream: Talk That Changed Art, 1975–1990. New York: Midmarch Arts Press, 1992.

Siegel, Suzanne, Laura Silagi, and Deborah Krall. Mother Art: A Collective of Women Artists. Los Angeles: Ben Maltz Gallery, Otis College of Art and Design, 2011.

Sterling, Susan Fisher. Women Artists: The National Museum of Women in the Arts. Second edition. New York: Abbeville, 2010.

Stich, Sidra. New World (Dis)Order. Northern California Council of the National Museum of Women in the Arts, 1993.

Tamboukou, Maria. In the Fold between Power and Desire: Women Artists'

Narratives. Newcastle, UK: Cambridge Scholars, 2010.

Tan, Bridget Tracy, and Yeo Wei-Wei, eds. Women Artists in Singapore. Singapore: Select, 2011.

Taylor, Nora A. Changing Identity: Recent Works by Women Artists from Vietnam. Washington, DC: International Arts & Artists, 2007.

Ulenberg, Claire. Herstory: Women Artists in New Zealand. Auckland: Ferner Galleries, 2008.

Upstarts and Matriarchs: Jewish Women Artists and the Transformation of American Art. Denver: Singer Gallery, 2005.

Vartanian, Ivan. Drop Dead Cute: The New Generation of Women Artists in Japan. San Francisco: Chronicle, 2005.

Voigt, Anna. New Visions, New Perspectives: Voices of Contemporary Australian Women Artists. Roseville East, NSW: Craftsman House, 1996.

Von Blum, Paul. Other Visions, Other Voices: Women Political Artists in Greater Los Angeles. Lanham, Md.: University Press of America, 1994.

Walkup, Kathy. Hand, Voice and Vision: Artists' Books from Women's Studio Workshop. Rosendale, NY: Women's Studio Workshop, 2010.

Wasserman, Krystyna, et al. The Book as Art: Artists' Books from the National Museum of Women in the Arts. New York: Princeton Architectural Press, 2011.

Weidemann, Christiane, et al. 50 Women Artists You Should Know. Munich: Prestel, 2008.

Wilkinson, Michelle. Material Girls: Contemporary Black Women Artists. Baltimore: Reginald F. Lewis Museum, 2011.

Women Artists of Southern California:

Then + Now. Santa Monica: Track 16 Gallery, 2007.

Womenartists@NewBritainMuseum. New Britain, Conn.: New Britain Museum of Art, 2010.

Yoshimoto, Midori. Into Performance: Japanese Women Artists in New York. New Brunswick, NJ: Rutgers, 2005.

Zelevansky, Lynn. Sense and Sensibility: Women Artists and Minimalism in the Nineties. New York: Museum of Modern Art, 1994.

BIBLIOGRAPHY

INDIVIDUAL ARTISTS

GHADA AMER

American, born Egypt 1963

**Monographs and
Solo Exhibition Catalogues**

Amer, Ghada. *Ghada Amer*. Amsterdam: De Appel Amsterdam, 2003.

Amer, Ghada. *Ghada Amer*. Beverly Hills: Gagosian Gallery, 2004.

Amer, Ghada. *Ghada Amer*. Brétigny-sur-Orge, Paris: Centre d'art et de culture, 1994.

Amer, Ghada. *Ghada Amer*. Indianapolis: Indianapolis Museum of Art, 2003.

Amer, Ghada. *Ghada Amer*. Kassel: Kunsthalle Fridericianum, 1998.

Amer, Ghada. *Ghada Amer*. London: Gagosian Gallery, 2002.

Amer, Ghada. *Ghada Amer*. Milan: Electa, 2007.

Amer, Ghada. *Ghada Amer*. Montreal: Musée d'art contemporain de Montréal, 2012.

Amer, Ghada. *Ghada Amer*. San Francisco: San Francisco Art Institute, 2002.

Amer, Ghada. *Ghada Amer*. Seoul: Kukje Gallery, 2004.

Amer, Ghada. *Ghada Amer*. Valencia: Institut Valencià d'Art Modern, 2004.

Amer, Ghada. *Ghada Amer: Another Spring*. Seoul: Kukje Gallery, 2007.

Amer, Ghada. *Ghada Amer: Breathe Into Me*. New York: Gagosian Gallery, 2006.

Amer, Ghada. *Ghada Amer: Color Misbehavior*. New York: Cheim & Read, 2010.

Amer, Ghada. *Ghada Amer: Intimate Confessions*. Tel Aviv: Tel Aviv Museum of Art, 2000.

Amer, Ghada. *Ghada Amer: Pleasure*. Houston: Contemporary Arts Museum, 2001.

Amer, Ghada. *Ghada Amer: Reading between the Threads*. Oslo: Henie Onstad Kunstsenter, 2001.

Kim, Clara. *Ghada Amer: Unraveling Language: Ghada Amer's Art of Writing / Délier les langues: l'art d'écrire de Ghada Amer*. Geneva: Galerie Guy Bärtschi, 2002.

Reilly, Maura. *Ghada Amer*. New York: Gregory R. Miller & Co.; distributed by DAP (New York), 2010.

Studies

Cayne, Naomi. *Sex, Power, and the Stitch: The Contemporary Feminist Embroidery of Ghada Amer*. Thesis (MA)—Temple University, Philadelphia, 2007.

Domene-Danés, Maria. *Ghada Amer: Embroidering a Hybrid Work*. Thesis (MA)— Department of the History of Art, Indiana University, 2010.

Hericks-Bares, Eva Susanne. *Creating Art "Within Boundaries Without": Ghada Amer and Zineb Sedira*. Thesis (MA)—Stony Brook University, NY, 2006.

McCabe, Jennifer. *Boundaries in Contemporary Art: Shahzia Sikander, Ghada Amer, Shirin Neshat*. Thesis (MA)—San Francisco State University, 2003.

Musawwir, Jennifer S. *Patterns of Discourse: Shahzia Sikander: Ghada Amer*. Thesis (MA)— Department of Art, Hunter College, The City University of New York, 2005.

JANINE ANTONI

Bahamian, born 1964

**Monographs and
Solo Exhibition Catalogues**

Antoni, Janine. *The Girl Made of Butter*.

Ridgefield, Conn.: Aldrich Museum of Contemporary Art, 2000.

Antoni, Janine. *Janine Antoni*. Kusnacht, Switzerland: Ink Tree; distributed by DAP (New York), 2000.

Antoni, Janine. *Janine Antoni: activitats esculturals: cicle, teixit inacabat*. Barcelona: Fundació "la Caixa," 1996.

Antoni, Janine. *Janine Antoni: Matrix 129*. Hartford, Conn.: Wadsworth Atheneum, 1996.

Antoni, Janine. *Moor*. Stockholm: Magasin 3 Stockholm konsthall; Santa Fe, NM: SITE Santa Fe, 2003.

Antoni, Janine. *Slip of the Tongue*. Glasgow: Centre for Contemporary Arts, 1995.

Antoni, Janine. *Swoon*. New York: Whitney Museum of American Art, 1998.

Antoni, Janine, and Dan Cameron. *Janine Antoni*. Ostfildern, Germany: Hatje Cantz, 2000.

Studies

Finaly, Sarah. *Janine Antoni: Renegotiating the Body*. Thesis (MA)—George Washington University, Washington, DC, 2000.

James, Erica Moiah. *Re-Worlding a World: Caribbean Art in the Global Imaginary*. Thesis (PhD)—Duke University, Durham, NC, 2008.

Karamitsos, Stephanie Ann. *The Art of Janine Antoni: Labor, Gender and the Object of Performance*. Thesis (PhD)—Northwestern University, Evanston, Ill., 2006.

Light, Sandra J. *Converging Energies: A Comparison of Selected Works by Janine Antoni and Joseph Beuys*. Thesis (MA)—University of Cincinnati, 2002.

Schneider, Anja Isabel. *Tracing Earthworks: Janine Antoni in the Legacy of Feminist Art*. Thesis (MA)—Courtauld Institute of Art, University of London, 2001.

Smith, Caitlin. *Two Women on All Fours: Mierle Laderman Ukeles & Janine Antoni at the Wadsworth Atheneum Museum of Art*. Thesis (MA)—University of Connecticut, 2011.

YAEL BARTANA

Israeli, born 1970

**Monographs and
Solo Exhibition Catalogues**

Bartana, Yael. *Short Memory*. Tel Aviv: Center for Contemporary Art; New York: PS1 Contemporary Art Center, 2008.

Bartana, Yael. *Yael Bartana*. Ostfildern, Germany: Hatje Cantz, 2008.

Bartana, Yael. *Yael Bartana: In the Army I Was an Outstanding Soldier*. Padua: Fondazione March per l'arte contemporanea, 2007.

Bartana, Yael. *Yael Bartana: och Europa kommer att häpna / And Europe Will Be Stunned*. Berlin: Revolver Publishing, 2010.

Bartana, Yael. *Yael Bartana: Three Works*. Cambridge, Mass.: MIT List Visual Arts Center, 2004.

Bartana, Yael, et al. *A Cookbook for Political Imagination*. Berlin: Sternberg Press; Warsaw: Zachęta National Gallery of Art, 2011.

Bartana, Yael, et al. *Yael Bartana: And Europe Will Be Stunned*. Southbank, Vic.: Australian Centre for Contemporary Art, 2011.

Eilat, Galit, et al., eds. *Yael Bartana: Videos and Photographs / Video's en Foto's*. Eindhoven: Van Abbemuseum; Rotterdam: Veenman Publishers, 2006.

Studies

Ahmed, Haseeb Waqar. *The Replicator: On the Social Destruction of Fact through Replication as Art*. Thesis (SM)— Department of Architecture, Massachusetts Institute of Technology, Cambridge, 2010.

CECILY BROWN
British, born 1969

Monographs and Solo Exhibition Catalogues

Ashton, Dore, and Lari Pittman. *Cecily Brown*. Hamburg: Deichtorhallen, 2009.

Brown, Cecily. *Cecily Brown*. Des Moines: Des Moines Art Center, 2006.

Brown, Cecily. *Cecily Brown*. Madrid: Museo Nacional Centro de Arte Reina Sofia, 2004.

Brown, Cecily. *Cecily Brown*. Milan: Electa, 2003.

Brown, Cecily. *Cecily Brown*. New York: Rizzoli, 2008.

Brown, Cecily. *Cecily Brown*. New York: Gagosian Gallery, 2003.

Brown, Cecily. *Cecily Brown*. New York: Skira Rizzoli, 2012.

Brown, Cecily. *Cecily Brown*. Rome: Gagosian Gallery; distributed by Rizzoli (New York), 2011.

Brown, Cecily. *Cecily Brown: Days of Heaven*. Berlin: Contemporary Fine Arts, 2001.

Brown, Cecily. *Cecily Brown: Paintings*. Oxford: Modern Art, 2005.

Brown, Cecily. *Cecily Brown: Paintings 1998–2000*. New York: Gagosian Gallery, 2000.

Brown, Cecily. *Cecily Brown: Paintings 2003–2006*. New York: Gagosian Gallery, 2006.

Essl, Karlheinz. *Cecily Brown*. Klosterneuburg, Austria: Sammlung-Essl, 2012.

Görner, Veit, and Kathrin Meyer. *Cecily Brown: Based on a True Story*. Cologne: Snoeck, 2010.

Zilczer, Judith. *Directions: Cecily Brown*. Washington, DC: Smithsonian, Hirshhorn Museum and Sculpture Garden, 2002.

TANIA BRUGUERA
Cuban, born 1968

Monographs and Solo Exhibition Catalogues

Bruguera, Tania. *7+1 Project Rooms*. Vigo, Spain: Fundación Marco, Museo de Arte Contemporánea de Vigo, 2010.

Bruguera, Tania. *Taller de Tania Bruguera febrero de 2008*. Madrid: Universidad Complutense de Madrid, 2010.

Bruguera, Tania. *Tania Bruguera*. Amsterdam: Prince Claus Fund for Culture and Development; Venice: Biennale di Venezia, 2005.

Bruguera, Tania. *Tania Bruguera: esercizio di resistenza*. Turin: Franco Soffiantino arte contemporanea, 2004.

Bruguera, Tania. *Tania Bruguera: On the Political Imaginary*. Milan and New York: Charta, 2009.

Bruguera, Tania. *Tania Bruguera: Portraits: Kunsthalle Wien, Project Space, Kunsthalle zu Kiel*. Cologne: Walther König, 2006.

Bruguera, Tania. *Vigilantes: The Dream of Reason: Arte de Conducta October 2004–January 2005*. Toronto: Fado: Ontario College of Art and Design; Montreal: La Centrale Galerie Powerhouse, 2004.

Cippitelli, Lucrezia, and Domenico

Scudero. *Tania Bruguera*. Milan: Postmedia Books, 2010.

Studies

Li, Lisa. *Women and Body Art in Cuba*. Thesis (MA)—University of Miami, 2006.

Vargas, Cecilia Leonora. *Tania Bruguera: Performative Gestures and Participant Behavior*. Thesis (MAHA)—Modern Art History, Theory, and Criticism and Arts Administration and Policy, School of the Art Institute of Chicago, 2010.

Zarate, Daniela. *Tania Brugera: Universality from the Periphery*. Thesis (MA)—Courtauld Institute of Art, University of London, 2006.

CAO FEI
Chinese, born 1978

Monographs and Solo Exhibition Catalogues

Cao, Fei. *Cao Fei Journey / Cao Fei lü cheng*. Paris: Frac Ile-de-France / Le Plateau; Guangzhou: Vitamin Creative Space, 2008.

Cao, Fei. *Cao Fei, PRD Anti-Heroes*. Sittard, Netherlands: Museum Het Domein, 2006.

Cao, Fei. *Cao Fei: Utopia*. Fortitude Valley, BC, Qld.: Institute of Modern Art, 2009.

Cao, Fei. *Nu / Nù*. Guangzhou: Vitamin Creative Space, 2007.

Cao, Fei. *RMB City: A Second Life Planning by China Tracy (RL: Cao Fei)*. Beijing: Vitamin Creative Space, 2007.

Cao, Fei. *RMB City: Cao Fei SL Avatar: China Tracy / Ren min cheng zhai: Cao Fei di er ren sheng hua shen: Zhongguo Cuixi*. Guangzhou: Vitamin Creative Space, 2008.

Cao, Fei. *RMB City: Cao Fei (SL: China Tracy)*. Toronto: A Space Gallery, 2010.

Studies

Benfield, Dalida Maria. *Apparatuses, Globalities, Assemblages: Third Cinema, Now*. Thesis (PhD)— Ethnic Studies Department, University of California, Berkeley, 2011.

NATHALIE DJURBERG
Swedish, born 1978

Monographs and Solo Exhibition Catalogues

Djurberg, Nathalie. *Beckersstipendiet 20 år: Beckers konstnärsstipendium 2006: Nathalie Djurberg*. Stockholm: Becker, 2006.

Djurberg, Nathalie. *Nathalie Djurberg*. Los Angeles: Hammer Museum, 2008.

Djurberg, Nathalie. *Nathalie Djurberg: BASE 103*. Munich: Sammlung Goetz, 2008.

Djurberg, Nathalie. *Nathalie Djurberg: denn es ist schön zu Leben*. Nuremberg: Verl. für Moderne Kunst, 2007.

Djurberg, Nathalie. *Nathalie Djurberg: Turn Into Me*. Milan: Progetto Prada Arte, 2008.

Djurberg, Nathalie. *Why do I have this urge to do these things over and over again?* Milan: Galleria Giò Marconi, 2005.

TRACEY EMIN
British, born 1963

Monographs and Solo Exhibition Catalogues

Brown, Neil. *TE: Tracey Emin*. London: Tate Publishing, 2006.

Elliott, Patrick. *Tracey Emin: 20 Years.* Edinburgh: National Galleries of Scotland, 2008.

Emin, Tracey. *Always Glad to See You.* London[?]: Tracey Emin, 1996.

Emin, Tracey. *Holiday Inn 1998.* Bremen: Gesellschaft für Aktuelle Kunst, 1998.

Emin, Tracey. *Monoprint Diaries.* London: White Cube, 2009.

Emin, Tracey. *Monoprint Diary.* London: White Cube; Emin International, 1991.

Emin, Tracey. *My Life in a Column.* New York: Rizzoli, 2011.

Emin, Tracey. *One Thousand Drawings.* New York: Rizzoli, 2009.

Emin, Tracey. *Strangeland.* London: Sceptre, 2005.

Emin, Tracey. *Strangeland.* Munich: Blumenbar, 2009.

Emin, Tracey. *Ten Years: Tracey Emin.* Amsterdam: Stedelijk Museum Amsterdam, 2002.

Emin, Tracey. *This Is Another Place.* Oxford: Modern Art Oxford, 2003.

Emin, Tracey. *Those Who Suffer Love: Tracey Emin.* London: White Cube, 2009.

Emin, Tracey. *Tracey Emin.* Sydney: Art Gallery of New South Wales, 2003.

Emin, Tracey. *Tracey Emin: Borrowed Light.* London: British Council; distributed by Cornerhouse Publications (Manchester), 2007.

Emin, Tracey. *Tracey Emin: I Can Feel Your Smile.* New York: Lehmann Maupin, 2005.

Emin, Tracey. *Tracey Emin: I Need Art Like I Need God.* London: Jay Jopling, 1998.

Emin, Tracey. *Tracey Emin: Love Is What You Want.* London: Hayward Publishing; distributed DAP (New York), 2011.

Emin, Tracey. *Tracey Emin: 20 años.* Malaga: CAC Málaga, Centro de Arte Contemporáneo Málaga; Ayuntamiento de Málaga, 2009.

Emin, Tracey. *Tracey Emin: Works 1963–2006.* New York: Rizzoli, 2006.

Emin, Tracey. *Tracey Emin: You Left Me Breathing: November 2–December 22, 2007.* Beverly Hills: Gagosian Gallery, 2008.

Emin, Tracey. *Tracey Emin at Turner Contemporary: She Lay Down Deep beneath the Sea.* Margate, Kent, UK: Turner Contemporary, 2012.

Emin, Tracey. *Traceyland.* Amsterdam: Meulenhoff, 2006.

Emin, Tracey. *When I Think about Sex.* London: White Cube, 2005.

Goetz, Ingvild. *Why I Never Became a Dancer.* Ostfildern, Germany: Hatje Cantz, 2011.

Merck, Mandy, and Chris Townsend. *The Art of Tracey Emin.* London and New York: Thames & Hudson, 2002.

Vaizey, Marina. *Personal Vision: Tracey Emin at Turner Contemporary.* London: CV Publ., 2012.

Studies

Belden, Kris. *Disconcerting Self-Disclosure in the Work of Richard Billingham and Tracey Emin.* Thesis (MA)—School of the Art Institute of Chicago, 2003.

Kappel, S. *Gender, Subjectivity and Feminist Art: the Work of Tracey Emin, Sam Taylor-Wood and Gillian Wearing.* Thesis (PhD)—University of Westminster, 2007.

Murdoch, Antoinette. *Confessions around Sexuality as a Form of Practice in the Artwork of Tracey Emin.* Thesis (MA)—University of the Witwatersrand, Johannesburg, 2010.

Scheuermann, Barbara Josepha. *Erzählstrategien in der zeitgenössischen Kunst: Narrativität in Werken von William Kentridge und Tracey Emin.* Dissertation—Philosophische Fakultät, Universität zu Köln, Cologne, 2005.

Stafford, Camelia. *Mine: The Use of Personal Possessions in the Works of Tracey Emin, Micheal Landy and Georgina Starr.* Thesis (MA)—Courtauld Institute of Art, University of London, 2001.

KATE GILMORE
American, born 1975

Group Exhibition Catalogues

Biesenbach, Klaus, et al. *Greater New York.* Long Island City, NY: PS1 Contemporary Art Center in collaboration with the Museum of Modern Art; distributed by DAP (New York), 2005.

Kotik, Charlotta, and Tumelo Mosaka. *Open House: Working in Brooklyn.* Brooklyn: Brooklyn Museum, 2004.

Castro, Jota, and Christian Viveros-Fauné, eds. *Spasticus Artisticus.* [n.p.]: La Moule Heureuse Editions, 2010.

Lincourt, Carrie, and Amy Smith-Stewart, eds. *The Influentials: School of Visual Arts, Women Alumni Invite Artists Who Have Shaped Their Work.* New York: Visual Arts Press, 2011.

Nieves, Marysol, ed. *Taking AIM!: The Business of Being an Artist Today.* New York: Fordham University Press, 2011.

Schor, Gabriele, ed. *Held Together with Water: Art from the Sammlung Verbund.* Ostfildern, Germany: Hatje Cantz; distributed by DAP (New York), 2007.

SHARON HAYES
American, born 1970

Monographs and Solo Exhibition Catalogues

Hayes, Sharon. *After Before: In the Near Future.* New York: Art in General, 2007.

Hayes, Sharon. *Sharon Hayes.* Chicago: Art Institute of Chicago, 2012.

Hayes, Sharon. *Have You Ever Taken a Poll Before?* Madrid: Centro de Arte Reina Sofía, 2011.

Hayes, Sharon. *Sharon Hayes: In the Near Future.* Vancouver: Contemporary Art Gallery, 2011.

Hayes, Sharon. *Sharon Hayes: There's So Much I Want to Say to You.* New York: Whitney Museum of American Art; New Haven and London: Yale University Press, 2012.

KATARZYNA KOZYRA
Polish, born 1963

Monographs and Solo Exhibition Catalogues

Czubak, Bozena. *Katarzyna Kozyra, Prace: 1993–1998.* Leipzig: Inst. Polski w Lipsku, 1998.

Kozyra, Katarzyna. *Badeanstalt.* Arhus, Denmark: Kvindemuseet, 1999.

Kozyra, Katarzyna. *Casting: Katarzyna Kozyra.* Warsaw: Zachęta Narodowa Galeria Sztuki, 2010.

Kozyra, Katarzyna. *In Art Dreams Come True.* Jelenia Góra, Poland: Galeria BWA, 2005.

Kozyra, Katarzyna. *Katarzyna Kozyra.* Cinisello Balsamo, Milan: Silvana; Trento: Galleria civica di arte contemporanea, 2004.

Kozyra, Katarzyna. *Katarzyna Kozyra.* Helsinki: Erikoispaino, 2000.

Kozyra, Katarzyna. *Katarzyna Kozyra: In Art Dreams Come True*. Ostfildern, Germany: Hatje Cantz; distribution by DAP (New York), 2007.

Kozyra, Katarzyna. *Katarzyna Kozyra: Señores de la danza*. Madrid: Museo Nacional Centro de Arte Reina Sofía, 2002.

Kozyra, Katarzyna. *Katarzyna Kozyra: The Men's Bathhouse: XLVIII International Biennale of the Visual Arts, Venice, 12 June–7 November 1999, Polish Pavilion*. Warsaw: Zachęta Narodowa Galeria Sztuki, 1999.

Kozyra, Katarzyna. *Katarzyna Kozyra: Umjetnicki Paviljon, Zagreb*. Zagreb, Republic of Croatia: Muzej suvremene umjetnosti, 2001.

Studies

Jedrzejczak, Adelina. *The Body in Contemporary Polish Art: Pawel Althamer, Katarzyna Kozyra, Dominik Lejman*. Thesis (MA)— Courtauld Institute of Art, University of London, 2004.

Popovicová, Iva. *New Body Politic: Czech and Polish Women's Art of the 1990s*. Thesis (PhD)—Rutgers, State University of New Jersey, 2006.

JUSTINE KURLAND
American, born 1969

Monographs and Solo Exhibition Catalogues

Kurland, Justine. *Justine Kurland: Spirit West*. New York, Paris, and Geneva: Coromandel Design, 2001.

Kurland, Justine. *Old Joy*. San Francisco: Artspace Books, 2004.

Kurland, Justine. *This Train Is Bound for Glory*. New York: Ecstatic Peace Library; distributed by DAP (New York), 2009.

KLARA LIDEN
Swedish, born 1979

Monographs and Solo Exhibition Catalogues

Fröhlich, Uwe, John Kelsey, and Klara Liden. *Klara Liden: Peneplains and Marauding Bands / Rumpfflächen und Plündererbanden*. Bielefeld, Germany: Kerber; distributed by Cornerhouse (Manchester) and DAP (New York), 2011.

Gioni, Massimiliano, Jenny Moore, and Klara Liden. *Klara Lidén: Bodies of Society*. New York: New Museum, 2012.

Liden, Klara. *Klara*. Zurich: Kunsthalle, 2010.

Liden, Klara. *Klara Lidén*. Cologne: Walther König, 2010.

LIZA LOU
American, born 1969

Monographs and Solo Exhibition Catalogues

Lou, Liza. *Gather Forty, 2010*. Jerusalem: Israel Museum, 2010.

Lou, Liza. *Liza Lou*. London: Jay Jopling/White Cube, 2006.

Lou, Liza. *Liza Lou*. New York: L&M Arts, 2008.

Lou, Liza. *Liza Lou*. New York: Skira Rizzoli, 2011.

Lou, Liza. *Liza Lou*. Santa Monica: Smart Art Press; Santa Monica Museum of Art, 1998.

Lou, Liza. *Liza Lou*. Venice, Calif.: L&M Arts, 2011.

Lou, Liza. *Liza Lou: American Idol: Works from 1995–2010*. Paris: Galerie Thaddaeus Ropac, 2010.

Lou, Liza. *Liza Lou: American Presidents*. Virginia Beach: Contemporary Art Center of Virginia, 1999.

Lou, Liza. *Liza Lou: Durban Diaries*. London: White Cube, 2012.

Lou, Liza. *Liza Lou: Kitchen*. Davis, Calif.: John Natsoulas Press, 1996.

Lou, Liza. *Liza Lou: Leaves of Glass*. Høvikodden, Norway: Henie-Onstad Kunstsenter, 2001.

TERESA MARGOLLES
Mexican, born 1963

Monographs and Solo Exhibition Catalogues

Baddeley, Oriana. *Teresa Margolles and the Pathology of Death*. London: University of the Arts London, 2009.

Escobedo, Alpha, Leobardo Alvarado, Rein Wolfs, and Teresa Margolles. *Frontera*. Cologne: Walther König; distributed by DAP (New York), 2011.

Margolles, Teresa. *Galería Salvador Díaz Presents "21," the First Solo Exhibition in Spain by Teresa Margolles*. Madrid: Galería Salvador Díaz, 2007.

Margolles, Teresa. *Teresa Margolles*. Metz, France: Fonds régional d'art contemporain de Lorraine, 2005.

Margolles, Teresa. *Teresa Margolles*. Vienna: Kunsthalle Wien, 2003.

Pimentel, Taiyana, Elmer Mendoza, Teresa Margolles, and Medina Cuauhtemoc. *Teresa Margolles: ¿De qué otra cosa podriamos hablar?* Barcelona and Mexico City: Editorial RM, 2010.

Pimentel, Taiyana, Elmer Mendoza, Teresa Margolles, and Medina Cuauhtemoc. *Teresa Margolles: What Else Could We Talk About?* Barcelona and Mexico City: Editorial RM; distributed by DAP (New York), 2010.

Sierra, Santiago, Udo Kittelmann, Elmer Mendoza, and Teresa Margolles. *Teresa Margolles: Muerte Sin Fin*. Ostfildern, Germany: Hatje Cantz; distributed by DAP (New York), 2004.

Yepez, Heriberto, Nike Batzner, Patrizia Dander, and Teresa Margolles. *Teresa Margolles: 127 Cuerpos*. Cologne: Walther König; distributed by DAP (New York), 2006.

Studies

Banwell, Julia Mary. *Teresa Margolles' Aesthetic of Death*. Thesis (PhD)—University of Sheffield, 2009.

Conrad-Bradshaw, Rya. *Healing Threats: Reclaiming Memory and Violence in the Work of Doris Salcedo, Rosangela Rennó, and Teresa Margolles*. Thesis (MA)—Courtauld Institute of Art, University of London, 2004.

Lindenberger, Laura Augusta. *From Morgue to Museum: Contextualizing the Work of SEMEFO and Teresa Margolles*. Thesis (MA)—University of Texas at Austin, 2006.

Olivas, Adriana Miramontes. *(En)Countering Gender Violence and Impunity: The Art of Teresa Margolles and Regina José Galindo*. Thesis (MA)—University of Texas at San Antonio, 2012.

JULIE MEHRETU
American, born Ethiopia 1970

Monographs and Solo Exhibition Catalogues

Allen, Siemon, Kinsey Katchka, and Rebecca Hart. *Julie Mehretu: City Sitings*. Detroit: Detroit Institute of Arts, 2007.

de Zegher, Catherine, and Thelma Golden. *Julie Mehretu: The Drawings*. New York: Rizzoli, 2007.

Fogle, Douglas, ed. *Julie Mehretu: Drawing Into Painting*. Minneapolis: Walker Art Center; distributed by DAP (New York), 2003.

Mehretu, Julie. *Excavations: The Prints of Julie Mehretu*. Minneapolis: Highpoint Editions, 2009.

Mehretu, Julie. *Julie Mehretu: Black City / Ciudad Negra*. Ostfildern, Germany: Hatje Cantz; distributed by DAP (New York), 2006.

Mehretu, Julie. *Julie Mehretu: Manifestation*. Berkeley: Berkeley Art Museum, University of California, 2004.

Mehretu, Julie. *Julie Mehretu: Paintings 2004*. Berlin: Carlier/Gebauer, 2004.

Mehretu, Julie. *Julie Mehretu, Seven Acts of Mercy*. Miami: World Class Boxing, 2005.

Young, Joan, Brian Dillon, and Julie Mehretu. *Julie Mehretu: Grey Area*. Berlin: Deutsche Guggenheim; distributed by DAP (New York), 2009.

WANGECHI MUTU
Kenyan, born 1972

Monographs and
Solo Exhibition Catalogues

Wangechi Mutu. *In Whose Image*. Nuremberg: Verlag für moderne Künst; distributed by DAP (New York), 2009.

Wangechi Mutu. *New Work: Wangechi Mutu*. San Francisco: San Francisco Museum of Modern Art, 2005.

Wangechi Mutu. *A Shady Promise*. Bologna: Damiani, 2008.

Wangechi Mutu. *Solch ungeahnte Tiefen: Wangechi Mutu / This Undreamt Descent: Wangechi Mutu*. Nuremberg: Verlag für moderne Kunst Nürnberg, 2012.

Wangechi Mutu. *Wangechi Mutu*. Los Angeles: Susanne Vielmetter Los Angeles Projects, 2005.

Wangechi Mutu. *Wangechi Mutu*.

Montreal: Musée d'art contemporain de Montréal, 2012.

Wangechi Mutu. *Wangechi Mutu: Amazing Grace*. Miami: Miami Art Museum, 2005.

Wangechi Mutu. *Wangechi Mutu: This You Call Civilization?* Toronto: Art Gallery of Ontario, 2010.

Wangechi Mutu. *Wangechi Mutu, Artist of the Year 2010: My Dirty Little Heaven*. Ostfildern, Germany: Hatje Cantz, 2010.

Wangechi Mutu. *Yo-n-i*. London: Victoria Miro, 2008.

Studies

Kuechler, Joyce M. *Transcending Boundaries: Wangechi Mutu's Collaged Women*. Thesis (AM)—University of Illinois at Urbana-Champaign, 2007.

Lewis, Sarah Elizabeth. *Conceptual Remainders in the Work of Ellen Gallagher, David Hammons, Glenn Ligon, Wangechi Mutu, and Senam Okudzet: Representing Black Forms in the Face of Hyper-Legibility and Global Itinerancy*. Thesis (MA)—Courtauld Institute of Art, University of London, 2004.

CATHERINE OPIE
American, born 1961

Monographs and
Solo Exhibition Catalogues

Opie, Catherine. *Catherine Opie*. Los Angeles: Museum of Contemporary Art, 1997.

Opie, Catherine. *Catherine Opie: American Photographer*. New York: Guggenheim Museum; distributed by DAP (New York), 2008.

Opie, Catherine. *Catherine Opie: Empty and Full*. Ostfildern, Germany: Hatje

Cantz; Boston: Institute of Contemporary Art, 2011.

Opie, Catherine. *Catherine Opie: In between Here and There*. Saint Louis, Mo.: Saint Louis Art Museum, 2000.

Opie, Catherine. *Catherine Opie: 1999 [&] In and Around Home*. Ridgefield, Conn.: Aldrich Contemporary Art Museum, 2006.

Opie, Catherine. *Catherine Opie: Skyways & Icehouses*. Minneapolis: Walker Art Center, 2002.

Opie, Catherine. *Catherine Opie: The Photographers' Gallery, London*. London: Photographers' Gallery, 2000.

Opie, Catherine. *Chicago (American Cities)*. Chicago: Museum of Contemporary Art, 2006.

Opie, Catherine. *Inauguration*. New York: Gregory R. Miller & Co.; distributed by DAP (New York), 2011.

Studies

Bridges, Jennifer Tobitha. *From Typologies to Portraits: Catherine Opie's Photographic Manipulations of Physiognomic Imagery*. Thesis (MA)—Virginia Commonwealth University, Richmond, 2005.

Corn, Melanie Elizabeth. *Queer Looks: Investigating the Photography of Catherine Opie*. Thesis (MA)—University of California, Santa Barbara, 2000.

Hurtado, Laura Allred. *Motherhood and Representation at the Sackler Center for Feminist Art: Judy Chicago, Catherine Opie, Canan Senol*. Thesis (MA)—Department of Art and Art History, University of Utah, 2011.

Moore, Carolee Cecilia. *Challenge and Formal Construction in the Works of Catherine Opie*. Thesis (MA)—University of Texas at San Antonio, 2009.

Weller, Rebecca Ann. *Writing the Body: the Work of Mira Schor, Lynn Hershman, and Catherine Opie*. Thesis (MA)—University of California, Riverside, 1998.

PIPILOTTI RIST
Swiss, born 1962

Monographs and
Solo Exhibition Catalogues

Bronfen, Elisabeth, and Hans Ulrich Obrist. *Pipilotti Rist*. London: Phaidon, 2007.

Engberg, Juliana. *Pipilotti Rist: I Packed the Postcard in My Suitcase*. Southbank, Vic.: Australian Centre for Contemporary Art, 2011.

Morsiani, Paola, et al. *Wishing for Synchronicity: Pipilotti Rist*. Ostfildern, Germany: Hatje Cantz, 2007.

Rist, Pipilotti. *Apricots along the Streets*. Zurich: Scalo; distributed by Thames and Hudson (London), 2001.

Rist, Pipilotti. *Congratulations!* Baden, Switzerland: Lars Müller, 2007.

Rist, Pipilotti. *Elixir: The Video Organism of Pipilotti Rist*. Rotterdam: Museum Boijmans van Beuningen, 2009.

Rist, Pipilotti. *Gravity*. Stockholm: Stockholm Konsthall, 2007.

Rist, Pipilotti. *Himalaya: Pipilotti Rist: 50 KG (nicht durchtrainiert)*. Cologne: Oktagon, 2000.

Rist, Pipilotti. *I Love You Forever, Pipilotti*. Zurich: Tages-Anzeiger, 1997.

Rist, Pipilotti. *I'm Not the Girl Who Misses Much*. Stuttgart: Oktagon Stuttgart, 1994.

Rist, Pipilotti. *Jestem swoja wlasna obca swinia / I Am My Own Foreign Pig / Ich bin mein eigenes fremdes Schwein*. Warsaw: Centrum Sztuki Wspólczesnej Zamek Ujazdowski, 2004.

Rist, Pipilotti. *The Music of Pipilotti Rist's "Pepperminta": Original Motion Picture Soundtrack.* Zurich: Verlag Scheidegger & Spiess, 2009.

Rist, Pipilotti. *Pepperminta: homo sapiens sapiens: Boxa ludens: Biennale di Venezia 2005, Chiesa S. Stae.* Bern: Bundesamt für Kultur; Baden: Lars Müller, 2005.

Rist, Pipilotti. *Pipilotti Rist.* London: Phaidon, 2001.

Rist, Pipilotti. *Pipilotti Rist.* São Paulo: Museu da Imagem e do Som, 2010.

Rist, Pipilotti. *Pipilotti Rist: Augapfelmassage.* Munich: Prestel, 2012.

Rist, Pipilotti. *Pipilotti Rist: Eyeball Massage.* London: Hayward Publishing; distributed by DAP (New York), 2011.

Rist, Pipilotti. *Pipilotti Rist: Fundació Joan Miró Barcelona: partit amistòs, sentiments electrònics / Friendly Game, Electronic Feelings / partido amistoso, sentimientos electrónicos.* Barcelona: Fundació Joan Miró; Girona: Fundació Caixa Girona, 2010.

Rist, Pipilotti. *Pipilotti Rist: les monobandes vidéo / Pipilotti Rist: Single Channel Tapes.* Montreal: Oboro, 2000.

Rist, Pipilotti. *Pipilotti Rist: Museo Nacional Centro de Arte Reina Sofia.* Zurich, Berlin, and New York: Scalo; distributed by DAP (New York), 2001.

Rist, Pipilotti. *Pipilotti Rist: Show a Leg.* Glasgow: Tramway, 2001.

Rist, Pipilotti. *Pipilotti Rist: Sip My Ocean.* Chicago: Museum of Contemporary Art, 1996.

Rist, Pipilotti. *Pipilotti Rist: The Tender Room.* Columbus, Ohio: Wexner Center for the Arts, 2011.

Rist, Pipilotti. *Remake of the Weekend.* Cologne: Oktagon, 1998.

Rist, Pipilotti. *Soundtracks de la vídeo instalaciones de Pipilotti Rist.* Castile and León: MUSAC, 2005.

Rist, Pipilotti. *St. Galler Kulturpreis 2007: Pipilotti Rist.* St. Gallen, Switzerland: St. Gallische Kulturstiftung, 2008.

Rist, Pipilotti. *Stir Heart, Rinse Heart: Pipilotti Rist.* San Francisco: San Francisco Museum of Modern Art, 2004.

Rist, Pipilotti. *A Super-Subjective Pillow Case Next to a Mini Poster Organ.* Kitakyushu, Japan: Center for Contemporary Art, 2001.

Rist, Pipilotti. *Verleihung des Wolfgang-Hahn-Preises 1999 an Pipilotti Rist am 10. November 1999.* Cologne: Gesellschaft für Moderne Kunst am Museum Ludwig, 1999.

Rist, Pipilotti. *Wishing for Synchronicity: Works by Pipilotti Rist.* Houston: Contemporary Arts Museum Houston, 2009.

Söll, Änne. *Pipilotti Rist.* Cologne: DuMont, 2005.

Studies

Lavigne, Julie. *L'art féministe et la traversée de la pornographie érotisme et intersubjectivité chez Carolee Schneemann, Pipilotti Rist, Annie Sprinkle et Marlene Dumas.* Thesis (PhD)—McGill University, Montreal, 2005.

Mühlhausen, Nicole. *Analyse des tons in den video-installationen "Vorstadthirn" und "Extremitäten (weich, weich)" von Pipilotti Rist.* Norderstedt: Grin Verlag, 2005.

Thompson, Sarah Alston. *Pipilotti Rist's "Sip My Ocean": Sound and Representation in Installation.* Thesis (MA)—Virginia Commonwealth University, Richmond, 2008.

Wood, Heather. *Body, Mind, Soul: Female Agency in Performance, 1960–Present.* Thesis (PhD)—The University of Texas at Dallas, 2010.

MIKA ROTTENBERG
Israeli, born Argentina 1976

Monographs and Solo Exhibition Catalogues

Rottenberg, Mika. *Mika Rottenberg.* New York: Gregory R. Miller & Co. and De Appel Arts Centre; distributed by DAP (New York), 2011.

Rottenberg, Mika. *New Work: Mika Rottenberg.* San Francisco: San Francisco Museum of Modern Art, 2010.

KARA WALKER
American, born 1969

Monographs and Solo Exhibition Catalogues

Als, Hilton, and F. Calvo Serraller. *Kara Walker: The Black Road.* Malaga: CAC Centro de Contemporáneo, 2010.

Pindell, Howardena. *Kara Walker: Evasion, Denial, Privelege* [sic]. New York: Midmarch Arts Press, 2011.

———. *Kara Walker–No, Kara Walker–Yes, Kara Walker–?* New York: Midmarch Arts Press, 2009.

Shaw, Gwendolyn DuBois. *Seeing the Unspeakable: The Art of Kara Walker.* Durham, NC: Duke University Press, 2004.

Walker, Kara. *Bureau of Refugees.* Milan and New York: Charta, 2008.

Walker, Kara. *Capp Street Project: Kara Walker.* Oakland, Calif.: CCAC Institute, 1999.

Walker, Kara. *Freedom, a Fable: A Curious Interpretation of the Wit of a Negress in Troubled Times, With Illustrations.* Los Angeles: Peter Norton Family, 1997.

Walker, Kara. *Kara Walker.* Chicago: The Renaissance Society at the University of Chicago, 1997.

Walker, Kara. *Kara Walker.* Copenhagen: Gl. Strand, 2008.

Walker, Kara. *Kara Walker.* Frankfurt am Main: Deutsche Bank, 2002.

Walker, Kara. *Kara Walker.* Freiburg im Breisgau, Germany: Kunstverein Hannover; Modo, 2002.

Walker, Kara. *Kara Walker.* Gütersloh, Germany: Bertelsmann, 2001.

Walker, Kara. *Kara Walker.* Mexico City: Instituto Nacional de Bellas Artes; Museo de Arte Álvar y Carmen T. de Carrillo Gil, 2005.

Walker, Kara. *Kara Walker.* New York: IRADAC, The Institute for Research on the African Diaspora in the Americas and the Caribbean, 1998.

Walker, Kara. *Kara Walker: A Negress of Noteworthy Talent.* Turin: Fondazione Merz, 2011.

Walker, Kara. *Kara Walker: After the Deluge.* New York: Rizzoli, 2007.

Walker, Kara. *Kara Walker: Fall Frum Grace, Miss Pipi's Blue Tale, Six Miles from Springfield on the Franklin Road… calling to me from the angry surface of some grey and threatening sea, 8 Possible Beginnings or The Creation of African-America, a Moving Picture by Kara E. Walker, Testimony: Narrative of a Negress Burdened by Good Intentions.* Warsaw: Centrum Sztuki Współczesnej Zamek Ujazdowski, 2011.

Walker, Kara. *Kara Walker: Fantasies of Disbelief.* Des Moines: Des Moines Art Center, 2000.

Walker, Kara. *Kara Walker: Grub for

Sharks: A Concession to the Negro Populace. Liverpool: Tate Liverpool, 2004.

Walker, Kara. *Kara Walker: My Complement, My Enemy, My Oppressor, My Love*. Minneapolis: Walker Art Center, 2007.

Walker, Kara. *Kara Walker: Pictures from Another Time*. Ann Arbor: University of Michigan Museum of Art, 2002.

Walker, Kara. *Kara Walker: Slavery! Slavery!* Washington, DC: International Arts & Artists, 2001.

Walker, Kara. *Kara Walker: Upon My Many Masters—An Outline*. San Francisco: San Francisco Museum of Modern Art, 1997.

Walker, Kara. *Safety Curtain 1: Kara Walker*. Vienna: P&S, 2000.

Walker, Kara, and Ian Berry. *Kara Walker: Narratives of a Negress*. Saratoga Springs, NY: Frances Young Tang Teaching Museum and Art Gallery, Skidmore College; Cambridge, Mass.: MIT Press, 2003.

Walker, Kara, and Tommy Lott. *Kara Walker Speaks: A Public Conversation on Racism, Art, and Politics with Tommy Lott*. New York: Black Renaissance Noire, 2003.

Studies

Abbott, Sandra L. *The Silhouettes of Kara Walker*. Thesis (MA)—Northern Illinois University, DeKalb, 2000.

Caesar, Tiffany D. *The Trickster, the Griot, and the Goddess: Optimal Consciousness in the Works of Ntozake Shange, Kara Walker and India.Arie*. Thesis (M.A.)—University of Louisville, Kentucky, 2010.

Harrington, Catherine. *Considering the Grotesque in Response to Contemporary Critique of Kara Walker's Silhouette Art*. Thesis (MA)—Simmons College, Boston, 2009.

LaViscount, Takenya A. *Presenting Kara Walker's Art: Case Studies of the Studio Museum in Harlem and the Walker Art Center*. Thesis (MA)—American University, 2006.

Little, Karin. *Kara Walker's Sarcasm*. Thesis (MA)— Courtauld Institute of Art, University of London, 2002.

Martin, Courtney Jasmine. *"Side-Long Glance": An Examination of the Artist Kara Walker*. Thesis (MA)—State University of New York at Stony Brook, 2001.

Miers, Scarlett. *The Cut between Reality and Imagination in Antebellum Silhouettes: "Gone With the Wind," Kara Walker and Henry Darger*. Thesis (MA)—California Institute of the Arts, Valencia, 2010.

Moeller, Whitney. *Parody as a Tool of Critique in Kara Walker's "Slavery! Slavery!"* Thesis (MA)—Indiana University, 2008.

Moore, Laura Ashley. *"The feeling of being thrust into history": Kara Walker, the Memory of Slavery, and the Postmodern (Black) Self*. Thesis (AB)—Harvard University, Cambridge, Mass., 2009.

Peabody, Rebecca Rae. *A Strategic Cut: Kara Walker's Art and Imagined Race in American Visual Culture*. Thesis (PhD)—Yale University, New Haven, Conn., 2006.

Rochmes, Sophia Ronan. *Constructs of Contradiction: Challenging Racism through Stereotype in the Art of Chris Ofili and Kara Walker*. Thesis (BA)—Amherst College, Mass., 2004.

Shaw, Gwendolyn DuBois. *Seeing the Unspeakable: The Art of Kara Walker*. Thesis (PhD)—Stanford University, Calif., 2000.

Tate, Margaret. *Race-ing and Gendering Art Criticism: Politics of Identity in the Reviews of Lorna Simpson, Glenn Ligon, and Kara Walker*. Thesis (MA)—University of Mississippi, 2008.

JANE AND LOUISE WILSON
both British, born 1967

Monographs and Solo Exhibition Catalogues

Corrin, Lisa. *Jane & Louise Wilson*. London: Serpentine Gallery, 2000.

Wilson, Jane, and Louise Wilson. *Jane & Louise Wilson*. Amsterdam: De Appel, 2004.

Wilson, Jane, and Louise Wilson. *Jane and Louise Wilson*. Derby, UK: QUAD, 2008.

Wilson, Jane, and Louise Wilson. *Jane and Louise Wilson*. London: Ellipsis, 2000.

Wilson, Jane, and Louise Wilson. *Jane & Louise Wilson*. Salamanca: Ediciones Universidad de Salamanca, 2003.

Wilson, Jane, and Louise Wilson. *Jane and Louise Wilson: A Free and Anonymous Monument*. London: Film and Video Umbrella; BALTIC Centre for Contemporary Art; Lisson Gallery, 2004.

Wilson, Jane, and Louise Wilson. *Jane and Louise Wilson: Erewhon*. Houston: Blaffer Art Museum, University of Houston, 2005.

Wilson, Jane, and Louise Wilson. *Jane & Louise Wilson: Haunch of Venison, Zürich*. London: Haunch of Venison, 2007.

Wilson, Jane, and Louise Wilson. *Jane and Louise Wilson: Las Vegas, Graveyard Time*. Dallas: Dallas Museum of Art, 2001.

Wilson, Jane, and Louise Wilson. *Jane & Louise Wilson: Tempo Suspeso*.

Santiago de Compostela: Xunta de Galicia: CGAC; Lisbon: Fundação Calouste Gulbenkian, 2011.

Wilson, Jane, and Louise Wilson. *Normapaths*. London: Chisenhale Gallery, 1995.

Wilson, Jane, and Louise Wilson. *Stasi City*. Hannover, Germany: Kunstverein Hannover, 1997.

Wilson, Jane, and Louise Wilson. *Stasi City, Gamma, Parliament, Las Vegas, Graveyard Time*. London: Serpentine Gallery, 1999.

LISA YUSKAVAGE
American, born 1962

Monographs and Solo Exhibition Catalogues

Yuskavage, Lisa. *Lisa Yuskavage*. Mexico City: Fundación Olga y Rufino Tamayo, 2006.

Yuskavage, Lisa. *Lisa Yuskavage*. New York: David Zwirner, 2006.

Yuskavage, Lisa. *Lisa Yuskavage*. Philadelphia: Institute of Contemporary Art, 2000.

Yuskavage, Lisa. *Lisa Yuskavage*. Santa Monica, Calif.: Smart Art Press, 1996.

Yuskavage, Lisa. *Lisa Yuskavage: Small Paintings, 1993–2004*. New York: Abrams, 2004.

Yuskavage, Lisa. *Tit Heaven*. New York: DAP, 2003.

Studies

Patterson, Lauren Hoerst. *Sex and the Studio: Subject and Studio Practice in the Paintings of Lisa Yuskavage*. Thesis (MA)—Temple University, Philadelphia, 2006.

Ziegler, Matthias. *Verrückte Weiblichkeit!: Ambiguität und*

Subversivität in den Bildern von Lisa Yuskavage. Thesis (PhD)—Universität Zürich, 2010.

Zis, Michelle. *Mass Cultural and Homosocial Issues in Lisa Yuskavage's Paintings.* Thesis (MA)—School of the Art Institute of Chicago, 2005.

ANDREA ZITTEL
American, born 1965

Monographs and Solo Exhibition Catalogues

Prince, Nigel. *Andrea Zittel: A– Z Living Experiment.* London: August Media Ltd., 2002.

Zittel, Andrea. *A–Z Advanced Technologies: Fiber Forms.* Tokyo: Gallery Side 2, 2002.

Zittel, Andrea. *A–Z for You—A–Z for Me.* San Diego: San Diego State University, 1998.

Zittel, Andrea. *Andrea Zittel.* Munich: Sammlung Goetz, 2003.

Zittel, Andrea. *Andrea Zittel: A–Z Cellular Compartment Units.* Birmingham: Ikon Gallery, 2001.

Zittel, Andrea. *Andrea Zittel: A–Z Mobile Compartment Units (A–Z Mobila Rumsenheter).* Stockholm: Moderna Museet, 2003.

Zittel, Andrea. *Andrea Zittel: Between Art and Life.* Milan: Mousse Publishing, 2011.

Zittel, Andrea. *Andrea Zittel: Broadway Window.* New York: New Museum of Contemporary Art, 1993.

Zittel, Andrea. *Andrea Zittel: Critical Space.* Munich: Prestel, 2005.

Zittel, Andrea. *Andrea Zittel: Diary #01.* Milan: Tema Celeste, 2002.

Zittel, Andrea. *Andrea Zittel: Gouachen und Illustrationen.* Göttingen, Germany: Steidl, 2008.

Zittel, Andrea. *Andrea Zittel: Lay of My Land.* Munich: Prestel, 2011.

Zittel, Andrea. *Andrea Zittel: Three Living Systems.* Pittsburgh: Carnegie Museum of Art, 1994.

Zittel, Andrea. *Introducing the A–Z Administrative Services 1993 Living Unit.* San Francisco: Jack Hanley Gallery, 1993.

Zittel, Andrea. *Introducing the A–Z Travel Trailer Unit.* San Francisco: San Francisco Museum of Modern Art, 1995.

Zittel, Andrea. *Living Units.* Basel: Museum für Gegenwartskunst, 1996.

Zittel, Andrea. *Personal Programs.* Ostfildern, Germany: Hatje Cantz, 2000.

Studies

Brackman, Yvette Sophia. *Elizabeth Hawes, Varvara Stepanova and Andrea Zittel: Three Approaches to Clothing Design.* Thesis (MA)—University of Illinois at Chicago, 1997.

Glenn, Allison M. *Site Reflexivity and the Contemporary Environment: Small Liberties in Andrea Zittel's High Desert Test Sites.* Thesis (MAHA)—Modern Art History, Theory, and Criticism and Arts Administration and Policy, School of the Art Institute of Chicago, 2012.

Laurence, Timothy. *An Examination of Design Art: Andrea Zittel and Jorge Pardo.* Thesis (MA)—College of Fine Arts, University of New South Wales, 2006.

Morland, Arno. *The Contemporary Significance of Design in Art.* Thesis (MA)—University of the Witwatersrand, Johannesburg, 2005.

INDEX OF NAMES

Page numbers in *italics* refer to illustrations.

Page numbers in **boldface** refer to the main chapter on the artist.

ACKNOWLEDGMENTS THE EXPERIENCE OF WORKING ON our first book, *After the Revolution: Women Who Transformed Contemporary Art*, was so inspiring to each of us that a sequel, focused on a younger generation of women artists working globally, seemed inevitable. We are very thankful that Prestel Publishing agreed. We are grateful to have had the good fortune to work with Ryan Newbanks, Editor at Prestel, who patiently and expertly guided and edited the entire project.

We would like to thank the project's production managers, Sue Medlicott and Nerissa Vales, and Prestel's intern, Elizabeth Lotto, for her assistance with picture research. We are fortunate once again to work with bibliographer Amy Lucker, Head of the Institute of Fine Arts Library, New York University. We also wish to thank Beverly Joel for her inspired design.

Many thanks to Maura Reilly and the students in her seminar on feminist art at the Queensland College of Art in Brisbane, Australia, for their comments and input at a crucial stage in the book's conceptualization.

Perhaps the unsung heroes in a project of this magnitude are the galleries, artists' studios, and other sources that provide crucial research material and images. For this assistance, we would like to thank: Jennifer Belt and Ryan Jensen, Art Resource; Nicolette Enke, Yael Bartana studio; Deborah Cristiano, Studio Tania Bruguera; Adam Sheffer and Ellen Robinson, Cheim & Read; Renee Cox; Tamsin Casswell, Tracey Emin studio; Ronald Feldman Gallery; Grace Evans, Zach Feuer Gallery; James McKee and Eugenia Ballvé, Gagosian Gallery; Kate Gilmore studio; Chris Prause, Rachel Engler, and Caroline Luce, Gladstone Gallery; Klemens Gasser and Tanja Grunert, Inc.; Nohra Haime Gallery; Josephine Halvorson; Lisa Hoke; Deborah Kass and Mark Markin, Paul Kasmin Gallery; Melisa Rangel, Galerie Peter Kilchmann; Anna Walewska, Katarzyna Kozyra Foundation; Ingrid Cincala-Gilbert, L&M Arts; Gregory La Rico and Stephanie Smith, Lehmann Maupin; Robert Fitzpatrick and Patrick Armstrong, Tanya Leighton Gallery; Charlie Tatum and Lisa Carlson, Lombard Freid Projects; Eliza Hill, Caroline Burghardt, and Tiffany Edwards, Luhring Augustine; Sarah Rentz, Julie Mehretu studio; Josephine Nash and Mamie Tinkler, Mitchell-Innes & Nash; Renee Reyes, Andrea Rosen Gallery; Martha Rosler; Claire Feeley, Serpentine Gallery; Elise Siegel; Scott Briscoe, Sikkema Jenkins & Co.; Inbal Ammar, Noa Reshef, and Maya Pasternak, Sommer Contemporary Art, Tel Aviv; Carissa Rodriguez, Reena Spaulings Fine Art; Cecilia Jurado, Y Gallery; Małgorzata Bogdańska, Zachęta National Gallery of Art; Chris Rawson, David Zwirner Gallery; and Simon Greenberg, 303 Gallery.

THE RECKONING

The research that interns Erika Garcy, Olivia Feal, and Anna Sorenson undertook in gathering information used for the charts was invaluable. Mary Delle Stelzer and Stuart Stelzer were instrumental in helping to organize and analyze this data. Thanks also to Francine Newberg for her editorial perceptiveness.

Most important, we want to thank the twenty-four artists featured in this book for their exceptional accomplishments in creating bodies of work that are in dialogue with the past while remaining relevant and influential: Ghada Amer, Janine Antoni, Yael Bartana, Tania Bruguera, Cecily Brown, Cao Fei, Nathalie Djurberg, Tracey Emin, Kate Gilmore, Sharon Hayes, Katarzyna Kozyra, Justine Kurland, Klara Liden, Liza Lou, Teresa Margolles, Julie Mehretu, Wangechi Mutu, Catherine Opie, Pipilotti Rist, Mika Rottenberg, Kara Walker, Jane and Louise Wilson, Lisa Yuskavage, and Andrea Zittel.

— ELEANOR HEARTNEY, HELAINE POSNER,
NANCY PRINCENTHAL, AND SUE SCOTT

REPRODUCTION CREDITS

Kara Walker
Artwork © Kara Walker; Images courtesy of Sikkema Jenkins & Co., New York (224 [Photo by Gene Pittman], 225, 226, 227, 228, 229 [Photo by Dave Sweeney], 230).

Jane and Louise Wilson
All images courtesy of 303 Gallery, New York (102, 104, 107, 108, 109).

Lisa Yuskavage
All images courtesy of the artist and David Zwirner, New York/London (110, 113, 114, 115, 117).

Andrea Zittel
Artwork © Andrea Zittel; Images courtesy of Andrea Rosen Gallery, New York (164 [Photo by Oren Slor], 166 [Photo by Peter Muscato], 168 [Photo by Jessica Eckert], 169 [Photo by Tom Loonan], 170 [Photo by Peter Muscato]).

Published by Prestel, a member of Verlagsgruppe Random House GmbH

© 2013 Prestel Verlag, Munich • London • New York
Text © 2013 Eleanor Heartney, Helaine Posner, Nancy Princenthal, and Sue Scott
All artwork © the artist or their estate. See pages 254–55 for a full list of reproduction credits.

Prestel Verlag
Neumarkter Strasse 28
81673 Munich
TEL. +49 (0)89-4136-0
FAX +49 (0)89-4136-2335

Prestel Publishing Ltd.
14-17 Wells Street
London W1T 3PD
TEL. +44 (0)20-7323-5004
FAX +44 (0)20-7323-0271

Prestel Publishing
900 Broadway, Suite 603
New York, NY 10003
TEL. +1 212-995-2720
FAX +1 212-995-2733

www.prestel.com

Library of Congress Control Number: 2013941003

ISBN 978-3-7913-4759-2

EDITORIAL DIRECTION
Ryan Newbanks

DESIGN
Beverly Joel, pulp, ink.

PRODUCTION
The Production Department

ORIGINATION
Fine Arts Repro House Co., Ltd., Hong Kong

BIBLIOGRAPHY
Amy Lucker

PROOFREADING AND INDEX
Samantha Waller

PRINTING AND BINDING
Great Wall, Hong Kong

Verlagsgruppe Random House FSC® N001967
Printed on 157gsm Korean Neo matte FSC®, supplied by Moorim Paper Co. Ltd., Korea

FRONTISPIECE
Julie Mehretu, *Stadia I*, 2004 (detail). Photo by Richard Stoner, Courtesy of the artist and Marian Goodman Gallery, New York. Reproduced in full on page 214.